From an aesthetic point of view

point of view

Philosophy, art and the senses

From an aesthetic point of view

Philosophy, art and the senses

Edited by Peter Osborne

Library of Congress Catalog Card Number: 00-102184

A catalogue record for this book is available from
the British Library on request

The right of the individual contributors to be acknowledged
as authors of their work has been asserted by them
in accordance with the Copyright, Designs
and Patents Act 1988

Copyright © 2000 of the individual contributions
remains with the authors

Introduction and compilation
copyright © 2000 Peter Osborne

First published in 2000 by
Serpent's Tail,
4 Blackstock Mews,
London N4 2BT

Website: www.serpentstail.com

Typeset in Stone Serif by Avon Dataset Ltd,
Bidford on Avon, B50 4JH

Printed in Great Britain by Mackays of Chatham plc,
Chatham, Kent

10 9 8 7 6 5 4 3 2 1

Contents

Introduction

From an aesthetic point of view

Peter Osborne

What is the place of aesthetic in the experience of art? And how
has it changed in the two hundred or so years since the emergence
of art in the distinctively modern sense of a relatively autonomous
domain of practices, experience, authority and value – a discrete
field of cultural production, in Bourdieu's sense of the term?[1]
These questions are raised, again and again, in discussions of
contemporary art, yet the poverty of prevailing discourses of the
aesthetic repeatedly impedes their development. As Raymond
Williams remarked, there is something 'irresistibly displaced and
marginal' about the 'common and limiting phrase "aesthetic
considerations"'.[2] Williams drew particular attention to the
opposition of aesthetic to 'practical or utilitarian' concerns. But
the contrast between aesthetic and cognitive or intellectual
matters is equally marked, despite the late nineteenth-century
association of aestheticism with intellectualism in a conception of
'high' culture in which the contemplative character of aesthetic
disinterest acts as a modern-day surrogate for the ancient
contemplation of ideas.[3] Indeed, with the development of an
ideology of pure opticality in the visual arts (corresponding to
what Duchamp called 'retinal painting'), and a growing
dependence of economic value upon the aesthetic dimension of
commodity display, the counter-positioning of aesthetic to
intellectual values implicit in the etymology of the term 'aesthetic'
(from the Greek *aisthesis*, meaning sensation or perception by the

senses) has in many ways been strengthened.

It is notable, for example, that the so-called 'conceptual' art of the late 1960s and early 70s opposed itself indefatigably to the aesthetic, as such, rather than conceiving of itself as rethinking or reworking it in some way. While the antipathy of the cultural studies and art theory of the 1970s and 80s to anything connected to aesthetics is well known. Aesthetics appeared there as an anti-intellectual form of cultural elitism, the claims to universality of which are based on little more than a mystical veil of intuition shrouding a defence of inherited authority.

However, one should note an abiding ambiguity in the cognitive valency of the aesthetic even here, *within* the terms of its opposition to the intellect, which has been present at least since Aristotle. For without this ambiguity, aesthetic could never have attained the cultural or philosophical significance it has come to possess in the West since the first flowering of aesthetics, as a discourse on the senses oriented towards the criticism of art, during the Renaissance. The term 'aesthetics' was, famously, not coined until the mid eighteenth century. However, the psychological language of aesthetics had a long prehistory. It was during the Renaissance that this language was first appropriated to the problem of explaining the 'rightness' of works of art, leading to that metaphorical generalization of the concept of taste (*gusto*) which was the basis of the seventeenth and early eighteenth-century criticism to which Baumgarten's work was the first systematic philosophical response.[4]

For Aristotle, *aisthesis* was not a form of *episteme* or intellectual knowledge (in this, he followed Plato), but it did nonetheless involve a *judgement* of sense: 'each sense . . . judges/discriminates the specific differences of its own sensible object'.[5] Unlike Plato, Aristotle thus attributed an independent non-intellectual cognitive value to the senses. In inventing the term 'aesthetics' (*aesthetica*, in the Latin) to denote the science of the sensory knowledge of

beauty – 'perfection of sense' – Baumgarten was deploying a broadly Aristotelean conception of *aisthesis* to counter the shortcomings of the Platonic inheritance of Leibnizian rationalism in matters of taste: its derogatory, or at best contradictory, estimation of the senses. Kant may have rejected Baumgarten's notion of a pure sensory knowledge, but his notorious anti-cognitivism in aesthetics is as much an effect of the limitations of his conception of cognition as it is of any kind of sensual purism. In Kant's account, not only is sensible intuition an indispensable element of knowledge, but the faculty of understanding plays an essential, albeit logically undetermining, role in aesthetic judgement itself. Aesthetic may not yield a form of 'knowledge', for Kant, but it does give rise to a logically distinct type of judgement. As such, it is inscribed into the general field of cognition, as a cognitively significant aspect of all experience.

In fact, one can read Kant's *Critique of Aesthetic Judgement* (1790) as a study in the cognitive ambiguity of the aesthetic. In it, aesthetic is subjected to a productive but unresolved double-coding. On the one hand, in its core sense, 'aesthetic' refers to the independent functioning of the faculty of sensibility (sensible intuition), the transcendental doctrine of which is proffered as the first part of the Transcendental Doctrine of Elements in the *Critique of Pure Reason*.[6] Here, aesthetic is *opposed to* and *excludes* the understanding, which is the seat of concepts, conceived as representations of forms of judgement. On the other hand, insofar as aesthetic is nonetheless the name for a particular kind of judgement – 'non-conceptual' or indeterminate judgements of the beautiful and the sublime – it refers to a relation (a relation of reflection) between the faculties of sensibility and those of understanding and reason, respectively. Here, aesthetic *includes* reference to the two other cognitive faculties. Most fundamentally, it is concerned with the 'harmony' of these three faculties and hence with the unity of subjectivity

itself. (This is the topic of Christoph Menke's essay.)[7]

As a consequence of this double-coding, the logical indeterminacy of aesthetic judgement may be read in two radically different ways, giving rise to quite different assessments of the philosophical significance of aesthetics: (i) as a type of cognitive inadequacy, and (ii) as a movement towards an experience of totality and a metaphysics of subjectivity (the relational totality of cognitive faculties). Broadly speaking, these two assessments correspond to the position of aesthetics within the 'analytical' and 'continental' traditions of post-Kantian philosophy, respectively. Indeed, the disparity between the places of aesthetics within the two traditions is one of the most striking symptoms of their divergence. To do philosophy in the mainstream of the analytical or 'Anglo-American' tradition in the period following the Second World War was to view the world from what Quine famously described as 'a logical point of view'.[8] And in Urmson's Oxford-oriented encyclopedia of Western philosophy of 1960, in an entry on aesthetics which the editor wrote himself, we are are left in no doubt that as a consequence 'aesthetics, more than any other branch of philosophy seems doomed either to pretentious vagueness or to an extreme poverty which makes it a poor stepsister to other main fields of philosophical inquiry.'[9] Indeterminate judgement becomes 'pretentious vagueness' or 'extreme poverty' of content.

In the so-called 'continental' or 'modern European' tradition, on the other hand, Kant's understanding of aesthetic judgement has provided the starting point for a variety of engagements with both the metaphysical and epistemological traditions which are in no way merely regional (that is, confined to aesthetics as a particular 'branch' of the discipline), but involve alternative conceptions of the philosophical project itself. Hermeneutics, dialectical logic, Nietzschean affirmation, negative dialectic, deconstruction, a Lyotardian thinking of 'the event', and even

Deleuzean materialism, all take their cue, in one way or another, from Kant's conception of a judgement which is reflective and undetermining in its logical form. 'Continental' philosophy, one might say, views the world from an aesthetic point of view. As such, it tends to attribute an importance to art for philosophy far in excess of anything acceptable to – or at least, susceptible to articulation for – even the most sympathetic analytical philosopher of art.[10] It is for this reason that the prospect of the end of art (discussed in Alexander Düttmann's 'De-arting', below) carries for the 'modern European' tradition such epochal philosophical significance.

It is the virtue of 'an aesthetic point of view', in the expansive post-Kantian sense, that it is at once systematic in its philosophical orientation (that is, directed towards reflection on the relations between the elements of a whole – paradigmatically, the faculties of the human subject) and anti-systematic in form, since the singularity of the judgements to which it leads means, in Kant's words, that 'there neither is, nor can be, a *science* of the beautiful'.[11] There is only critique. Such is the proto-Romanticism of Kant's aesthetics. Criticism of taste (the philosophical elaboration of its conditions and consequences) is not, however, the same thing as the judgement of a work of art *qua* art, as Kant also made clear. To judge art aesthetically *qua* art – to say, for example, 'this is a beautiful *painting*' – is to make what Kant calls a 'logically conditioned' aesthetic judgement: an aesthetic judgement conditioned by a particular concept; in this case, painting.[12] In this respect, there is a disjunction between art and aesthetic even in Kant, which is a trace of the more fundamental difference between their discourses established at the beginning of the aesthetic tradition, in Aristotle.

For Aristotle, the pleasures of perception were essentially connected to neither beauty nor art, which have independent conceptual genealogies. Art (*techne*), for Aristotle, was 'a reasoned

habit of mind concerned with making',[13] an intellectual virtue in
its own right (which *aisthesis* was not); while the beautiful (*kalos*)
was a metaphysical form in which the *good* and the pleasant were
conjoined in order, proportion, and definiteness. The gradual and
uneven convergence of these three strands of Western thought –
aesthetic, beauty, and art – was a historical process of great length
and enormous complexity, involving, among other things, the
separating out of certain specific arts judged 'beautiful', and the
development of specialized institutions devoted to their pro-
motion. Beauty is the mediating term between art and aesthetic. It
is ironic in this regard that both the philosophical concept of
aesthetics (in Baumgarten) and the modern philosophical concept
of art (in the early German Romantics) should have been based on
the generalization of a literary model; while the terms 'aesthetics'
and 'art' have subsequently, and increasingly, tended to be
restricted in their application to the context of the visual, the
musical and the performing arts. (The effect on the philosophical
understanding of language of the aesthetic transformation of the
literary model in the transition from 'poetics' to 'aesthetics', is the
topic of the contribution by Jacques Rancière.) The complex
relations here between the historically received plurality of the
arts and the emergence of a generic concept of art are further
complicated by the tangled web of connections between different
national cultural traditions, traceable through the various
terminological exchanges between European languages. We still
lack an adequate history of literature's loss of its claim to fill the
sign of 'art', for example.

The idea that aesthetic, beauty, and art might be systematically
conceptually united under the hegemony of the aesthetic is
relatively recent in historical terms (the late eighteenth century),
had a relatively brief active philosophical life (about a hundred
and fifty years), and was fraught with difficulties from the
outset. (See Jonathan Rée's 'The aesthetic theory of the arts').

For not only did significant sectors of the institutions of art remain recalcitrant to the idea that art's significance be reduced to pure aesthetic judgements, but by the early twentieth century avant-garde art had begun to revolt against the classical notion of beauty, however radically aesthetically appropriated and Romantically transformed; indeed, to revolt against the very idea of disinterest constitutive of aesthetic in its modern form. Beauty is little more than a residual conservative value in the art of the last fifty years. While in its canonical Kantian interpretation, the sublime is not a form of experience to be had from art, but only from nature.[14] Contemporary visual art stands on the ruins of beauty. This has left the place of aesthetic in the experience of contemporary art uncertain and confused, for all the endeavours of formalist modernism to rescue form from the ruins.

Art, it would seem, in its emphatic modern sense at least, is irreducibly aesthetic. That is, one reason it is taken to be culturally important is because it offers something – a pleasure of the senses, in a cognitively expanded interpretation – which exceeds and ruptures the fixity of determinate judgement, in a singular but logically indeterminate manner. Yet this notion of the aesthetic (a reflective judgement of taste) appears to capture so little of what is significant and challenging about specific works of modern art that it often seems to drop out as a meaningful factor in their analysis. If certain pleasures of perception derive from the reflective experience of the cognitive faculties in general, associated with the distinctive *singularity* of certain kinds of object (works of art), the discourse of aesthetic nonetheless appears, ironically, to be inadequate to the cultural-historical *specificities* of the singularities in question. On the other hand, it remains unclear precisely what a judgement of art (as opposed to a free judgement of sense made about a work of art) might be. What does it mean, for example, to judge a painting *qua* painting? And

Peter Osborne

is it the same thing as judging it *qua* art? Or is there more philo-
sophically to 'art' than there is to any particular art – assuming
there is still some philosophical validity to the classification of
works into arts? And if so, what is it, if it is not just aesthetic, in
the sense of susceptibility to a 'free' or 'pure' reflective judgement
of taste? These questions go to the heart of the increasingly
troubled place of 'art' within contemporary culture, beyond the
commodified spectacles of the blockbuster shows of the new-style
museums.

Most of the essays in this volume were papers delivered to a
conference at Middlesex University in November 1998, polemically
entitled 'Where Theory Ends, There Art Begins' – a
'modernization' of Friedrich Schlegel's aphorism, 'Where
philosophy ceases literature must begin'.[15] The intention was to
explore the notion of aesthetic as that constitutive excess which
marks art off from other kinds of intellectual production. (The
theme is treated most directly in Sylviane Agacinski's essay,
'Theoretical excess', which inverts the problematic.) The essays are
of two kinds: historico-philosophical reflections upon the modern
concept of aesthetic and its relationship to art and the arts (Part
One); and more concrete discussions of the significance of
aesthetic to particular moments in the visual arts over the last
fifty years – the paintings of Francis Bacon, the photography of
Cindy Sherman, and the ambiguous ubiquity of the monochrome
(Part Two). The two parts correspond to the two main avenues of
inquiry opened up by a positive estimation of the logical
negativity of the aesthetic: (i) a broad movement outwards,
towards a reconsideration of cognate philosophical concepts, and
(ii) a more concrete turn towards works of art themselves,
demanded by the singularity of aesthetic judgement – a turn
which, in the irreducibly historical dimension of all interpretation
of art, is necessarily also a turn away from Kant, in the general
direction of Hegel.

This is, at the same time, a turning of the philosophical inter-
pretation of art towards culture, not just in the subjective sense of
Bildung as a cultivation or process of formation of subjectivity, but
also in the objective sense of relational totalities of practices
(Hegel's forms of 'spirit') connected to broader socio-historical
processes and practices. It is in relation to art's place within this
more expansive context that the question of the sense of
'aesthetic' most relevant to the comprehension of contemporary
art must ultimately be addressed.

Notes

1. Pierre Bourdieu, *The Field of Cultural Production: Essays on Art and
 Literature*, edited and introduced by Randal Johnson, Polity Press, Oxford,
 1993, ch. 1; *The Rules of Art: Genesis and Structure of the Literary Field*,
 trans. Susan Emanuel, Stanford University Press, Stanford, 1995, Pt I.

2. Raymond Williams, 'Aesthetic', in *Keywords: A Vocabulary of Culture and
 Society* (1976), Fontana, London, 2nd ed. 1983, p. 32.

3. For an acute analysis of the retrospective dimension of nineteenth-
 century aestheticism, see Carolyn Williams, *Transfigured World: Walter
 Pater's Aesthetic Historicism*, Cornell University Press, Ithaca, 1989.

4. David Summers, *The Judgement of Sense: Renaissance Naturalism and the Rise
 of Aesthetics*, Cambridge University Press, Cambridge, 1987, pp. 197, 320.

5. Aristotle, *De Anima*, 426b 5–10.

6. Immanuel Kant, *Critique of Pure Reason*, A19–49, B33–73.

7. Faculty psychology is the thread of continuity connecting Aristotle's
 writings on *aisthesis* to eighteenth-century debates. It was the
 Christianized neo-Platonic appropriation of Aristotle's faculty psychology
 which provided the intellectual framework for that aesthetic 'liberation'
 of painting, sculpture and architecture from the mechanical arts during
 the Renaissance which was the result of the new science of optics. (See
 Summers, *The Judgement of Sense*). Its influence is still to be seen in Kant,
 whose scientifically updated transcendentalized version was subsequently
 the butt of Nietzsche's wit.

8. Willard Van Orman Quine, *From a Logical Point of View: Logico-
 Philosophical Essays*, Harvard University Press, Cambridge MA, 1953.

9. The entry is reprinted in the revised edition of 1989, with the sardonic addition 'See also Adorno' – a new entry in that edition. J. O. Urmson and Jonathan Rée, *The Concise Encyclopedia of Western Philosophy and Philosophers*, Unwin Hyman, London, 1989, p. 3.

10. 'Susceptible to articulation . . .' because it is possible to attribute the highest human and cultural value to art without believing this value to be articulable in language, and hence a possible object of philosophical inquiry. There is complicity between logico-lingustic analysis and a mystical aestheticism of the 'high' cultural kind; as in the famous last sentence of Wittgenstein's *Tractatus*: 'Whereof one cannot speak, thereof one must be silent.' For a criticism of the 'utterly antiphilosophical' character of such mysticism – 'a taboo that virtually abolishes reason itself' – see Theodor W. Adorno, 'Skoteinos, or How to Read Hegel', in his *Hegel: Three Studies* (1963), trans. Shierry Weber Nicholsen, MIT Press, Cambridge MA, 1993, pp. 101–2.

11. Immanuel Kant, *Critique of Judgement*, trans. Werner S. Pluhar, Hackett, Indianapolis/Cambridge, 1987, 'Appendix. On Methodology Concerning Taste', p. 230. Cf. the famous footnote to the introductory section of the 'Transcendental Aesthetic' in the *Critique of Pure Reason* (A21, B35–6) in which Kant describes Baumgarten's endeavours 'to bring the critical treatment of the beautiful under rational principles, and so to raise its rules to the rank of a science' as 'fruitless'. In extending his own use of the term 'aesthetic' to include the critical treatment of the beautiful in the *Critique of Judgement*, Kant is often mistakenly thought to have changed his mind on this matter. However, as this quotation indicates, he found a third way.

12. See Kant, *Critique of Judgement* §16 'A Judgement of Taste by Which We Declare an Object Beautiful under the Conditions of a Determinate Concept is Not Pure'.

13. Aristotle, *Nicomachean Ethics*, 6 iv.

14. The Lyotardian attempt to make the sublime the central experiential form of modern art fails to address the conceptual rationality of Kant's restriction of its nature; much as the various attempts to import psychoanalytical categories such as 'the abject' into art theory have tended to be vitiated by their neglect of the broader framework from which they derive their legitimacy.

15. The exceptions are those by Christoph Menke and Alexander Düttmann. Menke's essay first appeared in the *Graduate Faculty Philosophy Journal*, Vol. 21, No. 2 (1999). Düttmann's piece first appeared under the title 'Entkunstung' in *L'Esprit Créateur*, Vol. XXXV, No. 3. We are grateful for permission to reprint them with some minor modifications, here. The quotation from Schlegel is from his *Ideas* of 1800. For a recent discussion of this particular idea, see Andrew Bowie, *From Romanticism to Critical Theory: The Philosophy of German Literary Theory*, Routledge, London and New York, 1997, ch. 2, 'Shifting the Ground: "Where philosophy ceases literature must begin" '.

PART ONE

What aesthetics can mean

Jacques Rancière

Translated by Brian Holmes

There are two widespread answers to the question of the meaning of aesthetics. The first says it's obvious: aesthetics is the part of philosophy that deals with the properties of artworks and with the properties that allow us to sense and appreciate them as such. There is aesthetics because there is art, just as there is political philosophy because there are governments and political conflicts. Yet we know there is nothing obvious about such a deduction. The fact that there are painters, poets, and architects is not reason enough for philosophy to deal with them in the form of a thinking of art. Even more, we know that the fact that there are all these things is not reason enough for art to exist as the general concept to which these diverse practices can be referred. *Art* in this sense has hardly existed for more than two centuries. And its existence is not the product of a unifying thought which has assembled a set of common properties into a single notion. It is rather the product of a dissociating thought. It proceeds from the rupture of the order that normed the fine arts and that rested on the distinction of the liberal arts and the mechanical arts, or leisure and technology. Between the practices of artists, the concept of art, and the philosophy of art, there is no necessary interrelation.

This 'non-necessity' forms the basis of the second answer to the question. It recognizes the importance of the gap between artists' practices and the idea or the philosophy of art. It concludes that

the link between the two is a construction of the latter. At the time of Romanticism and in the categories of German idealism, philosophy is said to have taken artists' practices captive within an idea of absolute or 'absolutized' art. In reality, it is said, this absolutization of art served to confound art practices with the self-proclamation and proof of the absolute for the sole benefit of philosophy (that is, of 'bad' philosophy). Should we therefore learn today to emancipate art practices and aesthetic behaviors from the romantic-idealist straitjacket, in order to consider them in themselves?

This fresh consideration of art admits two different versions. On one hand, the exponents of analytical aesthetics will insist on 'desacralization' and will invite us to replace the 'absolutized' concepts with modest and precise criteria, allowing us to classify the different manners whereby objects or practices can have an aesthetic status, according to their constitutive properties or to the type of perception of which they are the object. On the other hand, the exponents of the postmodern philosophy of the sublime will insist on the power of art's ontological and ethical provocation: art is said to bear witness to an 'aesthetic' condition of the subject. It is said to testify to the heteronomic condition of thought, to the violence that must come from elsewhere to set the soul into motion, and to the gap that separates thought from any adequate presentation to the senses. For Lyotard it is this violence of the *aistheton* that the hand of the artist inscribes. And aesthetics is the stultifying discourse that covers over this power of witness and of appeal, that turns the testimony of heteronomy into the self-affirmation of spirit. The historical fulfillment of aesthetics is the nihilistic reign of culture, from which the shock of painting must then deliver us.

But do these approaches which seek to emancipate art practices from aesthetic speculation not suffer the classic fate of all those discourses which, since the time of Feuerbach, have sought to

demystify Hegelian speculation: the fate of having to borrow from speculative philosophy the empirical properties in whose name it will be demystified? Neo-empiricism distinguishes speculative discourse from simple artistic practices and concrete aesthetic behaviors. But this very distinction is only possible once 'speculative' aesthetics, having absolutized the concept of art, has permitted all these practices and behaviors to be identically qualified. In his book *L'art de l'âge moderne*, Jean-Marie Schaeffer explains that every fictional text is an aesthetic text. 'To write a fictional text or a poem is to take part in a practice which is functionally aesthetic; that the readers of Ian Fleming are not (always) those of Joyce, Musil, or Proust in no way changes the fact that the two kinds of works fulfil the same function.' But what is this function and why is it called aesthetic? One can understand that reading a book is always reading a book and that whatever the book's legitimacy, one can experience the same pleasure. But what are the empirical properties that distinguish this pleasure from others? Why should it be placed in a specific class and receive the attribute 'aesthetic', if not on the basis of the constitutive distinction of aesthetic 'idealism', which identifies two classes of pleasure and two modalities of the sensible? It is only on this basis that the fictional suspension of reality can be identified in general with the aesthetic suspension of a mode of the sensible. The feigned iconoclasm that puts the canonical elite author and the pulp novelist on the same level is only possible on the basis of the type of equality introduced by the 'absolutization' of art.

The same thing happens when Lyotard seeks to counter the aesthetic lie with art's inherent power of thought. What is this power of thought if not the gap between two regimes of the sensible? One reads the following in *Moralités postmodernes*: 'Style does not separate the soul from an existence enslaved to the sensible; it casts doubt on the latter's existence. It contrasts the sensible with itself, and thus it contrasts the soul that consents to

mere seeming . . . with the soul that awakens to appearance, and trembles.' If I leave the religious connotations of this trembling aside, the specificity of the artistic gesture is here expressed in purely Hegelian fashion, as a separation between two modes of the sensible, seeming (*Schein*) and appearance (*Erscheinung*). To be sure, something different is appearing in these two discourses, and the mode of appearance refers to two opposing logics. Hegel contrasts spirit's self-manifestation to the empiricist acceptance of sense data. For Lyotard the power of appearance is that of the shock that comes from the *aistheton*. For Hegel the sensible receives the power of incarnation from thought which makes itself external to itself. For Lyotard thought receives its power from its obedience to the power of the purely sensible. But the place of art is still defined in the same way: it is the site of a repartition of two regimes of the sensible. Art reveals a difference of the sensible from itself. And it makes the difference of the sensible from itself coincide with a difference of thought in relation to itself. The meaning or sense of this coincidence may be opposite, but it manifests the same structure, the same system of conceptual polarities, the same matrix of possible descriptions of aesthetic experience and conceptualizations of 'why there is art'.

It therefore seems impossible to range the authentic practices of art on one side, and the interpretations supposedly added by philosophy on the other. The interpretations are of a piece with the very possibility of thinking of the objects and the practices. But this should not be understood in the sense of Danto's analysis: that of a world of objects requalified by the power of transubstantiation inherent in interpretation. The extreme case of objects which are indiscernible by everything but their interpretation is only a particular figure – and not the most interesting one – of a general regime of art. I call a general regime of art an articulation between three things: modes of production of objects or of the interrelation of actions; forms of visibility of

these manners of making or doing; and manners of conceptualizing or problematizing these manners of making or doing and these forms of visibility. The modes of conceptualization are not simply added interpretations; they are conditions of possibility for what artistic practices can produce and for what aesthetic gazes can see. Aesthetics is neither a part of philosophy naturally devoted to thinking about the part of the world constituted by artworks, nor the speculative construction with which a certain kind of philosophy has confiscated the meaning of artworks. It is a repartition of the sensible that brings together manners of making or doing, forms of visibility, and manners of speaking. It is the system whereby the discourses of the absolutization of art and those of its trivialization can coexist.

One can grant to Danto that the modes of production, exhibition, and reception of forms such as conceptual art or pop art correspond quite precisely to the Hegelian concept of the 'death of art'. But they only correspond to the concept of the end of art because they correspond to the idea of its beginning: the emblematic gesture of the child who skips stones over the surface of water in order to transform the space of sense appearances, that is, mere seeming, into the space of the sensible manifestation of his own will. The practices associated with conceptual and pop art can be identified with the 'post-history' of art because they are coherent with the idea of the temporality of art in which this 'will' is deployed, in which it can be invoked or denied, absolutized or demystified. Thus I cannot subscribe to the title of this colloquium, 'Where theory ends, there art begins', if it means art – art practice – begins where theory falls silent. One could just as well say: art begins when one closes the eyes that see it as art. Whether artists and theorists like it or not, our art begins where our theory – our way of linking the power of thought to the power of the gaze – begins.

Thus there is an aesthetic regime of art, a mode allowing for the

creation, perception, and thinking of its practices and objects.
That these objects should be constituted by their 'interpretations'
means more profoundly this: the aesthetic regime of art is the one
where the thinking of art is identical to an idea of thought itself.
What characterizes this coincidence? And why is it summed up in
the name aesthetics? The daring minds of today who doubt the
pertinence of this name seem to ignore one thing: the declarations
of the impropriety of the word 'aesthetic' accompanied the rise of
aesthetic thought itself. The aesthetic regime of thought did not
begin with the book by Baumgarten that invented aesthetics as an
enlarged poetics. It began with Kant's little note challenging that
invention. It was more precisely defined in August W. Schlegel's
Lessons in Aesthetics, which opens with the assertion that it is time
to get rid of this notion of aesthetics, a veritable *qualitas occulta*. It
was stabilized in Hegel's *Lectures on Aesthetics*, which rapidly tabled
the question: the word 'aesthetics', Hegel said, is improper to
designate the philosophy of beautiful art. But usage has imposed
the word and it can be adopted, he continues, on the condition
that one recognizes that the concept of the beautiful is exactly the
opposite of what is expressed by the word aesthetics.

Aesthetics is born as the refusal of its name. With Hegel it
provides itself good reasons to refuse that name: aesthetics, he
says, refers to the empirical sensations provoked by the works, and
not to their content. But the new thinking is interested in the
works in themselves, in the power of thought that inhabits them.
The name is therefore a misnomer with respect to the content of
the new thinking of art. Aesthetics, it would be said after Hegel,
designates a mode of reception of artworks. It is paradoxical that
this word should have imposed itself at the very moment when the
canons of literature and of mimesis placed the accent on the
unconditioned power of artistic *making*, which took the place of
outmoded norms.

Here I would like to defend the opposite thesis: aesthetics is in fact

the appropriate name for the new regime of the thinking of the works. It corresponds to this regime because of the shift to which it testifies: the shift of the place of *aisthesis* in the consideration of what is actually done by the poets and the painters, and the correlative shift in its very meaning. This is also a shift in the conceptual status of the sensible and of the idea of thought. The new regime of the works brings about the appearance of this idea of thought, the idea with which thought must henceforth confront itself, the idea that it states and avoids, that it formulates in contradictory ways, that it tries to pin down even while it slips away: the idea that the sensible is the presentation of an in-sensible which, strictly speaking, is the thought of thought. The place of art is the place of the adequation between a sensible different from itself and a thought different from itself, a thought identical to non-thought.

Kant and Hegel are therefore right to refuse the 'aesthetics' of Baumgarten, even if the reasons that they give are somewhat thin. Aesthetics as conceived by Baumgarten, that is, aesthetics as a generalized poetics, is impossible. It is impossible because poetics is not part of aesthetics, nor is it simply the old way of naming what aesthetics names. It is itself a regime of art, a specific mode of the possibility of works, combining forms of visibility and enunciative possibilities. It is a system of relations between *doing, seeing, saying* and *sensing*. Poetics and aesthetics are two different regimes of thought, two antagonistic modes of the visibility of artistic practices. And one of the points that separates them is the place occupied by *aisthesis*, the nature that corresponds to this place, and the general economy of art practices or works that corresponds to this nature.

From poetics to aesthetics

The transition from the age of poetics to the age of aesthetics is commonly described as the revocation of a system of norms founded on the principle of mimesis. The principle of mimesis or of representation defined the subjects represented, the genres adapted to the greater or lesser dignity of these subjects, and the forms of composition and expression adequate to these genres. The modern reversal of the representational model consists in three interconnected operations: first, the refusal of resemblance as the finality of art; second, the declaration of the independence of artistic form with respect to its content; third, the abolition of the correspondences and hierarchies between the subjects, the genres, and the arts.

This is a convenient presentation. It implies that the destruction of the mimetic model leaves a free *poiesis*, a productive faculty unleashed from all rules, in the presence of a pure *aisthesis*, a judgemental instance of taste or sentiment which is affected without any concept by the product of this liberated *poiesis*. But this schema is misleading. Because precisely, in aesthetics, *aisthesis* is no longer in the place assigned to it by the representational regime: the place of the receiver, of the instance that verifies the product of *poiesis*. Indeed, the heart of the poetic system was not the mimetic norm, but that which it allowed to take place: the verification of an accord between the poetic power of producing resemblances and the capacity to be affected by them, that is, to perceive them and to feel pleasure from them. Representation, in the idea of it established by Aristotle and deployed in the classical age of the seventeenth century through a complex and regulated network of conventions, is not primarily the copy/model relation; rather, it is the relation of address from a *poiesis* to an *aisthesis*. The classical norm of *poiesis* is that of *techne*, the adaptation of the means to the end. But it is up to those who use or enjoy it to judge

the adequation of a given production. In the poetic regime, it is always an *aesthesis*, taste or pleasure, that provides the final proof that the resemblance has been successfully achieved. And this proof is final because what is verified is not whether the work resembles its model but whether the faculties of making and of sensing are well adapted to each other, whether they spring from the same nature. In this sense, the Kantian idea of the experience of the beautiful as a verification of the harmony of the faculties belongs to the old model. It simply renders it incoherent by eliminating the grid of resemblances which was the intermediary of this verification. Thus there is no Kantian aesthetic, simply a Kantian suspension of poetics.

For there to be aesthetics, the *aisthesis* must change its place and nature. What characterizes aesthetics as a regime of art is this: *aisthesis* is no longer at the place of the receiver and verifier, to whom was destined the means/ends relation characteristic of *poiesis*. There is aesthetics when the place of the receiver is empty, when the aim of *poiesis* is accomplished completely in what it produces. But no simple absolutization of *poiesis* is instituted thereby. It is still *aisthesis* that governs *poiesis*. But the mode of governance has changed. *Aisthesis* no longer designates the receiver of the work. It is at once the work's material and its principle. The function of *poiesis* is to produce a sensible element that verifies the power of thought immanent to the sensible. The dimension of *aisthesis* is then the relation of the work to its origin and this relation is a relation of *aisthesis* to itself, a redoubling of *aisthesis*.

I would like to illustrate this point with a commentary on a little sentence from one of the great theorists of the art of scenography, Adolphe Appia. This sentence is taken from a book published in 1899, *Die Musik und die Inscenierung (Music and the Scene)*. It says this: 'In the future we would like to see upon the stage not what we know things are, but instead, how we feel them.' The sentence is apparently rather anodyne and could be interpreted as a

declaration of impressionist aesthetics, similar to the one that Proust puts in the mouth of Elstir: paint things as they appear to us and not as what we know them to be. But in this way one skips over the heart of the problem: the gap that the sentence presents between one sensible and another. There is the sensible that we see on the stage, the visible aspect of the play, and then there is the sensible that must appear there. Manifestly the two are not homogeneous, as they are in the example of Elstir. The sensible that must appear is the sensible as a manifestation of what the words say. Here is what marks the rupture with the classical regime of representation. In that regime, there was a determined relation between the words and the visible. The visible illustrated what the words said, through the resemblance of the decor to what the words evoked, through the expressive code that translated the sentiments, through the variations of posture that marked the inflections of thought. This classical regime itself referred to one of the great principles of representational poetics: the belief that speech is what governs the forms of the visible. The devaluation of the 'spectacle', of the *opsis*, in Aristotle's *Poetics* stemmed from a thinking of expression where the words make things seen, where the visual elements obey this power of making-seen inherent in words. The action of the dramatic poem is thus governed by the intellectual operation of plot, character, and discourse (*mythos, ethos, dianoia*). This operation deploys an intellectual space of the visibility of thought. The expressive capacities of the visible forms stem from their conformity with the power whereby the words cause the non-visible of thought to be seen. The correspondences and the hierarchies of the arts in the representational system were based on this primary order in which speech makes thought visible. The dramatic poem was not only the exemplary realization of the poetic order. It was its very allegory. And the stage of the theatre offered a material system for the realization of this allegory.

Appia's sentence then proposes, on the same material stage of theatre, a counter-allegory, the allegory of the aesthetic mode of art. It proclaims a strict reversal. But this reversal is not the reign of the *opsis* versus the primacy of thought. It is another disposition of saying, seeing, thinking and making. If theatrical staging is necessary, it is because words can no longer make us see what they say, can no longer make us feel or sense it. They signify it but they do not express it. Now, what art deals with is expression. But what is expression? It is the sensible presentation of the sensible element of the idea. It is no longer a matter of showing what words say, but of showing the invisible power that brings forth speech. And this invisible has itself changed in status. The words of the theatrical poem referred to a highly coded invisible which was that of the ideas and feelings experienced by the characters of the poem. The spectators' judgment and pleasure came from deciphering the code, from successfully inferring the relation between the words and their invisible: the structure of the action, the thought of the characters, the inwardness of sentiment. What the stage must now present is another invisible: the very power whereby the words make sense, the power of speech, as the place where thought comes to the sensible and where the sensible comes to thought.

To see 'how we feel things' is not to have an equivalent of the conditions of our perception: it is to provide a sensible *analogon* of the power of incarnating sense in the sensible matter of words, of sounds, of color. The aesthetic regime of the arts is a new regime of speech, of the non-sensible to which it testifies, and of the mode of this testimony. Speech is no longer the instrument whereby thought is expressed and defines a visible. It is the place where a signification becomes a sensible form, or a sensible form becomes a manifestation of sense, of meaning. The representational regime of art began to crack, in the eighteenth century, under the effect of a double operation, which can be summed up by the names of Chardin and Vico. It cracked, in

Diderot's eyes, when the genre-painter Chardin mixed on his palette not only the tubes of color, to represent a jar of olives, but also the air, the water, and the light, to make us sense the milieu of its visibility. It cracked, in a quite different place, when Vico no longer read in the epithets and metaphors of Homer the product of an art but the language of a thinking in its childhood. The link between the work and its interpretation reaches back to this double revolution in the regime of relations between the speakable and the sensible. The aesthetic regime of art hangs in the balance of this double revolution which it tries to reduce to just one, by identifying pure sensible presence and the invisible of thought. Thus it depends on the status of *aisthesis* as the equal point of a thought – that is, an in-sensible – that becomes sensible, and of a sensible that becomes thought – that is, that becomes an in-sensible. The general name taken by this equivalence in the aesthetic mode of art is language. The aesthetic mode of art is the one where the arts are no longer distributed hierarchically according to their proximity with the power of words to make us see, where instead they are equivalent as languages.

The allegorical value of 'aesthetic' art as scenography and the sentence by Appia that establishes its program now take on sharp relief. When 'everything is language', then there is a language that is particularly handicapped, the one which only has the words of spoken languages at its disposal. This is Mallarmé's problem: in order not to 'remain the most beautiful speech to emanate from some mouth', in order that its act should be the 'recommencement of the conditions and materials of thought', the poem must become its own scenography, the space of the manifestation of 'that which is not said in speech', the space of the manifestation of thought, if you will. But this thought can no longer be Aristotle's *dianoia*. It is thought in so far as speech does not say it. Mallarmé must then 'repatriate' to the language of words that which is said by dancers' steps or by musical phrases. The words must

reappropriate the intellectual power that is identified with the mute language of bodies or instruments. But this reconquered language must also be given its own spatiality. Theatrical scenography is born precisely as the space of this thought. It is the art that became necessary when words proved incapable of testifying to the sensible power that they themselves contain, and to the power of language that the forms contain. The old royal art, that of the dramatic poem, the 'imitation of acting men', must henceforth be supplemented by another art that renders sensible, not anger, jealousy, or love, but the inherent power of the poem, its value as a manifestation of the power of the sensible. Scenography must render sensible, give voice to, 'that which is not said in speech'. This is why the art of scenography is inherent in the aesthetic regime of the arts, while also being an allegory of this regime.

This is also why the technical invention that is at the heart of the new art of the stage is itself the oldest allegory of the passage from one world to another. It is the lighting permitted by the new energy of electricity that will construct the space of 'how we feel'. It is the beam of light sculpting the bodies or the clear contours of the sets that will be the medium of the new language. On the stage of the theatre, it is the lighting that will figure the world that is spoken by the words of the theatrical poem, the world necessarily betrayed by the decors and mimicry of the old theatre. But electricity is not only a scientific discovery and an invention of the nineteenth century. It is the utopia of this century: immaterial matter, matter equaling spirit. Electricity is not technology in the service of the new aesthetics. It is the technology of aesthetics, aesthetics realized as technology. Like the other arts born of the new technologies, photography and cinema, scenography is an art of light, an art that fulfills the aesthetic program, which is to render sensible that immateriality of the sensible which is the materiality of thought.

And of course, the metaphor of light goes much further back. The beam of light on the stripped-down forms of the sets is emblematic of the Platonic passage from one world to another. The decors, the mimicry, and the referential codes of the old theatre were the shadows of the cave, the shadows of the representational *doxa*. The language of light brings us out of that *doxa* to place us in the austere and splendid landscape of pure forms. Yet it is no longer a matter of passing from the sensible world to the intelligible world. It is a matter of passing from one sensible world to another sensible world. The splendour of the idea is that of the sensible inherent in the intelligible world. Appia's sentence is like the transposition of a sentence from Schelling which figures in one of the founding texts of the aesthetic mode of thought, the last chapter of the *System of Transcendental Idealism*: 'Through the world of the senses as through words the sense only glitters.' The 'sense' could appear, upon first reading, as the signification of spirit asserting itself through the obscure forms of the sensible. But the language of words is cloaked in just the same obscurity. The sense only shines through their veil. It is not linguistic meaning that asserts itself through the sensible. It is another modality of the sensible, a pure sensible, an 'inner world of the senses', that asserts itself as the reason for linguistic meanings. Schelling's text itself refers clearly to the text by Saint Paul which contrasts face-to-face vision with mirror vision. The 'pure sensible' is in no way the impressionist play of appearances. 'How we feel' is the sensible that is behind words, that is the point of identity between the sensible and thought, or the point of their reciprocal annihilation: the point of identity of the sensible with the non-sensible, of thought with non-thought.

A theatre of unstable doubling

What characterizes the aesthetic regime is this specific redoubling of the sensible. The aesthetic is born as a mode of thought when

the work is subsumed beneath the idea that the sensible is heterogeneous, that there is a variety to the sensible separate from the ordinary conditions of the sensible world. The aesthetic stage is the place where a language of sensible forms must manifest the invisible visibility of the visible. It is a matter of seeing what it is that causes there to be sensible things – and what is not sensible, the sensible as thought, the identity of a non-sensible sensible and of a thought that does not think. Appia's sentence does not only make manifest the problem of a specific art – theatrical staging – destined to double an already existing form of art. It defines the general status of the *aistheton* that governs the aesthetic regime of the arts: the pure sensible that is supposed to differentiate this regime from the regime of representation is a redoubled sensible, the sensible of the sensible. The power of this difference has an identifiable name: it is called spirit. The history of the aesthetic mode of art is the history of the complex relations of the sensible with its spirit.

For an example of this let us take an art which, in the aesthetic age, has held itself up as the art of sensation par excellence, and a discourse on this art from a theorist of the radical immanence of sensation. In *Logiques de la sensation*, Deleuze endeavours to analyze painting as a system that works directly on the nervous system. The pictorial figure is sensible form leading back to sensation and not to the object, it is presence freed from representation. But what characterizes this figure, presence or pure sensation? Its characteristic is to bear the sensible marks of the insensible that produces sensation. Take the analysis of the portrait of Innocent X that Bacon repaints after Velazquez. Bacon sought not to paint the horror but the cry, not the relation of the cry to its cause according to representational logic, but the cry itself. But what is the 'itself' of the cry? In Deleuze's analysis, it is another relation of the cry to its cause, and this cause is precisely the 'aesthetic' cause in general, the invisible that is inherent in

sensible manifestation: 'Innocent X cries, but he cries behind the curtain, not only as someone whom we do not see but as someone who does not see, who has nothing left to see, whose only remaining function is to render invisible those forces of the invisible that make him cry, those powers of the future.' The oneness of 'pure sensation' is a 'coupling of forces': the sensible force of the cry and the force of what provokes the cry. But what provokes the cry if not another 'horror': the power of dissociation exerted by pure sensation, the schizophrenia that plunges every figure into chaos, but on whose edge all figures hesitate, hold back? Painting, says Deleuze, is a hysteria, that is, a withheld schizophrenia. Bacon's paintings lay down a round form, a path, a ring: these isolate the figure from representational logic. But they also expose it to the forces of the outside that slap at the figure; and they additionally form the partition against which the figure comes up short in its effort to escape itself, to rejoin the great ground of universal chaos whence come the forces that distort it: the desert of which Deleuze speaks in the same text and which he calls justice: 'a justice,' he says, 'which will no longer be colour or light, a space which will no longer be anything but Sahara.'

Thus the canvas of pure sensation is the theatre of a play of doublings: a portrait which redoes another; an art of the visible dedicated to the expression of a cry; a sensible expression which is the manifestation of its insensible cause; a configuration of the sensible which is a theatre of centrifugal and centripetal forces. The canvas of pure sensation is an allegory of painting. And it makes painting itself into an allegory of an image of thought: thought is the movement that records the forces of chaos, that lets them penetrate to destroy the landmarks of representation or of *doxa*; but it also contains and captures those forces, it cuts up chaos with its projected planes. The pure sensible of painting is therefore a place-taker, like the light beam in theatrical staging. It takes the place of the truly pure sensible, that is, of the in-sensible

sensible, of the desert of justice, the desert which is the Deleuzian figure of the Platonic plain of truth: the world of the pure sensible replacing the place of the pure idea. What characterizes the aesthetic mode of art is its manner of entangling the expressive power of artistic practices with an image of thought whose principle is this point of equivalence between the pure idea and the pure sensible. It is the link between a form of visibility of artworks and an image of thought: an image of thought outside itself, deploying the power of a sensible different from itself.

And there are two principle ways of thinking this form of equality between thought and the sensible, which is also a form of equality between thought and non-thought, between the sensible and the in-sensible. There is the Hegelian way, which captures the pure sensible from the very outset, making it the surface of appearance of spirit manifesting itself to itself. This is the allegory of the child skipping stones. The sensible is then ascribed to the place of form where the will to signification is inscribed, spirit's will to give itself its world. The work is spirit's station outside itself: spirit seeks itself in the sensible figure, failing always to find itself but, in the process of failing, assuring the success of the artwork, from the pyramid that seeks vainly to contain it all the way to the poem that brings it to the very limit of all sensible presentation, by way of the acme of Greek art where it gives itself the optimal figure of its sensible embodiment. Deleuze's analysis illustrates the opposite figure: the desert replaces the water over which skipped the child's stones. The power of spirit is that of the forces of chaos that suck up the figures or slap against them. Here it is not the sensible that is formed by thought. It is thought that becomes the theatre in which the forces of chaos penetrate or are contained. But the work is similarly the theatre of an identity of contraries. It is a stage on the path of spirit outside itself, of spirit marching toward its truth. The Hegelian truth of spirit/logos, following its path through the forms of its sensible presentation, is opposed to Schopenhauer's

truth of truth/chaos, shattering the landmarks of the world of representation. But if the Deleuzian spirit moves backwards down the Hegelian path, they nonetheless meet at an intermediary point, the point of the figure as the station of spirit. On the path from chaos to chaos, the flagellated, crucified figure that Deleuze describes in the painting of Bacon occupies the same structural place as the sculpted figure of the Greek god on the path to the logos. It is, Deleuze writes, 'a sort of incomprehensible station straight amidst all in spirit.'

The work in the age of the aesthetic could be defined as this 'station straight amidst all in spirit': in spirit, that is, in the *aistheton*'s difference from itself. It will be said that this midpoint refers to different geographies and histories. Nothing is further apart than Deleuzian 'becomings' and the Hegelian teleology of spirit. But we must look more closely. For that, we can begin with an enigmatic expression from Deleuze's text: the invisible forces that make Innocent X cry out are the 'powers of the future'. What then is this future? It is, I think, the same of which Appia's sentence speaks: 'In the future we would like to see upon the stage . . .' The distance of *aisthesis* from itself determines a task for the future. More profoundly, it doubles *poiesis*. The latter is the power of artistic fabrication and it is the will to art, the will to the manifestation of the equality of *aisthesis* with itself.

This doubling defines not one but two teleologies of the aesthetic. There is Hegel's teleology in the past tense: art's immanent will to spirit has been fulfilled. The aesthetic is not the new regime according to which works must be produced. Or, if one prefers, the aesthetic of artworks is, in its entirety, an aesthetic of interpretation, which rereads the history of past works, of pre-aesthetic works, as a vast tropology. But this teleology in the past tense is already a counter-teleology. It decrees the expiry of a first teleology: the one fixed by the fragments of Novalis, by the texts of the Athaneum or the *Oldest Systematic Program of German*

Idealism. This first teleology made the aesthetic mode of thought
into a program: the program of a sensible world entirely
penetrated by spirit and of an entirely sensibilized world of
thought. The Hegelian teleology thrusts the problematic identities
of aesthetic thought into the past: the identity of thought and
non-thought, of consciousness and the unconscious, of spirit and
the collectivity. Henceforth no aesthetic program will be possible.
All that remains to the art that would seek to realize the aesthetic
mode of thinking is the pure and empty form of the will: the
gesture that destines art to point forever to art.

Thus the Hegelian counter-teleology defines a moment of the
aesthetic, more complex than the one so readily described in our
day (that is, the slow process of the 'exhaustion' of modernity,
bringing the will to art to the final stage in which it recognizes
itself in the 'whatever' to which it was destined by the Hegelian
theme of the death of art). This counter-teleology defines an
extraordinary tension of the 'will to art', of the form and the time
of its realization, to which the texts of Deleuze bear exemplary
witness. On the one hand, they oppose the here and now of art's
sensible presence to any dissolution of the work in its spirit. 'The
work of art', writes Deleuze, 'is a being of sensation and nothing
other . . . it exists in itself. . . . The artist creates blocks of
perception and affects, but the sole law of creation is that the
composite must stand on its own.' The will to art is the will to the
work. But the will to the work is not the simple will to creation. It
seeks to manifest the sensible of thought, to reconquer it from the
anaesthesia that is called *doxa*. For the Hegelian death of art also
means this: when the forms of representation are no longer the
space of spirit's presentation to itself, they become an image of the
world, Plato's *doxa* or Flaubert's *bêtise*. The aesthetic program of
art is then to wash clean the canvas or the page always-already
covered over by the figures of the *doxa*. It is the reconquest of a
'lost' spirit, by its opposite figure: no longer the power of

embodiment and individualization of sense in form, but the power of disembodiment and de-individualization that sends the figures back to the great chaos of un-differentiated, un-individual life. The consistency of the sensible composite then appears as a site of combat, as a theatre of unstable doubling: the 'block of perception and affects' is a 'hysterical' station in the world of spirit, that is, in the power of dissociation that carries away the figures into the undifferentiated groundlessness to which Schopenhauer gave the paradoxical name of 'will'.

But the forces of the invisible that inhabit the cry of the painting are also the 'powers of the future'. They project the here and now of the painting into a history of the fulfillment of the aesthetic will. 'In the future we would like to see . . .' The block of sensations is the anticipation of a common sensible and a sensible community: 'a people to come', as Deleuze says. This people is not that of the work's reception. The work, on the contrary, only anticipates a people if it puts the audience out of play. The 'athleticism' of the figure, for Deleuze, aims at the elimination of the spectator. Appia had said so before him: the new theatre, the theatre as the art of scenography, 'seeks instinctively to free itself of the control of the public and to develop in a free atmosphere.' This does not mean that it wants to cut itself off from the people, but that it invents *its* people. To feel 'how we feel' is not a programme of spectators, it is the programme of an actor, of the people-actor. A few years after writing *Music and the Scene*, Appia met the father of rhythmical gymnastics, Jacques Dalcroze. And with him he formulated the principle of 'the living work of art', the work identified with the sensible presentation of a community to itself: a people of gymnasts attuned to the revolution of electricity.

The aesthetic mode of art thus defines a highly singular moment. This moment cannot be identified with the simple movement that exhausts the possibilities of art to the benefit of the concept alone.

But it is true that it initially projects it outside the present, in its teleology in the past tense or in its anticipation of its future. The will to art is shared out between the will to the work, the will to art's self-manifestation, and the will to the people that art calls for. But this will to art is also subject to the great conceptual divide of the 'will' in the aesthetic age, between the affirmation of spirit marching toward its glorious body and the will to return to original groundlessness and reasonlessness. And the 'people' of art also partakes of this great divide, between the people of gymnasts in the living work of art and the people remounted on the canvas, making the artist's work the gesture that holds them back, that maintains the present but also obstructs the release outside of this 'people' and this 'future' which belong to the fundamental configuration of *aisthesis*. Aesthetics is not the fateful capture of art by philosophy. It is not the catastrophic overflow of art into politics. It is the originary knot that ties a sense of art to an idea of thought and an idea of the community.

Modernity, subjectivity and aesthetic reflection

Christoph Menke

It is a well-known fact that the term 'subject' acquired its still predominant meaning only as late as the mid-18th century, leading to the formation of the term 'subjectivity' at the end of the century. In this recent or 'modern' use, the term 'subject' is no longer taken just in its grammatical meaning, where a subject is everything of which something can be predicated, but refers to anything that (and, thus, anyone who) can say 'I'. In this sense, the predicate 'subjectivity' is not coextensive with, but is confined to the realm of human beings. There are human beings who are not yet or are no longer subjects, but there are no subjects that are not human beings. Only human beings have the capacity to say 'I'. This describes the new meaning the term 'subject' gains at that moment in the 18th century, but it does not yet explain why this new use of the term 'subject' marks the beginning of a new, 'modern' way of thinking (and living). For that semantic shift of the word 'subject' does not mean that subjectivity — referring to the capacity to say 'I' — was discovered only then and unknown before. Rather, the epochal significance of the new use of the term lies in the fact that – and the way in which – the reference to beings capable of saying 'I' is often mixed up in an opaque way with the indication of a quite different determination: namely the specifically modern determination of the subject of reflection. The modern emphasis refers to the subject as the instance or place of a process of reflection in which anything objectively existing or

pregiven is dissolved. This is what makes the shift in our speaking of a 'subject', some time in 18th century philosophical discourse, into a decisive fact for our understanding of modernity: it *connects* the reference to I-saying beings with the emphasis on a new practice of reflection.

However, this very connection indicates a problem which is no less basic for our understanding of modernity. This problem is expressed by the question, and the radically opposed ways of answering it, of *exactly how* to establish the connection between the two aspects of this new way of talking of subjects. Doubtless, the most influential and, if we look at the more recent discourse of the critique of the subject, the most controversial articulation of this connection is represented by German idealism. Here, the I and the subject of reflection are linked in the most direct way: in idealism, the 'object' and the 'subject', the 'what' and the 'who' of reflection are identified with, or understood in terms of, an I and its acts. For on the one hand, idealism conceives of reflection as disclosing the I and its acts as constituting its world; in the idealist reading, the new form of reflection that defines modernity establishes the subject as the ground or 'substance'. But on the other hand, the activity of the I is not just *what* is experienced in reflection, as being constitutive, such reflection itself is also conceived of as the free act of an I; reflection discloses the subject as the ground and is itself grounded in the subject. Furthermore, such reflection, in which the I becomes the ground, is identified with the self-relation in saying 'I'; saying 'I', then, implies or *is* the I's discovery of the I as the ground. Thus, the interpretation of modern reflectivity in German idealism comprises two aspects. First, reflection consists in tracing back phenomena of our world to an underlying activity – an activity which is then described as the deed of a subject itself, as the ground. Second, this reflection is also the deed of the subject itself – so that such self-reflection is then taken as an explanation of the self-relation in saying 'I'. In

both these aspects, the two dimensions of the modern notion of the subject – saying 'I' and reflecting one's world – are presented in German idealism as integrated or even identical: the I and its own, free deed is *what* is reflectively disclosed and the I is *who* is reflectively disclosing, for reflection is also its own, free deed.

As one can learn from, among others, Heidegger's critique, this idealist identification is not the solution to, but rather reiterates and even adds to, the problem of how to relate the I's self-relation and modern reflection. This problematization of the idealist answer is the first and most convincing step of the critique of the subject which Heidegger, following Kierkegaard and Nietzsche, and followed by authors as diverse as Foucault and Tugendhat, has elaborated. Heidegger claims that the idealist argument fails and that its two elements, I-saying and self-reflection, can in fact *not* be directly linked.[1] For the subject that is reflectively understood as constitutive or the ground of its world cannot be an I anymore; being an I or being *as* an I, namely 'existing', is not a free deed in which a world is constituted, but rather being *in* the world. And to relate to ourselves in saying 'I' or, more generally, in 'existing', also does not imply a self-relation which can be identified with reflectively knowing oneself: even less does it imply knowing, or establishing, oneself as the ground. With this, Heidegger shows that the idealist subject precisely by gaining the position of the ground loses itself: the idealist subject can only establish itself in self-reflection as constitutive or the ground if at the same time it gives up its subjectivity – its self-relation in saying 'I' or 'existing'. Thus, the idealist identification of I-saying and modern reflection fails.

Of course, Heidegger himself has understood this critical insight in a much more radical form: as directed not just against the idealist subject, but the modern subject of reflection 'as such'. The premise of this conclusion is Heidegger's taking over – his tacit and unquestioned taking over – of the idealist understanding (the

idealist *understanding*, not evaluation) of the modern idea of
reflection. Like the idealists, Heidegger, and his contemporary
followers conceive of modern reflection as self-reflection and
understand self-reflection as the subject's inner relation of self-
knowledge in which it establishes itself as the ground or origin of
a world-constitutive activity. Because he shares this idealist
understanding of modern self-reflection, Heidegger's anti-idealist
argument becomes an anti-modern one: Heidegger takes the
incompatability he has demonstrated in idealism – the
incompatability between saying 'I' and reflectively being the
ground – as indicating the inherent, disastrous negativity of
modernity.

With this critique of Heidegger's (and the similar one to be found
in Adorno and Horkheimer) the idealist tradition of thinking on
subjectivity has come to an end, but it has not yet been overcome.
For what is needed to overcome this tradition is a critique and
correction of the assumption Heidegger shares with it: namely, its
interpretation of the modern idea of reflection and the place of the
subject in such reflection. Regardless of fundamental differences,
this can be seen as the common project of German postwar
philosophy. In different fields, Blumenberg, Habermas, Henrich
and Tugendhat[2] all give new, post- and anti-Heideggerian accounts
of the modern idea of the subject, and its potential of reflection,
and they do this by reconstructing, in different versions, a non-
idealist tradition of the modern idea of reflectivity or subjectivity
– thus dissolving the Heideggerian identification of this modern
idea with its idealist explanation. Moreover, they pursue this
revisionary project of an anti-Heideggerian account of the modern
subject of reflection precisely by taking seriously a Heideggerian
insight. This is the insight which Dieter Henrich has reformulated
as the grounding of 'self-knowledge' in 'self-preservation'.[3] Modern
self-reflection does not establish the subject as the ground; for the
subject of reflection is always already a 'practical' subject – a finite

subject, entangled in the process of its self-preservation which is and remains irreducible to the subject's own act.

The aim of this essay is to further pursue this line of a revision of our understanding of the modern idea of reflection. While the aforementioned authors gave a new interpretation of subjectivity in either epistemological or practical, or moral-political respects, I will refer to the context of aesthetic discourse: the German aesthetic discourse of the 18th century, between its beginning with Baumgarten and its highpoint (and to a certain degree endpoint) in Romanticism. Baumgarten, who was the first to have written a treatise on 'aesthetics', also for the first time uses the term 'subject' in its modern sense. The discipline of aesthetics and the modern use of the term 'subject' begin at the same time, they are invented in the same moment and, moreover, by the same author, in the same text. From its beginning, the discourse of aesthetics is a discourse – and at first not only a, but *the* discourse – about the subject and subjectivity. This is the reason why, traditionally, 18th century aesthetic discourse has been interpreted as the forerunner of the conception of subjectivity that German idealism developed at the end of the century. This view is rejected by the endpoint of the 18th century aesthetic discourse, early German Romanticism. For German Romanticism, especially in the version of Friedrich Schlegel, is not a poetological adaptation of, but rather *the* alternative to the idealist theory of the subject. Schlegel takes up and reformulates the 18th century aesthetic discourse on subjectivity in such a way that an alternative conception of modern subjectivity and its self-reflection gains shape. Moreover, Romanticism draws an alternative picture of modern reflection in both of its two aspects: in the dimension of the 'object' and of the 'subject' of reflection – of the activity that is disclosed in the modern subject's reflection and of the activity which the modern subject's reflection itself is.

Force and form

Alexander Baumgarten coined the term 'aesthetics' in 1735 (in his *Meditationes philosophicae de nonnullis ad poema pertinentibus*, par. 115-6) to indicate a new kind of investigation of the 'sensual', showing that sensuality is not just – as rationalist philosophy had claimed – the source of 'obscure and unclear' ideas, inferior to and thus to be superseded by reason, but the 'analogon' to reason.[4] The goal of this new 'science of sensual recognition' was thus not to reject but, rather, to complement the rationalist focus of analysis on the 'higher' or 'rational' forms of recognition. Baumgarten's aesthetic project started with the intent of showing that sensuality, in some contexts and for some objects, provides an adequate 'representation' of reality the same way reason does for rationalist philosophy. In the course of its realization, however, this project underwent a decisive change: Sensual cognition – this is the basic insight of Baumgarten's new discipline of aesthetics – could not be shown to possess right or significance equal to rational cognition by analyzing it according to the model rationalist philosophy had developed. The goal of aesthetics – the enlargement of the realm of legitimate cognition, including sensual forms – required an epistemological break with the very understanding of legitimate cognition as such.

It is in this context that Baumgarten for the first time uses the term 'subject' in the sense it still has for us. The term 'subject' is an aesthetic invention – an invention that is simultaneous to the invention of (the discipline of) 'aesthetics'. For the subject is the central category of the new conception of cognition Baumgarten develops in order to establish a relation of 'analogy' between reason and sensuality. This becomes evident in the chapter on psychology in Baumgarten's *Metaphysica* (1739).[5] The first section of this chapter still begins with the traditional or 'grammatical' understanding of the subject. According to that understanding,

'subject' translates *hypkeimenon* and refers to anything which can have predicates. In this sense, Baumgarten calls the 'soul' a 'subject' simply because it has 'general predicates'. But in the further development of this chapter, when it comes to the 'lower' or sensual forms of recognition, the field of aesthetics, Baumgarten introduces a new use of the term 'subject'. Here (in *Metaphysica*, par. 527), he speaks of the subject as having certain 'forces' (*vires*) or 'faculties' (*facultates*) of various degrees, which it uses to 'realize' (*actuare*) certain projects or certain conditions. The subject is someone having, and being able to use, capacities to reach certain goals; it is an agent who, on the basis of its 'natural' faculties, and further developed through exercises, is able to perform and realize certain activities. With this conception, Baumgarten reformulates an idea of rational agency already known before.[6] What is new in Baumgarten, however, is not just the name he gives to this idea – the name 'subject' – but its application to sensual cognition. The activities Baumgarten's subject performs are not just certain, particular deeds, but refer precisely to that dimension of its relation to the world which had been traditionally described in terms of passivity and causation. The new form of 'aesthetic' analysis – this is how Ernst Cassirer has summarized the innovative move – shows that 'the sensual reception of an impression is a form of spiritual activity [*geistiger Tätigkeit*]; in deeper insight [and this is the insight of "aesthetics"] also mere receptivity is dissolved in spontaneity'.[7] Baumgarten's aesthetics revalues sensual recognition, against the rationalist declaration of its inferiority, by understanding it in a structurally new way: as constituted by the activity of the subject. Or, in revaluing sensual recognition, Baumgarten's aesthetics establishes a new discourse about the subject, as not passively representing objects but, rather, actively constituting its object-relations.

In this initial move, establishing the subject and its activities as constitutive of its world, Baumgarten's aesthetic conception of the

subject could be taken as the point of departure of a theoretical development that leads directly to idealism. At least, this is the perspective expressed in Cassirer's just quoted proto-Kantian account of Baumgarten. However, this is too simple a view. For contrary to the idealist teleology Cassirer sees at work in 18th century German philosophy, Baumgarten's conception of the aesthetic subject does not only lead (via Kant) to idealism, but rather to the opposite understanding of the subject in Romanticism. This becomes clear from the emphasis Baumgarten lays on a concept which – as Dieter Henrich has shown in his aforementioned article – remains alien to any idealist discourse (in the sense of idealism explained before, with which Henrich of course would disagree), namely, the subject's faculties or – more importantly – 'forces'. For as depending on and even consisting of forces or faculties – in fact, Baumgarten at one point says that 'my soul is (nothing but) force' (*anima mea est vis; Metaphysica*, par. 505) – the subject is seen as a performer of activities which, although constitutive, cannot be interpreted in the idealist sense, as originated or grounded in the subject. The aesthetic subject is an 'existing' or 'practical' subject, indissoluble into transparent, reflective self-knowledge. The subject of aesthetics 'exists' only in the process of realizing the forces and faculties, which this subject (who for Baumgarten is always a 'certain' [*certum*], particular subject) has and exercises.[8]

This becomes evident from the further development of 18th century aesthetic discourse, which provided an increasingly radical interpretation of the idea of a subject consisting of forces. A first step in this radicalization is the analysis of 'aesthetic behaviour' which Herder presents in his critique of Baumgarten.[9] According to Herder, Baumgarten's rejection of the rationalist tradition did not go far enough. For Baumgarten, as does this tradition, focuses his analysis of the subject's faculties on the wrong level: that is, on the conscious operations of the subject. However, the soul's conscious

operations such as cognition, deliberation, decision, judgment etc. can only be adequately understood as expressions of a more basic level, which Herder describes as 'the dark ground in us' or, more precisely, as 'the dark mechanism of our soul' that always remains 'in the shadow of forgetting'.[10] The reason why Herder speaks of 'mechanism' here stems from his objection to Baumgarten's interpretation of forces in terms of 'faculties'. Faculties are capacities that an autonomous subject possesses, controls and uses. By contrast, the subject's forces, as we see them operating on the basic unconscious level, are beyond the subject's control, for the subject itself consists of nothing but its forces, it is nothing other or beyond its forces. Forces are therefore not capacities – as Baumgarten thought – because they have – as Herder says in accord with Leibniz – an 'entelechetic' constitution: the subject's forces operate (*wirken*) by themselves, following their own direction; they are neither 'used' nor 'controlled' by a conscious subject. This is a first radicalization of Baumgarten's analysis of the aesthetic subject: as the dark ground of the soul, the forces by whose operation the subject constitutes its (cognitive) object- and world-relations cannot be understood any more as the subject's rational, conscious capacities (which, themselves in fact, prove to be just an 'expression' of the soul's 'dark mechanism'). Thus, the world-constitutive activities themselves also cannot be understood as the subject's own, free deeds; rather, they consist of an autonomous operation of forces.

However, this indicates only one side of Herder's conception of force. The other side consists of the subjective, or more precisely, the individual teleology, through which Herder tried to reintegrate the operation of force. For Herder, the 'autonomous' operation of forces follows the (teleo-) logic of the self-realization and self-constitution of an individual, understood as a 'sensual universe' or 'totality'. This tension in Herder – between the autonomy and the teleology of the subject's forces – marks the starting-point for

Friedrich Schlegel. One can understand the anti-idealist analysis of the subject's constitutive activity in early German Romanticism as taking up Herder's conception of force while at the same time rejecting its teleological frame. For in Schlegel's view, this teleological frame in Herder leads to a double misunderstanding of the 'logic' of force.

The first misunderstanding of Herder consists in conceiving of forces, beyond the conscious subject's control, as nonetheless an individual subject's *own*. Thus, for example, Herder analyzes speaking as an individual's self-expression; in speaking, the individual's peculiar way of feeling, seeing and judging is expressed. Schlegel, on the contrary, shows that speaking has to be understood as *Nachbildung*, reproduction. For a subject to be able to speak, it needs a universe of speech, of expression and presentation that exists prior to and independently of the subject. The activity of speaking is not just the expression of a self, but consists of a 'metamorphosis', the 'adaptation' and 'transfiguration' of a pre-existing, 'objective' reality of speech-acts, which Schlegel calls 'natural' or 'mythological': 'Everything is relation and transformation, adapted and changed, and such adapting and changing is its [poetry's] peculiar procedure, its inner life, its method if I may say so.'[11] This new understanding of subjective activity, not as creating but as transforming, also affects the understanding of force. For this metamorphotic relation of transfiguration and reproduction is thought of in Schlegel as a transfer of forces – not as an imitation of forms. The subject's forces, which operate in activities, are never just this – namely its, the subject's own forces. Rather, Schlegel understands them as constitutively related to forces which are 'stored' in objectively existing forms of expression – in the forms of a culture or a language. Thus, the subject is no longer the source or origin of its activities but, rather, a 'mediator' (*Mittler*): it can only produce new cultural or linguistic forms by taking up and transforming

the non-subjective forces of a language or a culture. While in Herder the subject is still the 'ground' and therefore, even if this is a 'dark' and 'unconscious' ground, is still its *own* ground, in Schlegel the subject becomes (ontologically) 'secondary' or, better, 'intermediary'.

This first critique of Herder's reinscription of the operation of force in the teleology of a subject's self-realization directly implies a second one. Not only can the forces operating in the activities of the subject not be understood as grounded *in* the subject, but the operation of these forces cannot be understood as inherently directed *to* certain, definite forms. Forms – this is Schlegel's second deviation from Herder's view – are the effects of the operation of forces, but they are not the goal of the operation of forces. Schlegel has further analyzed this intricate relation between force and form as the ambiguity governing the relation between what he calls *das Produzierende* and *das Produkt* – the producing process or act and the product.[12] Furthermore, it is precisely this ambiguity that defines romantic irony. On the one side, the process or act of producing generates certain forms, as its products; it – as Schlegel says – 'presents' (or manifests: *darstellen*) itself in such products. No product, however, can be a totally adequate presentation of the process of, and the forces in, its producing; any process of producing exceeds the product it has produced. This discrepancy between producing process and product is often expressed in Schlegel in the idealist terminology of the 'infinite' and the 'finite' – the 'infinite' is interpreted as referring to the subject's faculties, as constitutive or the ground. However, if one reads Schlegel, as I am proposing here, in the perspective of the tradition of aesthetics, as a thinking about constitutive activity, then the thesis of the ironic ambiguity between producing process and product can be understood as a radicalization of the thinking on force which Herder had begun.[13] In such a reading, romantic irony refers to the 'logic' of force – questioning the very idea of forces having

or following a 'logic'. For the romantic conception of irony articulates the insight that forces and their operation in activities cannot be thought according to the teleological model to be derived from singular actions of a subject. Rather, the operation of forces consists in a process of producing that time and again transgresses the 'finite' forms it has produced.

Subjectivity and representation

What does this presentation of a few positions in the 18th century aesthetic discourse add to the attempt to reach an alternative understanding of modern reflection and the subject of this reflection – an understanding that is 'alternative' in relation to the idealist conception which, among others, Heidegger still shares? To address this question to the 18th century discourse of aesthetics rests on two assumptions. The first assumption is a methodological one: there is no way to answer the question of how to understand the modern idea of reflection, and the role of the subject in it, other than by historical reconstruction. For, the question of how one can and should understand modern reflection always refers back to the question of how modern reflection in fact *has been* understood. The predicate 'modern' and, thus, any use of the concept of modernity, has these two sides: a normative and a historical side. We can neither simply invent an idea of modernity which we find normatively more convincing than its hitherto existing reality nor reduce the idea of modernity to the designation of a past and closed historical epoch.

The second assumption in addressing the question of modern reflection to the 18th century discourse of aesthetics was a hypothesis concerning this discourse itself: namely, that the discourse of aesthetics is one (though not the only) exemplary form of modern reflection. A first indication of this is the new use of the term 'subject' in aesthetics. The interpretation of

Baumgarten has shown what this new use entails: Baumgarten speaks of the subject in order to analyze processes of constitutive activity. This can be seen as the most basic move in which the modern discipline of aesthetics departs from the tradition of understanding the arts in terms of mimesis, of objective representation (reformulating at the same time basic insights of the tradition of poetics and, above all, rhetoric): that such objects, as artistic representations, are traced back to the 'aesthetic' activities of cognition as well as production, which constitute those objects. With this move, the aesthetic discourse becomes a discourse of reflection of a specifically modern kind. Modern reflection – this is the first lesson to be drawn from this brief look at the 18th century aesthetic discourse – aims at the disclosure of the hidden activity in which 'objects', the objects of our world, are constituted; modern reflection reveals the being produced and the process of producing objects, which we normally grant the character of objective reality. Thus, with the modern idea of reflection the very concept of 'reality' changes. Reality is no more what is evident or what is created – as Blumenberg has described its ancient and medieval conceptions. Instead, it is taken as being constituted by an 'activity' or a process of producing.

This notion of a reflection disclosing object-constituting activities or processes is the common core of its aesthetic and its idealist interpretations. However, in the idealist conception those constitutive processes are understood in terms of an I's free deeds, thus establishing the subject as the ground. Now, the second insight that can be gained from an interpretation of the 18th century aesthetic discourse is that this idealist identification of the constitutive process with a subject's deeds can be given up, *without* at the same time giving up the modern idea of reflection. For, in aesthetic reflection the constitutive process is described as the realization of forces. And such a process of the realization of forces, as becomes increasingly clear in the development from

Baumgarten via Herder to Schlegel, cannot be conceived of as an act or a deed, originated in and controlled by a subject. Aesthetic reflection – or, aesthetic discourse *as* reflection – shows the forces operating in a subject's activities to be in a triple sense beyond the reach of that subject: (i) because those forces operate according to their own 'entelechetic' logic, uncontrollable by the subject; (ii) because those forces exist in the reality of a language or culture, prior to and independently of the subject; and (iii) because the unfolding of those forces is marked by an ironic ambiguity of producing *and* transgressing, beyond the teleology of the subject. However, this aesthetic critique of the idealist subject, the subject as the ground, does not mean the abolition of the subject. Anti-subjectivism does not mean objectivism. Although the constitutive process modern reflection discloses cannot be understood as (nothing but) the deed of a subject, *without* the subject it wouldn't exist either.

Why this is so – and moreover, why this is *necessarily* so – can be made clear by turning to the other side of the modern idea of reflection. Up till now, I have called for the 'object' or the 'what' of reflection – for the constitutive 'activity', and the place of the subject in this activity, which is disclosed in reflection. But what kind of activity is that process of reflection itself? As we have seen, in its idealist interpretation, reflection is understood as self-reflection, and self-reflection, in turn, is identified with the self-relation in saying 'I'. Thus, reflection is understood as an act, interior to and autonomously performed by the subject. The aesthetic discourse, in its development from Baumgarten to Schlegel, however, provides an alternative, anti-idealist interpretation of this aspect of modern reflection.

This alternative understanding begins to emerge when aesthetic pleasure is not understood any more as delight in the features of an object, but as delight in the experiencing subject itself. This is the way in which Burke, taking up a suggestion by Dubos who

himself follows a hint in Descartes' *Les passions de l'ame* (art. 91), tries to explain the phenomenon of 'mixed feelings', i.e. the phenomenon that we feel pleasure while being terrified: '[. . .] terror is a passion which always produces delight when it does not press too close [. . .]. Whenever we are formed by nature to any active purpose, the passion which animates us to it, is attended with delight, or a pleasure of some kind, let the subject matter be what it will'.[14] With this move, pleasure is understood as reflective, and reflection, instead of being taken as a conscious act of knowledge, is understood as – with Kant's later term – an 'inner sense' (*innere Empfindung*). Again, it is not the opposition between the 'sensual' and the 'rational' that is important here. What is important, rather, is a point, which Mendelssohn underlines: namely that reflection, as an 'inner sense', is at the same time constitutively related to an 'outer' object and, thus, depends on certain 'objective' features which, however, are not simply features of the object 'itself', but rather of the situation of its experience.[15] Reflection is thus always 'situated' and related to an object. Schlegel took up these indications and radicalized them into the thesis that we can only speak of reflection with reference to the 'aesthetic' object itself – which implies in Schlegel that the aesthetic object, in turn, is understood in a non-objectivistic way, namely as a specific kind of (re-) presentation (*Darstellung*). This is what Schlegel means by defining romantic poetry as 'poetry of poetry' or 'transcendental poetry' (fr. 238). Such poetry is 'critical' or reflective: it is a presentation in which 'the producing process (or act) is co-presented (*mitdarstellen*) in the product'. As we have seen before, to trace back a 'product' to the process of its 'producing' is the central determination of the modern idea of reflection. What Schlegel's conception of 'transcendental poetry' is claiming, is the following: that the act which defines reflection, the act of referring a product back to its producing process, has to be understood as performed in and by a presentation, namely as the act of 'co-presentation' (*Mitdarstellung*) by which a

presentation becomes 'transcendental'. Reflection is not just a subjective act, an act which a subject performs in and by itself; reflection, rather, refers to the 'critical' operation of (co-)presentation – reflection *depends* on representation.

With this move, the aesthetic discourse establishes the irreducibility of reflection to ('mere') subjectivity. This is a further reason why reflection cannot be understood in the idealist way as a process of appropriation, of overcoming alienation by restoring the subject to the origin: not only – as we have seen before – because reflection is the experience *of* a process which is irreducible to the subject, but also – as we have seen now – because reflection *itself* is irreducible to the subject, for reflection is irreducibly dependent on the 'critical' or 'transcendental' potential of presentations. On the other side, however, precisely as dependent on representation, reflection cannot be entirely separated from the subject; in a way that is different from their idealist identification, reflection through representation *presupposes* the idea of the subject. In its aesthetic form, the modern idea of reflection can be characterized – again using a formulation of Schlegel's – as an experience in which the subject 'goes beyond itself' (*über sich selbst hinwegsetzen*).[16] But it is still a subject who has this experience. It is furthermore the case that *only* a subject *can* have this experience; for self-reflection as self-transgression to take place, it still needs a self. One reason for this lies in what is experienced, namely the operating of forces in the process of producing form. For such a process of producing form cannot be experienced in a detached way, as the 'object' of an 'observation'; it can only be experienced in what has been called a 'performative perspective'. As Albrecht Wellmer once stated in a context quite different from ours: a performative being can only be experienced in a performative perspective, i.e. in (re-) performing it. And to perform something, although it is not simply a subjective act, certainly requires the subject's

participation: a subject *doing* something. Now, the criterion for something to be a deed is that there is someone able to say 'I do it' or 'I did it'. Thus, an interpretation which rejects the idealist identification of reflection with an I's deed, cannot, and will not, separate them entirely. Reflection, in its modern sense, is *irreducible to* and *inconceivable without* the deeds of a subject.

Aesthetic subjectivity: Beyond reconstruction and deconstruction

The 18th century discourse of aesthetics provides a non-idealist interpretation of the two connected modern ideas of reflectivity and subjectivity. To be sure, some aspects of this interpretation refer specifically, and exclusively, to an *aesthetic* kind of reflection and subjectivity; this holds true, for example, for the ironic logic of force. Especially in its beginnings, however, the modern discourse of aesthetics was less concerned with these aesthetic specificities than with providing a general determination of reflection and subjectivity as such. This concerns both sides of reflection: the 'what' and 'who' of reflection. First, modern reflection is – in Herder's perspective – the 'genealogical', or it is – in Schlegel's sense of this term – the 'transcendental' disclosure of the processes in which form is produced in the operation of forces. In a more recent terminology, one can speak of the disclosure of 'performative processes', and take the rhetorical analyses of 'neo-romantics' such as Harold Bloom, Kenneth Burke, Judith Butler, Paul de Man, and Hayden White as contemporary examples. Second, as these examples again underline, modern reflection itself is an activity which is structurally dependent on a potential of representations – of discourses, texts, images – which Schlegel aptly has described as the co-representation of the producing with (or, rather, in) the product. This dependency on representations means that reflection is not an act a subject can perform on its own, for

it cannot perform it only by itself. This does not make the subjective act of reflection an intersubjective act of communication, but an act of reading (or writing), referring to a specific kind of object: namely, representations.

This aesthetic interpretation of the modern idea of reflection rejects its identification with the idealist project of establishing the subject as the ground. But so do most of the contemporary conceptions of modern reflection. There are, especially, two other non-idealist ways of understanding the modern idea of reflectivity, and its relation to subjectivity, from which the aesthetic model I have sketched has to be distinguished: the interpretation of modern reflection in *rational reconstruction* and in *textual deconstruction*. In the first of these interpretations, in rational reconstruction, modern reflection means rational justification; reflection is identified with 'grounding' or 'foundation' (*Begründung*). More precisely, modern reflection, here, means justification without recourse to transcendent certainties. According to the model of rational reconstruction, modern reflection is the rational foundation of our world in our activities and of our activities in themselves. This indicates at the same time the closeness and the difference between rational reconstruction and the aesthetic model of reflection. Both understand modern reflection as tracing back objective forms to the performative activities of their 'producing', and both reject the idealist identification of those activities as a subject's deed. However, each understands the reflective disclosure of performance in a different way; or they understand the forces operating in performance in a different way. In the model of reconstruction, reflective disclosure *is* rational reconstruction, for it sees those forces as the forces of arguments, directed at rational agreement. In the aesthetic model, however, forces are understood in a broad sense as 'rhetorical' – as the forces of language to produce (new) meaning through the tropological combination of (old) words and thereby to produce

consent through persuasion. Furthermore, according to the reconstruction model, reflection can only take place in rational discourse, while according to the aesthetic model reflection is any form of 'co-presentation' of the processes of producing in the product. I take this last difference to suggest that there is not a direct contradiction between rational reconstruction and the aesthetic model. What is needed, rather, is a wide, inclusive typology of different forms of (modern) reflection in which the logic, the sense, and the point of reflection would each time have to be described differently.

In its 'rhetorical' understanding of the reflectively disclosed processes, the interpretation of reflection derived from 18th century aesthetic discourse is closer to the other model, the model of textual deconstruction. Each understands reflectivity in terms of the co-presentation of the producing process in the product. The aesthetic model, however, is different from, and even opposed to, deconstruction in granting the subject a decisive role in such reflection. In deconstruction, reflection is an inner, autonomous process of texts. This constitutes the objectivism of deconstruction's idea of reflection which establishes its presently much discussed similarity with systems theory. Both rely on an idea of reflection, and even self-reflection, either of texts or of social systems, as conceptually independent of, even prior to, a subject's deeds. In this perspective, both deconstruction and systems theory, following attempts in the early Nietzsche and the late Heidegger, try to dissolve a connection that is constitutive for modernity: the connection between reflection and subjectivity. The aesthetic discourse shows that this separation between reflection and subjectivity rests on two false assumptions. First, it is not *necessary* to separate reflection and subjectivity, for their connection does not have to be interpreted in the idealist way, as establishing the subject as the ground. Second, it is not *possible* to separate reflection and subjectivity, for there is no process of

reflection, and especially no reflection as genealogical disclosure of the process of producing, without there being a subject in place: a being capable of saying 'I' and, thus, of doing something. This is the reason, and not a proto-idealist identification of subject and substance, why in the modern use of the term 'subject' reflectivity is linked to subjectivity: because, contrary to deconstruction and systems theory, there is no reflectivity without subjectivity. Thus, to try to overcome the link of reflectivity with subjectivity, as deconstruction and systems theory do, is as aporetic an attempt as their reverse identification in idealism. They both undermine precisely what they want to reformulate: the very idea of modern reflection.

Notes

1. The distinction between I-saying and self-reflection is crucial to Heidegger's early critique of the modern conception of subjectivity in *Being and Time*. In his lectures on *Self-consciousness and Self-determination* Cambridge, Mass. & London: MIT Press, 1989, E. Tugendhat has provided a compelling analytical reconstruction of Heidegger's argument.

2. For their critique of Heidegger's account of modern subjectivity, see the contributions by Hans Blumenberg and Dieter Henrich to *Subjektivität und Selbsterhaltung. Beiträge zur Diagnose der Moderne*, ed. by H. Ebeling, Frankfurt/Main: Suhrkamp, 1976.

3. D. Henrich, 'Die Grundstruktur der modernen Philosophie', in: H. Ebeling, *op. cit.*

4. A.G. Baumgarten, *Aesthetica*, par. 1 (in: A.G. Baumgarten, *Theoretische Ästhetik*, edited by H.R. Schweizer, Hamburg: Meiner, 1988). On the English, French and Italian sources of Baumgarten's critique of rationalism, cf. A. Baeumler, *Das Irrationalitätsproblem in der Ästhetik und Logik des 18. Jahrhunderts bis zur Kritik der Urteilskraft* (1923), Darmstadt: Wissenschaftliche Buchgesellschaft, 1974. For a detailed account of Baumgarten's conception see H. Caygill, *Art of Judgement*, Oxford: Blackwell 1989. For Baumgarten's place in modern aesthetics cf. A. Bowie, *Aesthetics and Subjectivity: From Kant to Nietzsche*, New York: Manchester University Press, 1990, p. 4ff.

5. I quote the chapter on psychology from A.G. Baumgarten, *Texte zur*

Grundlage der Ästhetik, edited by H.R. Schweizer, Hamburg: Meiner, 1983.

6. This is rightly, although one-sidedly, stressed by T. Eagleton. *The Ideology of the Aesthetic*, Oxford/Cambridge, Mass.: Blackwell, 1990, ch. 1.

7. E. Cassirer, *Freiheit und Form. Studien zur deutschen Geistesgeschichte* (1916), Darmstadt: Wissenschaftliche Buchgesellschaft, 1994, p. 76.

8. Baumgarten's *Aesthetica* (in A. G. Baumgarten, *Theoretische Ästhetik*, edited by H.R. Schweizer, Hamburg: Meiner, 1988) includes a chapter on 'natural aesthetics' (§§ 28–46) where Baumgarten enumerates several aesthetic faculties, which can be further developed by aesthetic training (*exercitationes*; §§ 47–61).

9. J.G. Herder, *Kritische Wälder. Oder Betrachtungen über die Wissenschaft und Kunst des Schönen*: 'Viertes Wäldchen: Über Riedels Theorie der schönen Künste', in: *Sämmtliche Werke*, ed. B. Suphan, Vol. 4, Berlin: Weidmann, 1878.

10. J.G. Herder, *Vom Erkennen und Empfinden der menschlichen Seele*, in: *Sämmtliche Werke*, ed. B. Suphan, Vol. 8, Berlin: Weidmann, 1892.

11. F. Schlegel, *Dialogue on Poetry and Literary Aphorisms*, ed. E.Behear, R. Struc, Penn State University Press, 1968, pp. 51–118.

12. Cf. Schlegel's fragment from the *Athenaeum*, no. 238.

13. As always, 'beginning' has to be taken in a relative sense. For Herder's concept of force is of course deeply inspired by Spinoza's and Leibniz' (which Gilles Deleuze has analyzed). As becomes clear from Baumgarten, the aesthetic discourse on force, however, has not just philosophical but also rhetorical sources; force in Baumgarten is a rhetorical concept. This needs further clarification. For the time being, see K. Dockhorn, *Macht und Wirkung der Rhetorik*, Bad Homburg: Gehlen, 1968.

14. E. Burke, *A Philosophical Enquiry into the Origin of our Ideas of the Sublime and Beautiful*, hrsg. A. Phillips, Oxford/New York: Oxford University Press, 1990, p. 42.

15. M. Mendelssohn, 'Rhapsodie oder Zusätze zu den Briefen über die Empfindungen'; in: *Ästhetische Schriften in Auswahl*, ed. O. Best, Darmstadt: Wissenschaftliche Buchgesellschaft, 1974.

16. F. Schlegel, Fragments (from the *Lyceum*), no. 108.

The aesthetic theory of the arts

Jonathan Rée

There is an obvious connection between art and the senses. We
may on occasion ascribe artistic qualities to purely intellectual
themes as opposed to empirical ones – to mathematical concepts
or logical proofs for example – but only, it would seem, by way of
metaphor, projecting features of physical experience onto a realm
of disembodied abstractions. Our everyday experiences of art
always lead back to something like the pleasures of the senses, and
without such a connection, art would presumably lose contact
with ordinary existence and turn into a self-indulgent, self-
referring, self-perpetuating game: art for artists' sake.

Or so we might think.

Within the western philosophical tradition, however, the idea of a
connection between art and the senses is not as well established as
one could expect. Plato regarded beauty as an object of
intellectual rather than empirical pleasure, though he conceded
that we could gain access to some shadowy approximation of it
through our sensory organs – or at least by sight and hearing, if
not touch, taste and smell.[1] Aristotle followed his master in
deprecating touch and taste (he thought they beckoned us towards
debauchery, drunkenness, gluttony and lechery), but he was broad-
minded enough to add smell to the canon of the noble senses.[2]

However these classical reflections on sensory pleasure concern

beauty rather than art – beauty as an attribute of natural objects
or young human bodies, rather than a quality of the products of
artistic labour. In fact the idea of a specific connection between
the arts and the senses cannot be traced back further than the
middle of the eighteenth century, when it was epitomised by the
adoption of the word 'aesthetics' (from the Greek *aisthesis*,
meaning sensation as opposed to intellect) to describe the science
of the fine arts and perhaps the source or criterion of artistic
value.

The usage is commonly said to have been initiated by Alexander
Baumgarten in his academic thesis *Reflections on Poetry*
(*Meditationes Philosophicae*, 1735) and his unfinished textbooks on
Aesthetica (1750, 1758). But in fact Baumgarten used *aestheta* in a
wholly traditional sense, to denote the objects of sensory
knowledge in general, and his only originality lies in his proposal
for a discipline of 'general poetics' which would teach students
how *aestheta* ought to be presented in spoken or written
discourse.[3]

The real begetter of the philosophical doctrine connecting the arts
with the empirical senses – what we might call *the aesthetic theory
of the arts* – was Gotthold Ephraim Lessing. Given that the
Renaissance conception of 'fine arts' (grouping together painting,
sculpture and architecture) had recently been expanded to create a
system of five arts (architecture, sculpture, painting, music and
poetry) there was an understandable temptation to try and map
the five fine arts onto the traditional five senses. Lessing did not
withstand the temptation, and the purpose of his *Laokoön*,
published in 1766, was to derive norms of artistic value from the
specific nature of different sensory fields. Thus he re-launched
Baumgarten's term 'aesthetics' with a new meaning: it would now
refer not to the discipline of representing 'sensory' matters in
discourse, but to the theoretical attempt to connect the different
bodily senses to the various fine arts, including the non-discursive

arts that Baumgarten had failed to consider, namely the *bildende Künste* – the 'formative' or 'plastic' arts of painting and sculpture.[4]

The peculiarity of eyesight, according to Lessing, was its ability to detect several spatially separate realities in a single moment or *Augenblick*, whereas the other senses – the 'dark senses' as Lessing called them – were confined to a procession of qualities which file past our consciousness one by one. That was why repulsive objects like putrefying wounds, which would make us sick if we had to touch or taste or smell them, could be safely represented to the eye: their power to upset or repel us is attenuated or diluted, Lessing said, because the 'sense of sight perceives in them and with them a number of other realities.'[5]

But Lessing regarded taste, smell and touch as 'lower senses', with no great significance for the fine arts. The only arts comparable to those that appeal to the eye were those that address the ear – especially poetry, but also literature in general. (He somehow managed to forget about music.) Poetry and painting were the two principal 'kinds of imitation', and the new aesthetics would deduce their proper scope from the truism that 'colours are not sounds and ears are not eyes'. Paintings consisted of 'figures and colours in space' depicting 'objects whose wholes or parts coexist'. Poems, on the other hand, made use of 'articulated sounds in time' (or 'signs that follow one another') and they should therefore be used to represent 'objects whose wholes or parts are consecutive'. Painters should dwell on the static simultaneous complexities of visible space, while poets could be set free to follow sequences of temporal events, especially human actions and passions.[6]

There are few stranger things in the history of philosophy than Kant's response to the aesthetic theory of the arts. In the *Critique of Pure Reason*, in 1781, he rejected the whole idea of a theory of art or artistic value.[7] Nine years later, however, he had changed his

mind, and in the *Critique of Judgement* he tried to out-Lessing
Lessing with a comprehensive attempt to integrate the system of
the five fine arts with a theory of sensory experience. However he
replaced Lessing's dualism of vision and hearing with a more
fundamental distinction between inner intuition, whose form is
purely temporal, and outer intuition, through which all our five
senses give us access to objects in space. This provided him with
the ground for a fundamental division between the arts of space
and the arts of time: that is to say between painting, sculpture,
architecture and landscape gardening, which concern physical
objects outside us, and music (colour-music as well as sound-
music), which is preoccupied with the 'beautiful play of
sensations' within.[8]

Like Lessing before him, Kant did not approve of artistic activities
that straddled the terms of his classification: theatre, dance,
pantomime and opera were freakish hybrids rather than true art
forms in their own right. But this left him with a problem about
the 'arts of speech' – that is to say rhetoric and literature,
especially poetry – which were not specifically spatial or temporal,
but which he nevertheless wanted to assign to 'the first rank
amongst the arts'.[9]

A generation later, Hegel tried to clear up this unfinished business
by devising a kind of synthesis of Plato, Lessing and Kant. The
speciality of the fine arts in general – so Hegel argued in the
Lectures on Aesthetics, first delivered in Berlin in 1823 – was that
whilst they are rooted in the soil of sensory experience, they also
strive towards a realm of higher spiritual truth, as plants grow
towards sunlight. It followed that a theory of art must start from a
'specific characterisation of the senses'. Like Plato, Hegel began by
excluding touch, smell and taste (they were unworthy of
spirituality),[10] and then went back to the Lessingian equations
from which Kant had shied away: 'just as sight relates to light or
physicalised space', he wrote, "so hearing relates to sound or

physicalised time". In other words space was specifically visual, and time specifically auditory, and this was the rock on which Hegel would construct a new aesthetic hierarchy of the arts.[11]

In Hegel's system, vision was more grossly physical than hearing, and the spatial arts were therefore inferior to the temporal ones. Architecture was the lowest of the arts, followed by sculpture and then painting. Music was more 'adequate to spirit' – indeed it was the perfect means of expressing 'essentially shapeless feeling' – but it could not scale the same heights as poetry, or 'the art of speech'. To Hegel, poetry was 'total art', or 'the absolute and true art of the spirit',[12] and he was able to offer an adroitly dialectical solution to the question that had baffled Kant. He realised that we do not hear speech simply by listening to it as pure sound. Even our own mother tongue remains mysterious to us till we have learned to recognise it visually, through the medium of writing. In some ways writing offers a more 'roundabout way to ideas' than speech, according to Hegel; but still we need to be able to represent speech to ourselves in the form of writing if we are to understand it consciously as language, that is to say as a finite set of arbitrary 'simple elements' rather than a limitless array of particular sounds. This contradiction between language as sound, spoken 'in time' to the ear, and language as script, written 'in space' for the eye, served to raise our minds towards 'the more formal nature of the sounding word and its abstract elements',[13] thus enabling poetry, best of all the arts, to purify and spiritualize our inner subjectivity.[14]

The aesthetic theory of the arts reached a kind of perfection in Hegel, and it has not ceased to reverberate through philosophical discussion ever since. It may have been hard to sustain the presumption that the arts differ because our different senses each cut their own swath through the world, but it has been equally difficult to shake it off. Post-Hegelian theorists of painting, for

instance, developed the idea with an ambivalence that borders on wilful paradox. In his essay of 1877 on 'The School of Giorgione' Walter Pater claimed that the only proper way to judge a painting was to see how closely it approximates to 'musical law', since music was, he thought, 'the typical, or ideally consummate art'.[15] And twenty years later, Bernard Berenson was instructing his readers that the only 'genuinely artistic' way of apprehending a painting was by allowing it 'somehow to stimulate our consciousness of tactile values'.[16]

Pater and Berenson suggested, in other words, that paintings should ideally appeal not so much to our eyes as to our ears or fingertips. Despite them, however, the traditional art-school disciplines of drawing, sculpture and painting have been reconstructed in the twentieth century and rebranded as 'visual arts' or even 'visual research' or 'visual culture'. The new nomenclature may reflect a real shift of emphasis from a training in practical skills to an education in theory and criticism, but it has an air of forced artificiality nevertheless: after all if visual skill were really the heart of the so-called 'visual arts', then driving a car or bird-watching or even reading a book would have a claim to be classed with them as well. And if the category of 'visual arts' had any validity, one could expect it to be accompanied by a corresponding category of auditory arts, and eventually olfactory, gustatory and tactile ones as well. But does the idea that both music and poetry are directed to the ear mean that they have anything at all in common as forms of artistic endeavour? The aesthetic tradition would have us believe that they are both essentially concerned with successions of simple events distributed along a line of time, and it also suggests that they are more inward and spiritual than the 'visual arts', which are taken to be preoccupied by complex simultaneities existing outside us in physical space. But you need only reflect on the obvious facts of ordinary experience to falsify this orthodoxy: listen to an

orchestra, or indeed look at a score, and you will see that music is itself an art of simultaneity, relying on the listener's ability to hear a concerted combination within each instantaneous sound-slice, and to distinguish between, say, the figure in the violins and its accompaniment in the bassoons. Similarly with poetry: if successive syllables were sensed as separate self-enclosed momentary entities, then the phenomena of rhythm and meaning would never arise. If music and poetry have anything essential in common, it is the fact that they can only be actualized in specific performances, real or imaginary, rather than that they have some special relationship to temporal succession. But mime, dance, and much of theatre and cinema require performance as well, so it cannot have anything specifically to do with sound or auditory experience.

The so-called 'visual' arts may also have important connections with each other, but that is because they entail the fashioning of substantial physical artifacts such as buildings, carvings, and paintings, rather than because they appeal to the eye. Moreover it is a fantasy to suppose that, as 'spatial' arts, they do not exist significantly in time: as Paul Klee once said, wistfully recalling a wasted youth filled with reflections on Lessing: 'space is a temporal concept too'.[17] We can look at works of 'visual' art in different seasons and in varying lights, and we can revisit them, either in memory or in reality, at different periods of our lives. In addition, they may actually change significantly over time, like fountains or mobile sculptures; and indeed if vision were really the connecting thread, then many aspects of opera, dance, drama and rhetoric, or the supposedly auditory arts of music and poetry, would count as visual arts as well. Collapse of the aesthetic theory of art.

If there is any field in which philosophy can claim to have made

real conceptual progress, it is surely the analysis of perception. Over the past four centuries or so the commonsensical idea of sensory knowledge as a kind of tank fed by five separate pipes, each supplied by one of the five senses, has been gradually but decisively discredited. It began to lose its shine when Descartes rejected the dichotomy between physical sensations and intellectual ideas and tried to replace it with a continuum ranging from the most 'confused' ideas to the most 'distinct'. But the enterprise lacked conviction until Kant's *Critique of Pure Reason*, which argued that the essential point about empirical experience is not that it is based in the five senses, but that it is informed by the three-dimensional structure of space and the one-dimensional structure of time. It followed that all the objects of the senses – colours, sounds, smells, textures and tastes – are located in both space and time. (No doubt that is why Kant hesitated over Lessing's equations between spatiality and vision or temporality and hearing.) The process was carried further a century later by Edmund Husserl and the phenomenological tradition that he founded. It now became clear that we do not experience the world by adding together the deliverances of the separate senses, but quite the reverse. We relate to the world through what one might regard as a single sense organ, our bodies, and it is only with the advent of conscious reflection that we try to divide our experience into five separate sectors each patrolled by its own sensory modality. We are originally connected to the world, in short, not through separate channels of sensation but through integrated networks of perception.

It is with our bodies as a whole that we explore the world as a whole. We do not perceive space through our sense of sight (nor yet through touch, as another philosophical tradition would have it), and then time through our sense of hearing (nor yet through inner intuition); and we do not finally add them together to form a representation of the spatio-temporal world. As Kant realised, the

five senses are all equally concerned with objects located in space and time: space has nothing special to do with vision, nor hearing with time. The objects of hearing, smell and taste are no less spatial than those of vision or indeed touch; and the objects of vision, touch, taste and smell are no less temporal than those of hearing. It is simply impossible to isolate what we derive through one sense organ from what we learn from the others.[18]

The aesthetic theory of art is a result of a kind of obstinate inversion. It pretends to argue from the physical properties of the different senses to the capacities of different kinds of art, but in fact it does quite the opposite. It jumps from the rough and ready physical fact that buildings, sculptures and paintings are relatively permanent objects, while performances of music are fleeting events, to the conclusion that vision is the capacity for sensing space without time, and hearing the capacity for sensing time without space. It then finds itself faced with the quite factitious problem of matching up two apparently separate aspects of the art of poetry, one audio-temporal (speech) and the other video-spatial (writing). But speech is not exclusively audible, and neither is writing exclusively visual (think of lip-reading or spelling out loud). The attempt to derive the functions of the different arts from the supposed differences between the five senses is based on a fallacy: the fallacy of aesthetic inversion, as it might be called. The whole thing is a sham.

The fallacy can spread its influence to the rest of philosophy too. One of the great clichés of twentieth-century cultural commentary – due perhaps to Oswald Spengler – is the thesis that modernity (whatever that may be) is afflicted by a bias towards vision and hence by a habit of seeing the world with a false kind of impassivity, as if it were a 'picture'.[19] There may or may not be some truth in this idea, but in any case it has overshadowed the fate of a sensory modality that has surely been more abusively fetishized than vision. Ever since the end of the seventeenth

century, taste has served as a kind of metaphorical emblem for artistic discrimination and connoisseurship. Part of its attraction in this role is that it conforms with a worldly scepticism about the possibility of a universal standard of artistic judgement. David Hume recalled the Thomist proverb which, as he put it, 'has justly determined it to be fruitless to dispute concerning tastes', and, noting that judgements of works of art are also contingent on individual circumstance and sensibility, he remarked that it is 'very natural, and even quite necessary, to extend this maxim to mental, as well as bodily taste'.[20]

But the variability of artistic judgements is not the only reason for the popularity of the language of 'taste' in descriptions of the workings of art. Of all the five senses, taste is the one most directly associated with simple pleasure. Indeed our idioms suggest that taste is the only sensory modality where degree of gratification corresponds to intensity of stimulation: extremes of noisiness, brightness, roughness and smelliness are normally held to be repulsive, but extreme tastiness is meant to be supremely attractive: the tastier the better. To call something a matter of taste implies that it exists for the sake of our gratification and that it is to be evaluated, as Hume goes on to say, purely in terms of our 'preferences'. If 'one person is more pleased with the sublime; another with the tender; a third with raillery', he says, then their disagreements are 'innocent and unavoidable, and can never reasonably be the object of dispute'. We should choose our favourite artists, rather as we choose our bosom companions, simply on the basis of how we get on with them, or sheer 'conformity of humour and disposition'.[21]

Hume's tolerance may be warm and generous, but its conceptual presuppositions are rather dark and murky. Phrases like 'mental taste' or 'preference' do not come anywhere near the kinds of significance that works of art can have in our lives. A meal can be entirely pleasing to our sense of taste – quite perfect in fact –

without being in any way fit for remembering, or learning from, or discussing with intimate friends. But a work of art that is not worth recalling is not worth anything, however much pleasure it may have provided. If a work of art fails, it is not because it disgusts us, or conflicts with our predilections or causes us pain, but because – whether through its fault or our own – it has proposed nothing interesting for our consideration; nothing strange, intriguing or memorable; nothing to which in future we might want to return.

It may be that theory as such will always fall short of what art does when it works. It is a problem of tone and address rather than content: the best format for discussions of works of art is surely an intimate conversation, a private letter, or a jotting in a journal or a sketchbook, or – best of all perhaps – silent communion. (You need to be very careful who you are with when you visit galleries, theatres or cinemas, and when you attend concerts or recitals or poetry readings.) That must be the source of the extraordinary power of the letters written to Clara Rilke by Rainer Maria Rilke in 1907, eventually published as a separate booklet called *Letters on Cézanne*. They are guided by a precise and tactful awareness that what is worth saying about art depends on the exact occasion: on who is speaking to whom, how their lives are linked, and how their times together – past, present and future – can be altered by works of art, and may alter them in turn. In one letter Rilke describes looking at some drawings by Rodin that were already well known to him: 'But did I really know them? There was so much in them that seemed different to me (is it Cézanne? Is it the passing of time?); what I had written about them two months ago had receded to the outer limits of validity.' Or again: 'I can tell how I've changed by the way Cézanne is challenging me now.' And his reflections always loop back to Clara: 'Would that you were sitting with me in front of the van Gogh portfolio,' he writes: 'how much you would see in it that I can't see yet.' [22]

The inadequacy of the language of taste to the workings of art is like a microcosm of the inappropriateness of the aesthetic theory of art as a whole. If we insist on defining experience in terms of the world's effects on our senses as opposed to our perceptual explorations of the world, then we will obliterate the space in which art is able to do its work – its probing, disturbing, challenging and rearranging of the terms of our shared engagements with reality. Works of art exist to surprise, refresh and retune our perceptions and our relations to our fellow-perceivers, and that is why documents like Rilke's letters touch a nerve that theories of art never reach. It might be convenient for the lazy metaphysician who lurks within us all if perception really were the solitary additive process envisaged by the theory of the five senses. But it would be a disaster for that metaphysician's counterpart, the restless artist. If perception were that straightforward, then art would not be necessary; indeed it would not even be possible.

Notes

1. Plato, *Republic*, 475b–476c.

2. Aristotle, *Problems* X., 52, 896b10–29; *Eudemian Ethics* III., 2 1230b21–1231a26; cf. *Nicomachean Ethics* VII., 7, 1150\1a8–15.

3. Alexander Baumgarten, *Meditationes Philosophicae de nonnullis ad poema pertinentibus*, Magdeburg, 1735, reprinted with English translation as *Reflections on Poetry*, translated by Karl Aschenbrenner and William B. Holther, Berkeley, University of California Press, 1954.

4. Gotthold Ephraim Lessing, *Laokoön: an essay on the limits of painting and poetry* (1766), translated by Edward Allen McCormick, Baltimore, Johns Hopkins University Press, 1984, Preface, p. 5.

5. *Laokoön*, ch. 3, p. 19; ch. 25, p. 131.

6. *Laokoön*, chs. 11, 15, and 16, pp. 62, 76, 78.

7. In a footnote to the *Critique of Pure Reason* Kant disparaged the German way of using the word *aesthetica* 'to signify what others call the critique

of taste' – a usage which he deplored at the time, and attributed to 'the abortive attempt made by Baumgarten, that admirable analytical thinker, to bring the critical treatment of the beautiful under rational principles, and so to raise its rank to that of a science'. See *Critique of Pure Reason*, A21, B35-6, translated by Norman Kemp Smith, London, Macmillan, 1933, pp. 66-7.

8. *Critique of Judgement* (1790), translated by James Creed Meredith, Oxford, Oxford University Press, 1952, §14, pp. 67-8, §53, p. 194.

9. *Critique of Judgement*, §51, p. 184; §53, p. 193 and fns., §53, p. 191.

10. G.W.F. Hegel, *Aesthetics: Lectures on Fine Art*, translated by T.M. Knox, Oxford, Clarendon Press, 1975, pp. 621, 39, 621.

11. G.W.F. Hegel, *Philosophy of Mind*, §401; see *Hegel's Philosophy of Subjective Spirit*, translated by M.J. Petry, vol. 2, p. 171.

12. *Aesthetics*, pp. 622-6.

13. *Philosophy of Mind*, §459; see *Hegel's Philosophy of Subjective Spirit*, vol. 3, pp. 187-191.

14. The above description of the history of the aesthetic theory of art resumes much of the argument of chapters 28 and 29 of my *I See a Voice*, London, HarperCollins, 1999.

15. Pater held that art is a 'constant effort' to obliterate the distinction of form from content, and consequently that 'All art constantly aspires towards the condition of music.' See Walter Pater, 'The School of Giorgione' (1877), *The Renaissance*, Library Edition, London, Macmillan, 1910, pp. 130-154, pp. 135, 138.

16. Bernard Berenson, *The Italian Painters of the Renaissance* (1894-1907), London, Phaidon, 1952, pp. 40-41.

17. Paul Klee, 'Schöpferische Konfession' (1920); see Paul Klee, *Théorie de l'Art Moderne*, edited by Pierre-Henri Gonthier, Geneva, Gonthier, 1964, p. 37.

18. As Hans Jonas says, 'visual perception is saturated with experience of other sorts'. See 'Sight and Thought: a review of *Visual Thinking*' (1971), in *Philosophical Essays*, Englewood Cliffs, Prentice Hall, 1974, pp. 224-236, p. 228.

19. Oswald Spengler, *Die Mensch und die Technik* (1931), translated by C.F. Atkinson as *Man and Technics*, London, George Allen and Unwin, 1932, pp. 24-5.

20. David Hume, 'Of the Standard of Taste' (1742) in *Essays and Treatises on Several Subjects*, Edinburgh, 1804, vol. 1, pp. 241-66.

21. David Hume, 'Of the Standard of Taste', pp. 261-2.

22. Rainer Maria Rilke, *Briefe über Cézanne*, edited by Clara Rilke (1952), translated as *Letters on Cézanne* by Joel Agee, London, Jonathan Cape, 1988, pp. 52–3, 49, 19.

De-arting

Alexander García Düttmann

Translated by Peter Gingerich

'De-arting (*Entkunstung*) [is] inherent in art, in uncompromising art no less than in art which gives itself away to the market.'
— *Theodor W. Adorno*

Entkunstung – 'de-arting,' Adorno's neologism, one of the few in his work and therefore all the more significant – occurs perhaps for the first time in his article 'On Jazz', written in 1953 and included by the author in *Prisms*, a collection of essays.[1] According to his *Aesthetic Theory*, 'de-arting' is inherent to heteronomous or regressive art as well as to autonomous or progressive art. That it is inherent to both artistic movements; that both movements result in a transformation of the work of art into 'just a thing among things'; that art is already 'de-arting' and that 'de-arting' is an originary process, as it were, gives a sense of the explosive force of the 'de'.

In two influential texts from the 1950s, Martin Heidegger's treatise 'The Age of the World Picture' and Hugo Friedrich's book on modern poetry, neologisms appear which are also constructed with the prefix de-; these neologisms seem to have a symptomatic function for philosophical or critical discourse in the twentieth century. (Think also of Benjamin's idea of 'de-position' [*Entsetzung*] in his essay 'Critique of Violence', published in 1921.) Heidegger names the decisive and fundamental characteristics of modernity and describes 'de-godding' (*Entgötterung*) as a modern phenomenon:

This expression does not mean the mere doing away with the gods, gross atheism. De-godding (*Entgötterung*) is a twofold process. On the one hand, the world picture is christianized in as much as the cause of the world is posited as infinite, unconditional, absolute. On the other hand, Christendom transforms Christian doctrine into a world view (the Christian world view), and in that way makes itself modern and up to date.[2]

As a withdrawal or escape of the gods, 'de-godding' perhaps points towards a general tendency which is also designated by the 'de-arting' of art – for isn't *Entkunstung* a process of destruction which affects the cult value of works of art?

The 'depersonification [*Entpersönlichung*] of the poetic subject', which Hugo Friedrich discovers in modern poetry[3] and which belongs to its 'negative categories', must be a 'dehumanization' (*Enthumanisierung*) and a 'de-objectivization' (*Entdinglichung*), an abstracting spiritualization which has its impossible place in a paradox: 'Poetry which escapes from a scientifically deciphered and technologized world and flees into an unreal world claims, in its creation of the unreal, the very same precision and intelligence that have made the world confining and banal'.[4] Adorno, who understands the process of 'de-objectivization', of the stripping away of that which makes something an object or thing, as the integrative force of the de-arted, modern work of art, also recognizes in this destruction a movement of reification.[5]

How does Adorno, in his *Aesthetic Theory*, relate to that which he occasionally calls the 'prognosis' of the end of art? How does he relate to the intertwining of spirit and history? This is the question of the relation between art and philosophy that dominates *Aesthetic Theory*. While the opening lines of the German edition, published after Adorno's death by his widow Gretel and Rolf Tiedemann, express clearly that the author took the end of art

as his point of departure, they say nothing about the position from which he argues. The reader of *Aesthetic Theory* who, for this very reason, looks at the 'Early Introduction' which closes the book (according to the editors, it was the author's intention to replace it with a new introduction) will quickly notice that, in order not to get lost, he must distinguish between the historicity of art and the historicity of aesthetics. This introduction begins with a statement: Adorno says that there is 'something obsolete' about 'the concept of philosophical aesthetics.'[6] Thus, the first part of the *Aesthetic Theory* and the early, discarded introduction both begin with the idea of something coming to an end: but while the opening lines of the first part mention the end of art, the opening lines of the introduction discuss the end of aesthetics. Though it might seem reasonable to introduce a book on the philosophy of art with an interrogation of the possibility of aesthetic reflection and with the question whether aesthetics is obsolete or not, such a beginning still remains conventional if one fails to recognize the difficulty which expresses itself in the possibility of another, a different beginning. This difficulty does not simply result from a biographical contingency, from a contingency inscribed in the composition of an unfinished work, for it turns out to be the enormous difficulty that lies in the complex and equivocal relationship between art and philosophy. Why is aesthetics obsolete if its anachronism does not exhaust itself in the fact that aesthetic reflection must endlessly revolve around an end of art which has been proclaimed again and again? Does the obvious shortcoming of aesthetics indicate that art still possesses some autonomy and a certain power of resistance?

When looking for possible answers to these questions, one can hardly be content with the hints that Adorno gives at first. Certainly, the historicity of aesthetics depends on the tension between the general and the particular: if no particular 'artistic practice' lets itself be dissolved in a general conceptual discourse,

the tension between both finally weakens the force of the concept and thus becomes itself increasingly loose. Certainly, the 'indifference towards aesthetic theory,' which might be induced by this very tension and which is also socially determined, might be another reason for the fact that aesthetics seems to be growing obsolete. However, to understand this obsolescence and this anachronism it is decisive to understand the dynamic which is brought about by the divergence of the general and the particular, i.e., by the asymmetry between work of art and philosophy of art. The divergence and the asymmetry first emerge with the historical development of art; therefore, they are not simply present in the tension between the particular and the general.

Adorno speaks of asymmetry, of the diverging tendencies in philosophical and artistic progress, in the following terms: 'The synoptical and contemplative attitude which science expects of aesthetics, is irreconcilable with progressive art' (458; 495). The more philosophy raises the claim to scientificity in order to be credible as philosophy, the more it distances itself from art, which progresses towards incommensurability with science. Such an argument supposes, of course, a position other than that of a philosophy on which science imposes its exigencies. Only when there is still art, only when art demands a thought which is able to register the historicity, the aging, the anachronism of aesthetics, can the question concerning art and its right to exist be raised. (This is the question Adorno asks at the beginning of his *Aesthetic Theory*.)

If we take Adorno seriously, interrogating the possibility and impossibility of art is inseparable from the anachronism of aesthetics, from its irreducible exteriority, since nothing guarantees that aesthetic reflection and artistic practice run parallel as they develop. Not only is the relationship between the general and the particular, the concept and the work of art, theory and practice, a relationship marked by a tension; because their

relationship is more or less tense, all these terms are also exposed to an unforeseeable historical dynamic. Within this perspective, the question of art's right to exist is still part of art: art asserts its independence and autonomy even at that point where the philosophical reflection upon it might become aware of its finitude (of its possible ending) without being entirely capable of grasping an end of art. It is therefore not surprising that Adorno maintains, in the passages from *Aesthetic Theory* that deal with the positivist recognition of art as a social fact and with its proclaimed revolutionary abolition, that 'the sovereignty of the topographical gaze, which locates phenomena in order to examine their function and their right to exist' (355; 372), results from a usurpation, and that the 'creation of every authentic work [refutes] the pronouncement that a work can no longer be created' (356; 373).

The question of the end of art must remain relatively external to art; in this case, it can never be fully formulated or raised as such. As a question which to some extent remains external to art, it reproduces the exteriority of aesthetics, which consists of the fact that 'probably scarcely a significant work [has ever existed] which did not impart norms through its own form, virtually changing the [established] norms' (458; 495). Even those works of art which are mediated by established norms, by norms aesthetics determines conceptually, destroy in their very fidelity to these norms whatever it is that constitutes a particular normative order. For this reason alone there has never been a generally valid and binding canon of norms in the sphere of art (nor, perhaps, in the entire tradition). If we can assume that, in a period before the historical emergence of autonomous art, art 'oriented itself according to comprehensive norms which were not questioned by the individual works of art, but only dissolved into their immanent problematics' (458; 496), we must by the same token assume that this dissolution suspended the norms themselves, and that the difference between an initially heteronomous and later

autonomous art has never had the fixed form of a pure opposition. If, however, the exteriority of aesthetics was never absolute, if aesthetics has always maintained itself in a relationship relative to the work of art, which had to diverge from established aesthetic norms, then it is not enough to stress the asymmetry between art and philosophy and to point to the historical dynamic to which it is submitted. We must say, too, that the reactive element of aesthetics, its finitude, can be interpreted as proximity and fidelity to a work of art.

Aesthetic theory might insist on the autonomy of art and be aware of the anachronism of every aesthetics, but if we understand the historical dynamic underlying art and philosophical reflection as the product of absolute disparity, no aesthetic theory would be able to reflect upon art. Precisely because the anachronism of aesthetics becomes clear in 'progressive art' and because 'progressive art' wouldn't be progressive without the self-reflexive moment which leads to the recognition of the aesthetic anachronism, the end of art can become a question of aesthetic theory and, in fact, is always already posed by aesthetic theory. 'That interest in aesthetics has waned', Adorno writes,

> stems not only from aesthetics itself, from aesthetics as a discipline, but also, and to a greater extent, from a change in the object it deals with. Aesthetics tacitly appears to assume the possibility of art; from the outset, it focuses more on how art exists [Wie] than on whether it can exist at all [Dass]. Is it still possible to take such a view? It seems uncertain. (464; 503)

As a discipline, aesthetics is essentially anachronistic: it focuses on art's 'how', on the artistic content and form, before even defining and determining their specificity. Disciplines must by definition take their point of departure from their object and are not in a position to reflect upon the existence, the 'that-it-is' of the object, on which every 'how' depends. They can comprehend the structure and the historical or social transformations of the object,

but they are unable to provide a thematic and objective account of its very existence. For existence is neither a theme nor an object of any constituted discipline which attempts to proceed scientifically; it is rather an event (*Ereignis*): the appearance and disappearance of something which is not yet or no longer an object. In other words, the conversion of aesthetics into a science (into a discipline in the narrow sense) is perhaps irreconcilable with 'progressive art'; but each aesthetics, whether a scientific discipline or not, presupposes, as a discipline, that is, as a limited field of thought, the existence of its object. Its presupposition is its anachronism.

On the other hand, and since the recognition of this anachronism, the recognition of the autonomy of art becomes possible only through art's self-reflection, through the insight that 'progressive art' conveys, aesthetic reflection can also be directed upon art's presupposed existence, upon a presupposition which seems difficult to grasp. With this new orientation, we recognize the difference between aesthetics as a discipline (in the broader sense of a constituted field of thought and in the narrower sense of a field of scientific procedure) and a philosophy of art which deals with the 'how' only in order to grasp the 'that-it-is', the existence. It is within the context of such a necessary transition from a limited aesthetics to a general philosophy of art that one must understand one of Adorno's most enigmatic affirmations. In a sentence somehow detached from the context, he says that aesthetics after Hegel has forgotten the 'prognosis' of the end of art, whereas art profoundly felt its validity.[7] The finitude of aesthetics, its anachronism, is inessential from this perspective. Because of its inessential finitude, a limited aesthetics has no access to art's essential, graspable, and determinable finitude: in its essence, art is closed off to aesthetics. If art senses that it is finite; if it senses that the philosophical determination of its finitude comprehends its essence and thus affects it essentially, then the sensitivity Adorno attributes to art must derive from art's

participating in the determinable and comprehensible life of spirit. Aesthetic theory and philosophical aesthetics are different from aesthetics as a discipline because they are able to understand what it is that art senses; as a discipline, aesthetics is not as sensitive as art is; it is not alive the way art is alive; it is both too affirmative and not affirmative enough. In its very existence lies an affirmation of art's existence, through which art turns away from determination and comprehension, from the life of spirit, from life itself. As Hegel shows, life never coincides with 'what is from the outset *only* affirmative' any more than it exhausts itself in negation or in opposition. Sheer affirmation and sheer negation are deprived of life: 'life proceeds to negation and its grief, and it only becomes affirmative in its own eyes by obliterating the opposition and the contradiction.'[8]

Adorno's aesthetic theory agrees with Hegel's philosophy of art, then, in its criticism of the exteriority of limited aesthetics. This exteriority should not be mistaken for the distance between philosophical thinking and art, since, after all, it is art which distances itself from itself. It does so in order to determine itself as art, thus establishing its philosophical truth (such at least is its determination according to the dialectical philosophy of art). Aesthetics as a discipline always resembles the rule-based mechanics whose inadequacy for aesthetic reflection was proven by Hegel. If we follow Hegel's argument, anyone who believes that the work of art is the product of a human activity, and who is not able to grasp art as a free and necessary manifestation and formation of spirit, tends towards one of two complementary conceptions: either the hypostasis of the genius without consciousness of his activity, or the interpretation of artistic activity 'as the *conscious* production of an external object' which 'can also be *known* and *expounded*, and which can be learned and pursued by others' (25; 44). If speculative dialectics determines the end of art by inscribing its existence into the living movement

of spirit; if art presents itself as the sensible appearance of the idea, preceding religion and philosophy in the forms of artistic beauty, then the exteriority of aesthetics is definitively overcome and the specificity or particularity of art, which consists in the event of its existence (*Dass*) and depends on the singularity of its constitution (*Wie*), is determined conceptually – it is brought into its truth.

But does such an approach not miss the very existence of art? Is the existence of art not overlooked when art is determined or determines itself as a standpoint within a history in which and through which spirit achieves its absolute determinacy and its scientificity as absolute knowledge, as a knowledge which is no longer an external, limited, restricted knowledge, a knowledge full of implicit presuppositions? Do not an aesthetics which has been reduced to a discipline and a speculative or dialectical philosophy of art have such an omission in common? Does not the omission or failure that characterizes both (both miss the very existence of art, both fail to acknowledge it) follow from the fact that every philosophical discourse on the end of art (including and above all the discourse of positive dialectics) has to create a link with the event of an existence, with that which resists linkage and thus cannot simply be confined within the thoroughly determinate continuity of a coherent whole? Does not the philosophical determination of an end of art attempt to reverse the splitting of the end into completion and failure (an end can always be either a completion or a failure) by referring art's existence back to its essence, by reducing the 'that' to the 'what'? Is it possible, on the other hand, to engage in a philosophical discourse on art or to provide a coherent argument that determines the essence and the truth of art without raising the question of its end and without depriving it of its existence, of that which makes it an event?

If speculative thinking about art has the force and the power to assign a place in the history of spirit, if it can determine the time of art, it can do so because art both anticipates and outlives itself.

Were there no continuous relation between art and that which
prepares and announces its appearance, art would remain without
relation. It could not sublate nature and it would not be able to
refer to religion, i.e., to a higher form of consciousness. Art's
existence would be an abstract, empirical, aleatory event,
unmediated and devoid of any relation to the whole; art would
prove to be an indifferent historical incident, without beginning or
end, lost in an indeterminate reality and an inessential finitude.
Thus, art's limitation, its finitude, its historicity is a being-related
to the whole that gives it its reality, indeed, its absolute right to
exist. 'Art', Hegel says, 'has still a limit in itself and therefore
passes over into higher forms of consciousness' (102; 141). In
contrast to nature and the beautiful in nature, the work of art
does not exhaust itself in the uninhibitedness and indeterminacy
of a mere being-for-itself; it is rather and essentially a 'question',
an 'address to the resonating and responsive breast, a call to the
mind and spirit' (71; 102). But art is such a question, such an
address, such a call only on the basis of its limitation; therefore, it
requires the philosophical concept in order to determine the truth
of the finitude of truth, the truth of its own finite truth.

How does Hegel describe the continuous movement that takes
place in the very end of art? How does he understand the
transition from art to that higher form of consciousness which he
sees as the subjective interiority of religion? How does he
represent religion's opening onto philosophy? The 'after' marking
the afterlife of an art which has reached its end is determined by a
twofold progression. The needy spirit, which, in art, cannot find
the ultimate satisfaction of its need for realization and completion,
abandons art. At this point the concept of art has been fulfilled
and its essential finitude has been made manifest conceptually.
Art, a figure or form of the spirit, can never satisfy its need for
itself: it sticks too closely to the exteriority of its objectivity and
remains for that reason a finite formation of spirit. Its afterlife is

produced by the progression of (the) self-determination (of spirit). When thinking about art, one must not separate the 'for' or the 'after' of the need (religion comes *after* art because of the spiritual need *for* realization) from the 'after' of art (art survives itself and has an *after*life); one must not separate the 'pro-' of progress, with which the spirit marks its progressive self-determination, from the 'per-' of perdurance[9] through which art keeps itself alive, unable to claim a true right to existence. After its end, however, art does not merely perdure. Its perduring is a progressing, if we take Hegel's word for it:

> The 'after' of art consists in the fact that there dwells in the spirit the need to satisfy itself solely in its own inner self as the true form for truth to take. Art in its beginnings still leaves over something mysterious, a secret foreboding and a longing, because its creations have not completely set forth their full content for imaginative vision. But if the perfect content has been perfectly revealed in artistic shapes, then the more far-seeing spirit rejects this objective manifestation and turns back into its inner self. This is the case in our own time. We may well hope that art will always rise higher and come to perfection, but the form of art has ceased to be the supreme need of the spirit. (103; 142)

What might have caused Hegel to attach a hope for progress, elevation, and completion to the afterlife and continued life of a finite art?

As a form of consciousness, as a formation of spirit, art must outlive itself; its essential finitude is also its lack. When it has reached its completion, it is still limited; thus its limitation makes the spirit push away its objectivity: the spirit abandons its own formation, necessary and unsatisfactory at the same time. However, the end of art – the completion achieved with the establishment of the classical unity of inner and outer – must leave behind a remnant, an art which 'within its own sphere' (80; 113) transcends itself. If completed art abruptly erupted into

religion, its end would be a sudden disappearance and it would disallow all thinking of historical progress: there would be no continuous and determinate process of becoming, no process of becoming could be represented in terms of interiorization and sublation. In the same way that art transcends nature and natural life, art must, after its end, or more precisely, *in* its end, surpass itself. It must transcend itself as idea which has acquired existence for itself in its sensible appearance. In this sense the enduring and perduring art, which Hegel characterizes as Romantic, is no indeterminate and increasingly indeterminable remnant. The Romantic is art's transposition into representation, a separation of idea and form which cannot be considered a regression into the indifference of the Symbolic because, in Romantic art, the idea appears 'complete': it withdraws from a possible unification with the exterior to the extent to which it 'can seek and achieve its true reality and manifestation only within itself' (81; 114). Hegel's hope for completion and elevation of art after or in its end is probably motivated by this transcending movement of self-determination. But the closer the idea comes to itself and the more it approaches its own determinacy, the more 'fine art' and reflection draw apart: the need for a 'science of art' becomes increasingly strong, and art demands more and more emphatically a 'reflecting meditation' (11; 25–26), which no longer leads to production of works of art and literally knocks the wind out of artistic inspiration. It thus appears that the existence of art is determined only retrospectively; the existence of art is determined when art has lost its 'authentic truth and vitality', when, 'from the perspective of its highest determination', it has become something belonging to the past, and when the 'complaints and reproaches' over its reflective dissolution have set in. Precisely because the determination of art depends on its finitude, a double effect arises from the relation between completion and end, which allows us to determine the existence of art (its 'that-it-is' or 'that-it-was') and which is created by the necessary delay of the determination (art

remains conceptually undetermined when it reaches its completion, it comes to a determinate end only when its completion has inaugurated its decline). On the one hand, this relation allows us to think the mediation of history and idea; on the other hand, however, it programmes those contradictory reactions which respond to the paradox of existence (what is grasped in its existence no longer simply exists) and to the equivocation in the determination of the end (a determinate end is no more an end than a purely indeterminate end: the experience of the end requires the [in]essential indeterminability which lies in its splitting, in the fact that an end always splits into the two extremes of a possible completion and a possible failure). If we use the terminology of speculative dialectics, the reactions provoked by the paradox of existence and the equivocation in the determination of the end must, of course, be described as belonging to representation, to an insufficient understanding of dialectical mediation.

The extent to which Adorno's philosophy of art belongs to the tradition of such reactions can be seen most clearly in the section of *Aesthetic Theory* which deals with the completion of art, which is to say, with the realization of the idea. Here, Adorno adheres to the philosophical determination of art and its end, which is most forcefully articulated in Hegel's attempt to mediate history and idea. But he also attributes to art an irreducible independence or autonomy. He perpetuates the deferral of the determination and thereby disallows the thought of a progressively self-determining idea that finds its first historical formation in art – in its sensible appearance. Making the deferral perpetual has a singular consequence: Adorno interprets the completion of art as passage into a reality which remains indeterminate and has a utopian character.

> Hegel was the first to recognize that [a temporal end] is implicit in the concept [of art]. That this prophecy[10] was not realized has

its paradoxical basis in Hegel's historical optimism. He betrayed
Utopia by construing existing reality as though it were Utopia, as
though it were the absolute idea. (47–48; 55)

By insisting on a perpetuated, continually deferred end of art,
Adorno moves between the failure to which a false resolution (an
ideological 'doubling' of existing reality [139; 145]) amounts, and
the realization or completion which truly brings art to an end.
This peculiar in-between position reveals that (the end of) art can
never be a discourse of philosophical determination. 'Historical
optimism' is constitutive of (the) determination (of the end) itself
and cannot simply be subtracted from it. The determination of the
end inevitably betrays it and turns out to be a prolongation or a
doubling of existing reality, an omission or failure. One cannot
determine the end without missing it, or transforming it into an
omission or failure – into a failure which misses itself or reduces
the double character of the end, the indeterminacy that is
(in)essentially proper to it and that deprives it of whatever might
be proper to it, an identity or an essence. The end is a remnant, an
impossible point of indifference formed by determinacy and
indeterminability; one must not identify it with the point of an
ultimate dialectical reversal.

We might say that, to the extent to which all philosophical
determinations of art implicitly or explicitly posit its end and try
to trace its existence to an essence (the determination of the end is
nothing else), there is no end of art which would not be disturbed
by a splitting, a paradox, or an equivocation.

Is what we call art an experience of this indeterminacy, an
experience of the indeterminacy that haunts determinability in all
determinations and that exposes the end as a relation which is not
already predetermined and which cannot hold together existence
and essence, history and idea, transcendence and immanence,
thereby creating and establishing a totality or a unity? If art and
its end resist determination (whoever determines art also

determines its limit and its end), the end of art is neither an abolition nor a sublation; thinking the relational character of the end, thinking the two poles or extremes that Adorno envisions in the 'de-arting' of autonomous and heteronomous art (in the socially dictated transformation of art into a commodity and in the reification of a thoroughly developed work of art which follows only its own law), means that art does not come to an end by letting itself be sublated or abolished. *Aesthetic Theory* tells us that in a transformed society, art would be something different, 'a third factor' (369; 386), as it were: it would be incommensurable with past and present art but it would nevertheless exist as a remembrance of the grief and suffering. Grief and suffering must remain its expression, because up to now the end has been little more than a failure, an omission or obliteration.

In the lectures on aesthetics which Adorno gave in the late sixties (available only in an unauthorized edition), we find a passage which indicates that reifying constitution, formation, and development of the work of art which is to be understood as its 'de-arting' is also brought about by mimesis: 'in opposition to the common theories of imitation which go back to Aristotle, works of art are imitations only in the sense that each work of art imitates itself; it attempts to become simultaneous to itself, to make itself into something identical with self.' If 'de-arting' is a reification, and if mimesis serves such a reification, too, then it seems certain that Adorno's thinking of art and its end is a thinking of 'de-arting'. To the extent, however, that this thinking leads to the indeterminacy of the end, one might have to say that 'de-arting' is a name for a movement which has to be regarded as a movement of salvation or rescuing. At the end, in the end: rescuing (of the end).

Notes

1. See 'Perennial Fashion—Jazz' in Theodor Adorno, *Prisms*, trans. Samuel and Shierry Weber (Letchworth, U.K.: Neville Spearman, 1967): 'Art is deprived of its aesthetic dimension [*Kunst wird entkunstet*], and emerges as a part of the very adjustment which it in principle contradicts' (131). The peculiar and long neglected concept of *Entkunstung* or 'de-arting' in Adorno's reflections on the philosophy of art was brought to my attention by Hermann Scheppenhäuser, who lectured on Adorno in Frankfurt during the 1980s. In the early nineties I attempted to reconstruct the 'logic' of this concept in a seminar at the Collège International de Philosophie in Paris and at the University of Strasbourg.

 [In Samuel and Shierry Weber's translation of *Prismen*, *entkunstet* is rendered as 'deprived of (art's) aesthetic dimension' (131). Another term is necessary since *Entkunstung* comprises, in a unique sense, something very like the 'aesthetic dimension' of art. As will become clear, *Entkunstung* does not simply negate or abolish art. The German prefix *ent-* is similar to the English privatives 'un-' and 'de-' in that it means the reversal or opposite of the root that follows. As it happens, the prefix 'ent-' also commonly functions as an intensifier (as in *entstehen*). 'De-' can perform such a function when the meaning of its Latin root ('of' or 'from') complements the meaning of the root it modifies (as in 'deliverance'). It is in this double sense that the prefix 'de-' in 'de-arting' should be understood. *Trans.*]

2. Martin Heidegger, *The Question Concerning Technology and Other Essays*, trans. William Lovitt (New York: Harper Torchbooks, 1977), 116–17; *Holzwege* (Frankfurt am Main: Vittorio Klostermann, 1980), 76.

3. Hugo Friedrich, *The Structure of Modern Poetry from the Mid-Nineteenth to the Mid-Twentieth Century*, trans. Joachim Neugroschel (Evanston: Northwestern Univ. Press, 1974) 127; *Die Struktur der modernen Lyrik von der Mitte des neunzehnten bis zur Mitte des zwanzigsten Jahrhunderts* (Hamburg: Rowohlts Deutsche Enzyklopädie, 1979), 162.

4. Friedrich, *The Structure of Modern Poetry*, 37; 57.

5. Here one should refer to Adorno's critique of personalism and depersonalization (*Depersonalisierung*). If personalism sticks to the principle of an 'unshakable unity' and thereby tightens once again the 'historically tied knot' of the person instead of loosening it, depersonalization fails to think the 'knot of the subject' and therefore never really unties it. 'The subject's dissolution presents at the same time the ephemeral and condemned image of a possible subject'. Cf. T.W. Adorno, *Negative Dialectics*, trans. E.B. Ashton (New York: Seabury Press, 1973), 281; *Negative Dialektik* (Frankfurt am Main: Suhrkamp, 1966), 275.

6. T.W. Adorno, *Aesthetic Theory*, trans. C. Lenhardt (London, New York: Routledge and Kegan Paul, 1984), 456; *Gesammelte Schriften*, Bd. 7

(Frankfurt am Main: Suhrkamp, 1970), 493. Subsequent page references will be to the English edition, followed by the German edition. The translation has often been drastically revised.

7. We will not consider the fact that the idea of an end of art in Hegel's lectures on the philosophy of art is not, strictly speaking, a prognosis, since the determination of an essential finitude does not operate according to probability or chance.

8. G.W.F. Hegel, *Aesthetics: Lectures on Fine Art*, vol. 1, trans. T.M. Knox (Oxford: Clarendon Press, 1975), 97; *Vorlesungen über die Aesthetik, Theorie-Werkausgabe*, Bd. 13, eds. Karl-Markus Michel and Eva Moldenhauer (Frankfurt am Main: Suhrkamp, 1970), 134. Subsequent references to Hegel will be given in the text, English page number preceding the German. [The translation has occasionally been modified. *Trans.*]

9. 'Das Nach des Bedürfnisses und das Nach der Kunst, das Fort des Fortstossens, mit dem der Geist seinen Fortschritt markiert, und das Fort des Fortbestehens . . . muss man zusammendenken.' In order to attempt to render this – very Hegelian – usage of prefixes as nouns, I have resorted to the neologism 'perdure', as a verbal form of the adjective 'perdurable'. As the latter means 'obstinately enduring' or, literally, 'capable of lasting throughout', so 'perdure' means 'to last throughout' or simply 'to endure'. The prefix 'per' gives a better sense of the temporality and relationality of this phenomenon than would the intensifier 'en-' in 'endure'.

10. Note that the prognosis becomes here a prophetic annunciation, where the thought is oriented towards a utopia.

11. Adorno, *Vorlesungen zur Aesthetik (1967–1968)* (Zurich: H. Mayer Nachfolger, 1973).

PART TWO

Theoretical excess

Transformations of painting

Sylviane Agacinski

There are many ways of thinking about the end of theory: a
threshold, a frame, or a border opening onto art. It could also be
the place or the instant of a withdrawal: the point when one must
leave theory, turn away from it in order to enter into art. Francis
Bacon was thinking of this second meaning when he said he
regretted that 'most people enter a painting through the theory
that has been made of it, and not because of what it is'. This regret
arose from the excess of theory induced by modernity. But, as an
intellectual 'vision', theory is always in excess with regard to the
sensitive vision or to the experience of things. Then, our question
might be: how does one distinguish theoretical excess from the
excessive place taken up by theory?

Before coming back to this question, I would like to make a few
remarks on the title of this meeting: 'Where theory ends, there art
begins'. I understand it as the inversion of a more familiar
formula: 'Where art ends, there theory begins'. These two
statements put together would mean that there is an alternative
between theory and art – either theory or art – or even a sequence:
each one in turn takes the place of the other. If art begins where
theory ends, and theory begins where art ends, this means that
there is an alternation between the two, or a circle obliging us to
go through one in order to get to the other. The relationship
between art and theory would then be *a question of time*. It would

be less a matter of bringing out a contradiction between art and theory than of asking a temporal question: should there always be *a time* for theory and *a time* for art?

The tempo of this alternation would vary from the fastest beat to the slowest, up to only two beats, for example: one beat for the history of art (for the event of art) and one beat for the science of art – the Hegelian beat. But theory can also be contemporary to art, as its framework or its necessary supplement. Or again, according to a metaphysical concept that is both classical and modern, the theoretical viewpoint orders and rules over the production of works as well as their reception. The conceptualization of art during the Renaissance, or in the modern period – the metaphysical mission attributed to art – does not seem to have caused any theoretical excess, submerging art and contributing to its withdrawal.

One could quite rightly say: *where art ends, there theory begins* about the Hegelian tempo, which has the end of art followed by the beginning of aesthetics. For Hegel, aesthetics always comes after, because it is the 'test' of art. But, of course, we are not talking about any kind of theory: it is knowledge, or the science of art which always comes after it (always too late, like philosophy), according to the dialectical relationship between the expression of spirit and the ensuing consciousness it acquires of itself. Theory, as an ultimate form of knowledge, must consider that its object is immutable, it is past, and therefore dead. Indeed, that was Kierkegaard's objection to Hegel: 'There is no science but that of the dead . . .'

One could argue that this theoretical knowledge can substitute itself for art and take its place, since it reveals the meaning of works in their historical diversity. Indeed, Hegelian aesthetics sees itself as the *Bewährung* of art (the consecration, the test): it affirms the truth of art by revealing it in the clear and precise language of the mind rather than through the sensitive forms of the works of

art. Theory, in its discursive and conceptual form, takes over from the experience of sensitive forms. One could even consider that if art was not quite finished, aesthetics would have to *finish it off*.

Beyond this historical development, Hegel knew that there have always been theories and philosophical conceptions of art. But he considered that 'the artist does not need philosophy', and even that 'if he thinks as a philosopher, he is doing something that is precisely opposed to the form of knowledge inherent to art.'[1] Thus, we have a question of form: an incompatibility between the form of knowledge (*die Form des Wissens*) inherent to art, which is expressed in sensitive forms, and philosophy's conceptual knowledge. Generally, the artist needs experience, reflection, but he does not need philosophy or theory.

The Hegelian division between art and theory is romantic: a work is a spontaneous expression of genius, that is of nature. (Through genius, Kant said, 'nature gives its rules to art'). Some painters, like Francis Bacon, consider a work more as an experimentation: in this case, theory is not opposed to natural spontaneity. Art became emancipated from the knowledge on which it traditionally depended.

Making and knowing

So far, we have accepted the principle of a division between art and theory. But if we look at the classical status of art, then we see that things are not quite so simple. The history of the concept of art is too complex, like that of theory itself, for one to speak in generalisations. But one can point to specific indicators which make us think that theory is first of all a part of art, and that within art, it distinguishes itself from its empirical counterpart. One can indeed say that, from the origin of the concept, art cannot be separated from the theoretical side that gives it its prestige and ensures its superiority over the craftsman. Greek antiquity carefully

Sylviane Agacinski

distinguished between the skill of the craftsman and the knowledge of 'the man of art', which concerned the finality of works of art in general, including the arts of imitation.

The intimate relationship between art and theory began with Aristotle's *Poetics*. We will leave aside the pure *theôria*, close to the Platonic *theôria*, which is a knowledge of eternal truths. It is foreign to *poïesis*, in other words, production. The production of works in general is part of art and is called *tekhnè*. In the strict sense, what we call the Beaux arts are imitation arts, that is to say arts of representation. For Aristotle, there are two ways of 'producing' a work of art, two ways of doing something (in the sense of 'making'): either one produces spontaneously and naturally, like Homer, the first figure of genius, or one produces artistically, which presupposes a certain kind of knowledge. This knowledge arises from an analysis of great works of art. In order for this theoretical knowledge to develop, these works have to already exist, placing theory in a secondary position with regard to empirical production.

But *tekhnè* – that is, art in the strict sense – is the theoretical part of the artist's skill or the artist's power. For Aristotle, poetic art (the *poïetikè tekhnè*) thus designates the theoretical knowledge of art and its rules, rather than the spontaneous capacity to produce, which requires natural talent and also involves habit, and even chance (Aristotle never excludes chance from *tekhnai*). This is why he wondered whether the work of Homer, the poet *par excellence*, was due to his knowledge of art (*dia tekhnèn*) or to his nature (*dia phusin*)[2]. Aristotle does not decide on the matter, but in chapter four he writes that art must have begun with improvisations, with simple experiences on the part of very gifted men who knew nothing of art.

Thus one can see that the production of imitation artworks is considered from the beginning as being split between the indiscriminate spontaneity of experience on the one hand, and

theoretical knowledge on the other. Within art, at the core of the invention of works, there is a gulf between empirical activity and theoretical knowledge. Already, there are the roots of a possible conflict between the two, between the 'practitioner' and the theoretician. This gulf affects the very origin of art, which is dual from the start: for if Homer can be considered as the inventor of poetry, one of the first geniuses to compose naturally, Aristotle himself as the first theoretician was the inventor of art as an object of knowledge. It was he who introduced theoretical knowledge into the very definition of art and made the artist a theoretician.

The theoretical part of art is, then, the knowledge of the principles and the rules of representation (*mimesis*). It is what gives art its status. This is why the theory of painting is indissociable from a knowledge of painting, from the possibility of judging and teaching it. At the same time, if one can 'do' without art (that is to say without theory, without knowledge), the opposite is never true in classical thinking: a work of art only exists where theory is insufficient. For Aristotle, theoretical knowledge, which is the subject of his *Poetics* and which will always be the fundamental reference of classical theories, is not a *sine qua non* condition of creation or invention, since natural genius can suffice. And it is always conditioned by the singularity of the works on which the principles are based. In this sense, theory is still the second instant in art.

In architecture, until the 18th century, the singularity of the work is prevalent: one moves from building to building with theory as a bridge: a movement from the singular to the singular, punctuated by generalities. During the classical period, it seems that this complementarity between knowledge and 'art' did not pose a problem. The theory of painting was not separable from the art of painting: indeed, for the classics, one had to know the essence of an art to be able to practice it properly. One had to know its end and its means. The debate between drawing and colour was

exemplary in this respect. The theoretical question was: colour or drawing, which is the essential 'part' of painting? Such classical artists as Champaigne or Le Brun favoured drawing, which helps us understand the true shape of things, while colour pleases the senses. 'The privilege of colour is to satisfy the eyes, while drawing satisfies the mind', claimed Le Brun in 1672. But moderns such as Gabriel Blanchard, or Roger de Piles, prefered colour precisely because it is more pleasant and charming. Colour 'charms everyone', says Blanchard. (Note the opposition between an appreciation of the intellect, openly elitist, and an appreciation of the senses, based on the tastes of a wider public).

At stake in this theoretical conflict is the truth of painting, the truth that painting is capable of. It is a question of knowledge: what, in painting is the essential of imitation? For the supporters of drawing, the exactness, the preciseness of forms gives truth to imitation. For the supporters of colour, the truth of painting is more in its charm: it is the effect of colour on the beholder which gives painting its beauty, its ultimate perfection. After Roger de Piles, the ancient concept according to which drawing *imitates* and colour *ornates*, like an accessory, was reversed. Little by little, it became accepted that painting imitates colour through the use of colouring that restores its harmony. The effect of this coloured composition played an essential role in painting, from Delacroix up to the 20th century.

In so far as theory reveals the essence of painting, bringing out what is to be seen, it is always necessary to the act of teaching. Theory has always learnt its lesson from what it talks about. It is not by chance that theoretical debate took place within the setting of the Academy. And later on, the most theoretically minded painters were always the ones who also wanted to teach painting and to 'lead a school'. Other artists turned away from both teaching and theory (haphazardly: Cezanne, Matisse, Giacometti and Francis Bacon . . .). But I doubt that one can totally do without

theory: it is perhaps always in excess, it will perhaps always exist as a supplement to the practice or experience of art, but it may be a necessary excess. It is the very excess of thought. (*Elle est l'excès même de la pensée.*)

The status of theory, like that of institutions, is like a frame: that is to say, something on the edge of a work which, without being exactly part of it, indicates its place. Just as the frame defines the space of representation, theory defines painting by recommending that we look at the part of painting that will enable us to appreciate its truth or intrinsic value. The question of knowing whether theory belongs to art or not is thus part of the same logic as asking whether a frame is inside or outside a work. It is the paradoxical logic of the supplement: a supplement is indeed added to the thing, but at the same time, the thing would not be what it is without its supplement. In this sense, theory provides a place for art, situates it, makes it appear as it is: it enables it to begin at the same time as it completes it. In this perspective, painting cannot be dissociated from its theoretical framework, but the latter is still on the edge of painting, as if on its border.

A true excess of theory

One must, however, distinguish between theory of painting and theory in painting. As a framework of painting, theory is a supplementary vision: it defines and judges it. On the other hand, the status of theory in painting is quite different: I mean by this the theoretical knowledge that conditions and anticipates the pictorial act itself. For example, I am thinking of 'conceptualising theories of art', in Panofsky's words, because they place the theoretical viewpoint, intrinsic to the intellect, as the very principle of painting or drawing. This is the case of Vasari's ideas about drawing. Speaking of the last purely graphical phase of drawing, he wrote that *disegno* 'is the apparent expression and the

assertation of the *concept* that one has in the mind.'[3]

The authority of the intellectual viewpoint is even more radical in the case of Mannerism, with the extraordinary division of drawing into two phases: the 'internal drawing' or the idea, and its execution or 'external drawing'. This split well illustrates the division between the theoretical and the empirical in reflections on art and, in general, on the subordination of empirical work to theoretical ideas.

The most ardent supporters of theory in painting, including the moderns, keep referring to the authority of the intellect. Subordinating the practice (or the reception) of art to theory is no longer part of what I call a necessary theoretical excess but, in my opinion, part of a true excess of theory or, if you prefer, an abuse of theory. And, of course, the empiricists fight against the authority of the intellect. The conflict between the theoretical and the empirical is always one of the eye, and it takes place between the sensitive vision of the body's eyes and the intellectual vision of what Plato called the eyes of the soul. In the history of painting, metaphysical theories, those that place representation under the authority of the intellect (of the idea, the concept, the mind, etc.) are largely dominant.

A large part of modern art again involves a great metaphysical wave, whether one thinks of Duchamp who wanted to move away from the 'physicality' of painting in order to examine ideas and to put painting 'at the service of the mind', or to cubism which wanted to paint what we know about things and not what we see (Kahnweiler), or to surrealism, and, of course, to the theoreticians of abstraction. Up until then, the representation of the understandable had always made use of the representation of sensitive things, whether they were chosen for their symbolic or allegoric values. The things of the world were not necessarily the subject of painting (they were more often religious, mythological, literary or even conceptual) but they

were always the means (remember the pattern of 'the borrowing of forms from nature' in Kant or Hegel). But by rejecting any form of imitation, the moderns believed in the possibility of an absolutely 'non referential', autonomous art, and they wanted to be pure creators of forms.

This break in painting with the experience of the outside world, led, as one could expect, to the notion that forms or colours could directly represent interiority, without any allusion to empirical reality. Thus, according to Kandinsky, colour would exercise a direct influence on the soul and express, no less directly, the internal life of the mind. For some artists, relinquishing the experience of the world – and the open struggle against any form of 'materialism' – put painting in a spiritualistic, even a mystical mode (Kandinsky, Mondrian or Malevitch). Once it was rid of the futility of worldly things, painting gave itself more ambitious spiritual missions, providing sometimes immaterial or spiritually internal figures (Mondrian or Kandinsky) or, with Malevitch's black square, a manifestation of what does not appear: that is, *being*, the absolute non-figurative. The white square is 'the revelation of abyssal being and the triumph of painting', (*c'est à dire l'être, le non-figuratif absolu. Le carré blanc est 'la manifestation de l'être abyssal et le triomphe de la peinture'*), as Marcadé wrote.[4]

The problem is that these works invent a wholly conventional link between their meaning and their appearance: when one looks at a geometrical painting of Mondrian or Stella, or a work of Ryman, one cannot know what one should see in it: a meaning transcending form, a simple object, or the 'demonstration of a way of doing' (as Naomi Spector said about Ryman). Only each particular theory enables us, not necessarily to appreciate the work, but to understand its status. Theory is no longer either a frame or a resource for representation, it is the very condition of each work which it legitimizes as a work of art. The creation of a work can no longer be dissociated from an adequate theory which is then the

only means of access to the work. The ancient theories of art could give several meanings to images, but they were all part of a general framework, of a common representation and experience of representation. *Mimesis was the framework of paintings.*

Having abandoned this framework, a work can no longer be accepted if the theory does not give it its status and through this enable it to exist. Thence the relationship between the theories and the places where art is exhibited: without an adequate theoretical support for each kind of work, people would no longer know what to exhibit. The consequence of autonomy is the disappearance of art behind theories, as its only access to the work. At the same time, the proliferation of theories signifies the lack of a new theoretical frame.

A different, parallel story of painting has developed since Cézanne and Matisse, a history that continues within the tradition of representation, and which remains linked to the visible world. Why do such painters mistrust theory?

The theoretician never stops at what is visible. In this, he is perhaps closer to the common onlooker than one thinks. 'Most people see through their intellect more often than through their eyes' remarked Paul Valéry, 'instead of seeing coloured spaces, they become acquainted with the concepts.' It is too little repeated: most people are theoreticians. But the painters who wished to forget theory and philosophy (Bacon, of course, but also Cezanne, Matisse and Giacometti) did not think that they could or should go beyond the sensitive vision: on the contrary, it seemed to them that they never could get to see enough, that they did not know how to look or see. Drawing or painting was for them a means to see, a means to feel. The experience of these artists remains linked to a certain kind of representation, that is to say, to the desire to represent an opaque or blind experience. It is not an idea that is represented. Matisse and Giacometti, for example, both rejected

the notion that a work of art could be born of an idea: one starts from an emotion, an impression, or even an obsession, as in the case of Bacon, but never from an idea, never from a theoretical vision.

The painter never knows how to represent the thing or the emotion: that is why he searches for forms or colours. He searches without knowing. In other words, through his work, he is undergoing a figurative experience. With Matisse, the exclusion of theory goes hand in hand with that of teaching. The only thing a painter can say, even though he should really 'cut off his tongue', is that painting is an adventure, a risky experience, and that 'each person must try his luck' without knowing in advance where he is going. Theory, on the other hand, claims to submit the work to a prior conception. But the distinction between prior conception and the accomplishment of a work was akin, for Matisse and Giacometti, to a form of industrial production.

And even when one forgets theory to throw oneself into the pictorial adventure, this does not mean that it can be theorized after the fact. For, as Matisse often said, the risky experience teaches us nothing: it remains obscure. It is not possible to escape the mysterious alchemy of work, even when it bears its fruit. Matisse sometimes reproaches theory for being too general and not enough about the works (he is rejecting superficial talk on painting); but sometimes he reproaches theory for being too particular, for only applying to specific cases, like the reflections of Delacroix (which look like custom-made clothes). Thus theory is always guilty of some excess (too general or too particular). And above all, it believes it can replace actual work by a form of knowledge.

Here, one should analyse how Matisse differentiates the status of work: on the one hand, passionate study and analytical work according to nature, and on the other, risky improvisations, a synthetic work. But the manner of drawing or painting excludes

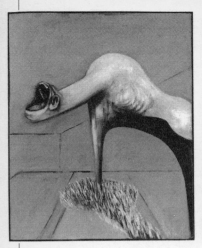 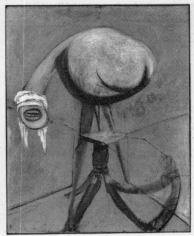

any prior idea of the results, and it is in this sense that Matisse can say 'I work without a theory.' For Matisse, there is no time for theory, precisely because theory claims to embrace the whole of an experience, one which always demands time. The experience (what the painter describes as work) is art itself, and the painter cannot be dispensed with. The impossibility of doing without work is the impossibility of doing without the time for art. As an intellectual vision, theory wants to shorten the time for art, to summarize it in a prior vision. But this is impossible. That is why, if Matisse sometimes talks of his painting, it is not in a theoretical way but in the form of a simple narrative of how he works.

Bacon rejected theory in an equally radical way. Art remains distinct from theoretical thinking, that is too say from conceptual forms. It does not deliver itself up as a thought – neither to those who do it, nor to those who receive it – but as a sensation, an impression, an emotion. It acts on our sensitivity, not on our intellect. No doubt a classical distinction, except that once the theoretician has accepted it, he immediately wants to get beyond the sensitive to the intelligible, to let go of the senses in order to

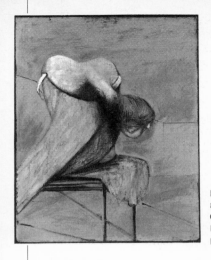

Francis Bacon, *Three Studies for Figures at the Base of a Crucifixion*, c1944, copyright © Estate of Francis Bacon / ARS, NY and DACS, London 2000. Reproduced with the permission of Tate Gallery, London 2000

make sense. The empiricist, on the contrary, wants to develop all the possibilities of sensation. He does not just want to restitute what he thought but, as Bacon said, to open himself up to the deepest things one can feel, to oblige one's sensitivity to open up.

Bacon's painting attempts to exacerbate the sensations. These patterns, like Bacon's paintings themselves, mean that painting in this case is not an autonomous creation: the desire to paint is always in a state of tension with the heart-rending experiences of life. And they, in turn, become obsessions which call for represent-ation. This is why Bacon, somewhat provocatively, claimed he worked in the field of reporting, as opposed to that of abstraction. But reporting is never illustrating: because illustrating means starting from a certain form of knowledge, from something whose form has already been given, either as an idea, or as a prior image.

The great difference between this practice of painting and classic representation is that it finds its models neither in intelligible things (ideas), nor in sensitive things, since the world of appearances is in itself mysterious. More precisely, if one does not

know how to represent, how to give the appearance of something, this means that one does not know what an appearance is. One is unaware of what, in appearances, moves us and impresses us. This is why one does not know how to give it. Which leads to a problem with several unknowns: 'How can one do this so that the mystery of the appearance is captured by the mystery of its making?'[5] The entire role of experimentation is there, in the mystery of its making. If there is no theory of representation that can lead to a method, one simply has *to try*. You must find 'your own technique' says Bacon. How? 'By trying to do it'. In praise of trying, like Matisse. The valorization of trying – the tried and tested – is the hallmark of empiricism?

It is not that the painter does not anticipate anything, it is not that he has no project, no idea. Of course not. He sees something in his mind – but, having tried a way of doing things, having tried a technique which leaves a great part to chance, to accident, his prior vision is *transformed by painting*. It is transformed 'by the very fact that there is painting', says Bacon. So that, in this case, far from being submitted to what it represents, far from reproducing the visible or even making something visible, painting is more a technique for transforming the visible: transforming appearances, transforming accepted images that have already been seen and are known (or even already painted, like the Velasquez painting), transforming mental images, that is to say our most familiar and most used representations – transforming *clichés*. Empirical research, always a little indiscriminate, could thus stand for the instant when theory really ends and when art *as an experience* begins.

Thus experience would transform theory. And because of this reversal, the empirical part of art always exceeds its theoretical counterpart. But isn't it also the case that Bacon's notion of his painting as a 'stenography of sensations', his indications on how not to look at his painting (as an illustration, for example) or how

to look at it (as a figure of obsession), are in fact part of a theoretical excess? Do we not have here a discursive 'supplement' framing the representation, and therefore enabling it to be seen?

This is no doubt the case, for if painting, as all representation, shows something, it never shows it in an obvious way: it can only show something if it is accompanied by a gesture, such as a finger pointing towards something to be seen. Painting also uses this gesture, as when a figure in a picture makes a sign to indicate the scene to be looked at, or there is an internal commentary on the image spelling out what must be 'read' or seen. *Theory as a discourse on what is to be seen in painting must not be a way of transcending the work to its meaning. It is a discourse which, exceeding art as a work (travail et oeuvre; labour and opus) contributes to its appearance or attests, a posteriori, that art has happened. It is then, perhaps, a kind of endless Bewährung...*

Notes

1. Hegel's *Lectures on Aesthetics*, trans T.M. Knox, Clarendon Press, Oxford, 1975. Introduction, chapter III, 'The Artist'.

2. Aristotle, *Poetics*, chapter 8.

3. Girogio Vasari, *Les vies des meilleurs peintres, sculpteurs et architectes*. Berger-Levrault, 1989, pp. 149–150.

4. Préface à *De Cézanne au suprématisme*, K. Malévitch, L'âge d'homme, 1993, p. 18.

5. Francis Bacon, *L'art de l'impossible*, Entretiens avec David Sylvester, Albert Skira, 1995, p. 206.

The horror of nonidentity

Cindy Sherman's tragic modernism

Jay Bernstein

At the age of twelve, at the moment that I became, as it were, an only child, my parents placed in my bedroom – as permanent babysitter, constant companion, surrogate sibling – a primitive television: a small, twelve inch screen ensconced in an overly large mock walnut surround, with a spiky, protruding two-eared aerial atop. Every Saturday night, whilst my parents floated off into the world of dinner parties, I would at eleven o'clock transgress the parental law of bedtime, flicking off all the lights and turning on the image machine, volume down, to watch horror movies: *Frankenstein*, *Dracula*, *The Mummy*, and all the 'sons of' and 'returns of'. I could not avert my eyes as the suspense built and built, and from the darkness of the room and the backlit brightness of the screen, monsters would appear. Although there was anticipation and even addiction here, the dominant emotion of this scenario was disappointment; the stiff-legged walk of Boris Karloff, the lugubrious intoning of Bela Lugosi were not frightening but faintly comic, something acknowledged by the programming with a faux Lugosi presenter, test tubes, cardboard basement setting with large plastic spiders. Desire and disappointment were the unbreakable rhythm of those transgressive nights.

A year later, during breaks in the school calendar, I would be taken to New York City to visit grandparents, and receive culture

training; wearing my navy blue blazer and red tie, there was always a forced frog-march around some museum or other. On one such march my routine boredom, indifference and resentment flowered into disappointment; it was Picassos – lots of them – which taught me that the anticipation of perception, the desire to see, could be enticed and thwarted by art as emphatically as by horror movies. Yet that disappointment was not permanent, for on an occasion as resented as all the others I suddenly, as if in a moment of waking, came upon a large canvas energetically strewn with lines and blobs of paint which magically seemed to lift off their dark background; and then, even more unsettling and uncanny, canvases made up of large rectangles of contrasting colours that hovered with an anxious floating motion above the picture surface. A painting by Jackson Pollock, a painting by Mark Rothko: these were the first objects I recall ever having *seen*.

Although seldom confessed, the rhythm of desire and disappointment punctuated by rare events that I want to call simply *seeing* dominate our sojourns into museums, galleries, places that promise visual engagement. Disappointment is always the dominant. None the less, the hermeneutical grid of my first encounters with the image, composed of a desire to see, horror movies, disappointment, and the satisfactions of abstract art, adumbrate the truth of Cindy Sherman's artistic achievement.

In what is one of the best essays on Sherman's art, Norman Bryson sets up his excavation by asking a series of pertinent questions: 'What is the nature of the transition, in the postmodern image universe, that seems to go in one move from everything-is-representation to the body-as-horror? From the proposition that what is real is the simulacrum to the collapse of the simulacrum in a Sadeian meltdown? From *Untitled Film Stills* to Cindy Sherman's present take on the body as house of horrors and house of wax?'[1] While pertinent, these questions operate with two assumptions that need to be contested. First, what makes Bryson so sure that we

are here witnessing a transition rather than a continuation, a probing of the same space from different angles? Bryson is doing no more at this juncture than echoing the standard critical line on Sherman, which on the face of it seems obvious, above all to the eye. Who could doubt the *Untitled Film Stills* and those of, what? – dirt, vomit, excrement, waste, formless matter? – were different, the latter coming from a space quite other to the space enclosing the first? Part of what controls Bryson's presumption that there is a transition and reversal here is that he believes that the transition occurs in 'the postmodern image universe.' But what if there never was, really, a postmodern image universe? What if the idea of such a universe insulates contemporary art from the deep structures of the culture of which it is a part, and thereby deforms the consistent and overarching problematic which Sherman's art engages? What if the claim of a 'transition' is a way of defusing the awkwardness of the *Film Stills* and, conversely, falsely dramatizes, makes histrionic, the horror, *informe*, and sex pictures?

Within contemporary art, Cindy Sherman's works are the most emphatically cognitive of which I am aware. Her late works all transpose us into another scene of knowing, another scene of both what *needs* knowing or acknowledging, and what is involved in such knowing. What needs knowing is something about our embodiment, our rootedness in the natural world, and what has happened to nature – inner nature, but also in a sense outer – as a consequence of the systematic and for her above all cultural ways in which their suppression has taken place. The implicit history of that suppression is recorded in her early works, from the *Untitled Film Stills* through the fashion pictures and 'pink robe' series.[2] In her late works various genres – fantasy, horror, pornography – are employed as mechanisms of *abstraction*, appropriate to photography, that release such embodiment for judgment. The consequence of the abstraction and reformation of the material is to reveal what might be called the *syntactic* quality of its objects –

their being *forms* of meaning beyond, and necessary conditions of, representational meaning.[3] If this latter claim is correct, then she is a modernist.

Even before looking at Sherman's works, there is the question of the appropriate frame of reference. By shifting the frame of reference in which we look at Sherman's photographs, the hope of this essay is that we might be able to *see* them.[4]

1. Abstraction and the extirpation of animism

In *Dialectic of Enlightenment* Adorno and Horkheimer provide their now all too familiar account of the emergence and structure of modernity as a closed and reified totality that is a consequence of a processive demythologization and disenchantment of the world that is a result of the domination of enlightened, instrumental rationality as the explicit logic of reflective thought and the implicit operator structuring societal rationalisation. However, coiled within this account, and controlling it, is a metaphorics and/or conceptualisation that is too little commented upon or taken up. 'The disenchantment of the world', they claim, 'is the extirpation of animism.'[5] Picking up this thought a little later in the first 'Excursus', they elaborate: 'The *ratio* which supplants mimesis is not simply its counterpart. It is itself mimesis: mimesis unto death. The subjective spirit which abolishes animation [*Beseelung*] from nature can master this inanimate [*entseelte*] nature only by imitating its rigidity and abolishing its own animism in turn.'[6] The language of reification, alienation, rationalization, ideology and domination suppresses the extent to which *Dialectic of Enlightenment* is organised around the distinction living/non-living, living/dead.

By abstracting from sensuous particularity, enlightened conceptualization brackets the most salient feature of the perceptual object: that the very thing before our eyes is a living

being. In treating every object as in principle subject to mean-ends ratiocination and hence as indefinitely manipulable, instrumental reason extirpates life from the world, or, perhaps, first brackets and then excludes the cognitive experience of our perceiving living beings like ourselves; or, perhaps, finally, as our experience of the living becomes more ambiguous, what counts as experiencing the living is delegitimated.

Mimetic cognition was originally that form of cognitive experience that took up the 'multitudinous *affinities* between existences.' Life knowing life. This is 'suppressed by the single relation between the subject who bestows meaning and the meaningless object, between rational significance and the chance vehicle of significance.'[7] The 'affinity' of subjects and objects functions as almost a dummy term, a surrogate concept that stands for all the vital similarities of subjects and objects that are passed over when likeness becomes mirroring or correspondence. But there cannot be cognition without mimesis, perception without affection. The rational subject in deploying the abstract conceptuality of enlightened reason is mimetically adopting himself to the world already disenchanted into dead matter. He (she?) is imitating, introjecting, death.

To his credit, Bryson recognizes and underlines the disappearance of the body as a fundamental process within the modern world without, however, perceiving that this is what modernity *is*, or connecting it systematically to societal rationalization. Or better, Bryson records the disappearance of the body without, quite, connecting it to the fundamental process of the extirpation of animism (although he implies their connection by, in a gesture wholly characteristic of Critical Theory, counterpointing the eclipse of the body with the resistance of pain as a non-fungible and hence non-rationally conceptualizable matter).[8] Here is his mini-history.

> From the eighteenth century on, practices in which the body
> possessed any kind of insistence are designated barbarous and
> hidden from view: . . . animals are not to be killed in courtyards
> by local butchers but in abattoirs on the outskirts of the city
> where no one goes; the display of meat as something frankly
> carved up from an actual beast . . . with a head, with internal
> organs, with a recognizable cadaverous form, is rethought so that
> meat can cease to appear as recently living flesh and becomes
> instead a hygienic, quasi-industrial product obtained who knows
> where or how; . . . the dying, no longer spend their last days and
> hours at home with their families and friends, their death
> continuous with the rest of their life and their surroundings, but
> instead are sequestered behind white walls and hospital screens.[9]

What is odd is that in so perspicuously seeing modernity as, at
least from the eighteenth century, extirpating animism from itself
and transforming the experience of life into a series of abstract,
hygienic signifiers, Bryson should think of this linguistified space
as synonymous with the postmodern image universe. Or perhaps
there is an intended irony in his account, for if modernity is the
processive extirpation of animism, and that extirpation is realized
in a linguistic idealism which accords all meaning to language
operating on dead matter – matter so dead it disappears behind the
endless movement of reason and signification – then
postmodernism is nothing other than the ideology of a modernity
oblivious to itself. Bryson's mistake, if mistake it is, is easy to
comprehend: the postmodern critique of modernity is primarily a
critique of high, enlightened rationalism (variously identified as
foundationalism, presence, teleology, progress, grand narratives) in
the name of the complex, local, relative and contextual. And there
is certainly a difference worth noting between these two. However,
that difference slides into insignificance before what they share:
the belief that reason and/or language is self-sufficient, wholly
independent from and wildly underdetermined by – to the point of
irrelevance – its object. It is the movement toward the self-
sufficiency of reason and/or language that, according to Adorno

and Horkheimer, is the fundamental gesture of enlightenment; the self-preserving drive to self-sufficiency and independence opposes subject to object, culture to nature, enabling thereby the equally sceptical formations of reductive scientism *and* relativistic culturalism. Postmodernism and enlightened rationalism, Vico (/ Joyce) and Descartes, converge in refusing affinity and dependence. Enlightened rationalism was always but one-half of cultural modernity: every rationalistic terror has had its critical and equally modern Burke. For every claim of a new rationalized beginning, there has been a consciousness of historical belatedness, of history without a meaning beyond its own groundless movements. Postmodernism has thus always been an – if not the – ideology of modernity and modernism has always come after postmodernism, is nothing but the critique of postmodernism.

Animistic and mimetic thought cognized its object as fully other. Following Hubert and Mauss, Horkheimer and Adorno contend that *mana*, 'the moving spirit', is not to be regarded as a subjective projection of the human onto the inhuman, but rather as an acknowledgement of the real supremacy of living nature over men. Hence, 'when the tree is no longer approached merely as tree, but as evidence for an Other, as the location of *mana*, language expresses the contradiction that something is itself and at one and the same time something other than itself, identical and not identical.'[10] For Horkheimer and Adorno, it is the primitive notion of *mana* that forms the remote origin and semantic core of auratic art: 'In the work of art that duplication still occurs by which the thing appeared as spiritual, as the expression of *mana*. This constitutes its aura.'[11] It is not the presumptive genealogy of aura from *mana* that is significant, as much as what that genealogy expresses about their conception of auratic art. In a manner Adorno never deviates from, auratic art is always a spiritualized, which is to say, animate other; hence aesthetic semblance is always

the semblance of life, an illusory infusion of life into dead matter. The uncanniness of aesthetic perception is thus not only the experience of meaning in what otherwise lacks meaning – brute sounds, paint on canvas; for something to be meaningful is equally for it to be the bearer of life. Artistic materialism, in theory and practice, is, has become, and can be retrospectively seen as a form of animism. The production of auratic works is the production of a semblance of a living thing.

In the rationalization of language its two components were separated out: the rationalized concept became the sign, and the mimetic remnant became image. The image is the refuge of mimetic cognition, the cognition of life. Of course sign and image are never quite separated from one another, especially in ordinary language; however they are rationalized into the distinct spheres of practice of science and art respectively, and the process of societal rationalization is the process by means of which it becomes a function of the pure sign. In so far as the relationship of signifier to signified composes the centre of the postmodern analysis of the sign, then what is thereby analysed is what Horkheimer and Adorno conceive of as the pure sign. It is thus unsurprising that the movement whereby the world is conceived of as an endless signifying chain should so perfectly replicate rationalism's extirpation of animism. It is the same extirpation.

Artistic modernism's claim was always that the inanimate was animate, the purely material meaningful in itself. This is why abstract expression appears to be the last moment in the process of modernist claiming: it belongs to that moment when the symbolic order has been thrown into doubt because it is increasingly both meaningless in itself (call it nihilism) and a betrayal of the perceptual world (symbolic codings of sensuous experience appearing merely conventional). Eschewing all elements that could be thought to belong to the domain of the pure sign,

through the mere arrangement of dead matter, paint on canvas, abstract expressionism sought to invoke a claim to meaning.[12] High modernism is indeed opposed to the postmodern image world, opposing auratic individuality to the play of the sign. The play of the sign is the play of form; auratic art always seeks to break through form in a moment of dissonance. 'Dissonance,' Adorno states, 'is effectively expression . . . If expression is scarcely to be conceived except as the expression of suffering . . . expression is the element immanent to art through which, as one of its constituents, art defends itself against immanence that it develops by its law of form. Artistic expression comports itself mimetically, just as the expression of living creatures is that of pain.'[13] The notions of suffering and pain that Adorno notes here are stand-ins for the whole range of the psychical articulations of injury and hurt: '. . . sadness, energy, or longing. Expression is the suffering countenance of artworks.'[14] The aura of a Pollock is nothing but the energy of the paint; the aura of a Rothko the countenance of sombre depression. Our eye in responding to drips, blobs, webs of lines of paint, fields of colour sees energy beyond any code or symbol, depression beyond any linguistic articulation of it; *these works visually mean the way a body in pain means*. That is their aura. What made these paintings unusual was the sheer proximity within them of formlessness and form, as if each element could be either a syntactical moment of ordering or a dissonant moment of breakthrough. But this is a liminal moment since the auratic quality of the modernist work soon became neutralized, becoming not uncanny or terrifying but beautiful, decorative, desirable and appropriable by all; worse, it began to signify art as opposed to life, to be seen as just the pure commodity fetish it always in part was. This moment of the withering of the claim of high modernism created a vacuum. Many art practices attempted to fill that vacuum – through either emulation (Stella, Twombley, et. al) or rejection (minimalism, conceptual art, installation art, happening art). Cindy Sherman's

photographs are the fullest, most consistent and sustained response to this situation yet devised.

2. *Untitled film stills*: The anxiety of narcissism

Sherman states that she stopped making the *Untitled Film Stills* when she ran out of clichés. The pathos and energy of this claim will become apparent. Clichés here are schemata of the self; not simply trite ideas about the self, easy or ready-to-hand representations or ideas of selfhood, but commandments about who the self must be.

> When a film presents us with a strikingly beautiful young woman it may officially approve or disapprove of her, she may be glorified as a successful heroine or punished as a vamp. Yet as a written character she announces something quite different from the psychological banners draped around her grinning mouth, namely the injunction to be like her. The new context into which these pre-prepared images enter as so many letters is always that of command. The viewer is required constantly to translate the images back into writing. The exercise in obedience inheres in the fact of translation itself as soon as it takes place automatically.[15]

The command structure of the film cliché is the mechanism through which individuals are subjected to the schemata on offer. This, however, makes problematic the object of the *Film Stills* series. It is tempting, both because of the title of the untitled series and because so many of the photographs appear to explicitly refer to either particular film styles (*film noir*, Hitchcock) or actresses (Marilyn Monroe, Lana Turner, Gina Lollabrigida), to think that the series is about the 'fabrication of dreams', a poking fun at Hollywood's constant work of mythologizing character types or individual stars – which is done in the series and does represent its ground level accessibility and charm – rather than being about culture industry clichés. While many of the clichés quoted in the *Film Stills* series do refer to easily identifiable

moments of film, others simply belong to the more anonymous clichés that belong to the same period, clichés that may or may not belong to identifiable films – although perhaps they should have. I certainly dated the characters in #10 and #61, #9 is a friend of my sister's, and #15, the high school tramp, well, everybody knew her (or pretended they had). These, and others like them, have the hallucinatory familiarity of film stills, but their banality points to a wider domain of cultural production, to an even more anonymous and invisible schematizing operation. That even these more banal photographs can summon the kind of familiarity and identification that belongs to 'film stills' themselves, underlines the stakes of the series: the power of the cliché.

Many, if not most, of the *Film Stills* catch a character in mid-action, so that we imaginatively project onto the scene a narrative structure – the very narrative, so to speak – from which the still has been culled. For example, in #40, an innocent is perched on a crumbling wall expectantly, if not a little too self-consciously. She is lower middle class and with an effort is dressed to look proper and decent. She is sitting outside her own family's apartment block and is waiting to be picked up by her date, who we imagine, although from the same class as she, is less constrained by lower middle class proprieties. The narrative speaks to the fragility of her self-identity, the crossings of desire, fear, expectation, anxiety, and, above all, vulnerability.[16] But, of course, there is no narrative here, no story; everything is already decided. The narrative, the film we mentally screen, is a 'still', stilled and frozen; hence the unfolding temporality which is meant to be the prerogative of the film over the photograph is a deceit. The truth of filmic temporality is the still. And that reduction is meant to be telling against both film and photography. In being captured by a cliché, a still, each character portrayed is enacting a mimesis unto death; they are the vehicle and the victim of the cliché they exemplify. Yet, each still is more than this, more than the cliché it quotes; the

Jay Bernstein

Cindy Sherman, *Untitled Film Still*, #40, 1979. Reproduced courtesy of the artist and Metro Pictures, New York.

more is the aura each still emanates. That aura is complex, at least double: the empty aura of the cliché itself, which is co-extensive with its power as cliché, and then the aura of Sherman's picture. Inauthentic and authentic aura are interwoven in uncomfortable, because not easily discriminable, ways.

The way in which each quoted cliché is both an object of desire and a command is the original cliché aura (an aura that is uncannily quoted by Sherman). Routinely, Sherman subjects the auratic quality of the original cliché to ironic treatment by placing a halo – with a hat, lighting fixture, or simply through the lighting of the top of the head – around the head of the character (#13, #21, #22, #47, #50, #53). Unless each quoted cliché possessed its own aura it would not have the power to make its ready identification simultaneously an act of recruitment. Our identification of each cliché, our ability to name it and identify it

'as' this or that stereotype, is the mechanism by which it slips into our consciousness, generating our identification 'with' the character. We see through the cliché, seeing it as a cliché, and none the less 'obey'. Adorno contends that this movement whereby we both see through (translating the image/hieroglyphic back into writing) and obey (identify 'with') is the fundamental mechanism of the culture industry: the time, appropriation and effort of translating the image is the means through which under the guise of letting itself be objectified under a concept (letting itself be conceptually mastered), it secretes itself into consciousness.[17] The culture industry effect thus operates in a manner that circumvents our insightful guarding against it; rather than our identifying and seeing through being something that destroys the illusion and credibility of the image ('how very Hitchcockian'), that work of mastery is the means through which we are in turn mastered.

Sherman too insists upon the auratic quality of the quoted cliché, that even before she has quoted them and worked upon them they are identifiable as clichés, and their being so identifiable, is a part of their allure rather than anything that undermines it. One way of underlining this point would be to notice how in some of the darker *Film Stills* the obvious artifice of quotation – framing, pose, angle of vision, etc – is dropped, and we are tempted, almost, to forget that these are quotations, and thus are almost, not quite, exposed to the cliché itself. Compare the artificiality of, say, #13 with the directness of #27; quote, unquote, but both clichés.

The Untitled Film Stills *are a mimesis of the mimesis unto death of the quoted cliché*. The second mimesis is the distancing work of Sherman's art. In all of Sherman's work there is an abiding interrogation and critique of photography. Each picture to a greater or lesser extent flags and calls attention to what I shall call 'the set-up'. Every element of every picture is carefully and explicitly placed in a way that makes our not becoming aware of their being so placed, finally, impossible. The pose, the frame, the

lighting, camera angle, cropping, foreshortening, background, whatever, are all presented and presented as artifice. There are no natural objects nor disinterested observings of given scenes. Both sides of the dialectic of the photograph, its disinterest and interest, are bracketed, made into second order constructs detached from the camera's mechanized and automatic judgement. By so explicitly producing the scene to be photographed, and so explicitly deploying and displaying the options which she as photographer has under her control, Sherman undermines the natural authority of the photographic image. Neither the causal indexing of the image nor the beautifying effect of the camera's disinterested, aestheticising gaze are permitted to operate, though both are quoted.

If Sherman's set-ups intrude upon and undermine the source of the photographic image's authority, then how can we account for the authority of the *Film Stills*? Her ability to so accurately capture, recapture or convey a cliché, however seductive and intriguing, cannot be the source of authority since, at that level alone, the power of the stills would be no better than, say, a comedian doing an impersonation. Nor, I have suggested, can the fact that she enables us, through flagging the set-up, to see through the illusion be the source of authority, since enabling in that way is a function of the culture industry. In this respect my referring to the *Film Stills* as quotations of clichés has been misleading since quotation tends to imply ironic distancing, an easy movement from being caught in a deception to emancipatory insight. Not only does the strategy of the culture industry of permitting us to see through it, yet anyway obey, turn ironic distancing against the ironic observer, but the engine of the *Film Stills* series, the endless proliferation of cliché, filmed and banal, calls into question the very idea of the privileged bourgeois subject who can oversee and stand apart from the identities on offer. If there had been just one *Film Still*, then its power would be

ambiguous, perhaps not much better than a photographed impersonation, a parlour game. It matters that this is a large series, and every one of its images a cliché of selfhood. The cumulative effect of the series is to throw into radical doubt the conceit of the autonomous – individuated, ironic – subject, and to pinpoint the blame for this disappearance on the culture industry's employment of the technology of image production.

Sherman cannot plausibly be seen as questioning the idea of the autonomous subject, but only its existence. She cannot plausibly be seen as stating or claiming or wanting to claim that the truth of the subject is that it is, in idea and reality, nothing but a tissue of clichés. For all their nostalgic glances at a recent past, all their easy charm, cleverness and knowingness, there is about the *Film Stills* something disconcerting, dark. And it is in the territory of their darkness that their authority as works resides. It is a widely noted feature of the *Film Stills* that the characters portrayed are routinely caught in moments of unguardedness, transition, preparation, exposure, of being somehow inside and outside the very clichés they embody. Even the most assured characters (e.g., #37, #50) are a little too assured, as if needing to attain or appropriate their secure identities. As Laura Mulvey states: 'Sherman accentuates the uneasiness by inscribing vulnerability into both the *mise en scène* of the photographs and the women's poses and expressions.'[18] Can the scope of vulnerability, the anxiety of identities that prohibit individuation and hence do not permit their inhabitants the possibility of attaining a relation of subjectivity *to* the world, be restricted and localized to the characters portrayed? The presumption of this restriction is unequivocal in the literature. For example, Verena Lueken states:

> . . . Cindy Sherman's *Film Stills*, despite the fact that the artist features in all of them, are not self-portraits. She is her own model and, as is the case with all models, this does not make her the subject of her art . . . she does not surrender to the voyeuristic

lust she provokes. She is the object of the beholder's regard but controls it too, because as photographer she directs it. It is thus the beholder, not the artist, who forfeits his status as universal subject . . . As an artist she is in complete command of her means. As her own model she is a host of intensified clichés. And as a person she admits to being just as confused as anybody else.[19]

All of this seems to me exactly wrong.

Part of the unease and fascination of the *Film Stills* is that we are intensely aware that in each and every one besides the character portrayed we are witnessing Cindy Sherman. Hence, what begins as a marvelling at her ability for impersonation and disguise, for the apparent mobility and indeterminacy of her features that permit her to take on so divergent a cast of characters, becomes increasingly a site of anxiety. And here it begins to matter terribly that these are photographs, and that as such there is going to remain the causal indexing of the image to the original – the 'death mask' of the original object, as Susan Sontag has it.[20] The indexing of image to original is what transforms the sense of what being a 'model' means between painting and photography. The camera's disinterested gaze pierces the artifice of the set-up, the elaborate paraphernalia of scene, pose, and construction, and by the very reiteration of images imposes a wholly indeterminate singularity as the anxious object of each picture: this is Cindy Sherman. The 'more' of each photograph, its auratic power and animism, turns precisely on the excess of each beyond artifice and explicit content, which is a consequence of the combination of the camera's mechanic looking and the proliferation of images, each being a part of an indefinitely long series. What is finally the most disturbing fact about the series is that they can be nothing else than self-portraits. The story they tell is, finally, of the unbearable tension between anxious singularity and clichéd identity. The narcissistic self is fascinated by its self, yet has no self with which to be fascinated. Hence, Sherman's proliferation of self-images

achieve their haunting power by exemplifying the desire for self in each of the inadequate forms that deny it.

3. Searching for the limit: Horror, the ugly

In contending that the auratic power of the *Untitled Film Stills* is an animism, and this animism the moment of excess or breakthrough beyond the image, there is implied a pathos that is, finally, incommensurable with the image itself; where this pathos must be regarded as consequence of the causal indexing of the image to, let's call it, the 'fact' of Sherman herself. Her interiority is distinguishable from the interiority of the characters portrayed as the effect of her reiterated appearance with each portrayal, and hence, because bound to the excess within the repetitions, can appear only as effect and not as image. Put otherwise: who she *is* is finally removed from the space of embodiment and hence image, and thereby relegated to the pathos of existential singularity – beyond place, space, and life; the empty aura of subjectivity displacing the animate self.[21] The pathos of singularity is the photographic equivalent or recapitulation of the first defiant moments of the exhibition of paint-on-canvas of early modernism – in Manet or Van Gogh, for instance. The analogy is more exact than it appears once the time lag between the two moments, with all its restricting consequences, is taken into account. In both cases, the stakes are the authenticity of works themselves rather than, or in opposition to, the illusion of the represented object. Unless the representing could bear the weight of being an object of unconditioned attention, then neither could what was represented. Van Gogh's displaying of paint-on-canvas does not substitute the painting for the represented object, but sets up an inner affinity between the arrangement of matter as the condition of representing and the material object represented in order that the worth or dignity or authenticity of each is revealed.

Sherman's sphere of operation is far more severely restricted because illusion, semblance, is no longer contrastive between art and reality; it has become pervasive.[22] This is part of the reason why the display of the set-up is not sufficient to engender a moment of materiality. The artifice of the set-up, to be sure, signals the fiction-making or creating of what is portrayed, against photographic realism; but because empty artifice, mere convention, semblance, is pervasive, simple display cannot provide escape from it. Only Sherman's self-same presence, by its repeated insistence, reveals itself as more than the collocation of codes inscribing it. Each photograph then is a sublimation and expression of the anxious singularity that is the remainder and limit of the culture industry's relentless production of clichés. To run out of clichés to repeat is an intensification of the crisis of subjectivity that is the incipient cause and meaning of the series.

The indeterminacy and ambiguity of Sherman's first forays into colour in the early 1980s are a consequence of the running out of identifiable clichés from her formative past. The lifting of the veil of nostalgia separating past and present is marked by a movement from the comforting black-and-white format of the *Film Stills* into an insistent brightness. The employment of colour functions as a tense operator enveloping the new images. The reason why these photographs are not as uniformly successful as their predecessors is that Sherman is unable to insinuate the complex exchange between cliché and self that was the pivot of the earlier series. Without that complex exchange with the eventual surfacing of herself in each image as its sublime effect, the immediate aura of each of these pictures is often as much the aura of the cliché as its representation. And the reasons are clear: the clichés being worked are not as readily identifiable as in the first series; there are not as many of them – hence the cumulative effect of repeating a repetition cannot get started; and in their (mostly) very presentness, the access to a space of separation between the

model and what is being modelled is radically abbreviated.[23]

While accurate, this is too quick in one respect. Implicitly, Sherman must be aware of these difficulties since these pictures hesitantly begin to search for and dramatize new ways of figuring the limit of cliché, of figuring a significant materiality of meaning that will exceed the image and imply a material or somatic reality that the clichéd image cannot capture. Neither light nor colour (#74), nor contrast between character and back projection (#66), nor the use of close-up (#76), nor dissolving of the image into the background (#69), nor setting off the coloured image of self against a black background (#112, #116), nor the implicit continuity of self and pink robe (#97 – #99), are adequate to this task. These strategies are too painterly, too much akin to finding technical equivalents within photography for modernist painting's forms of acknowledging its material medium. If photography is a medium, and not an art, then photographic authenticity cannot be achieved through immersing the image in the medium's technical means.[24] Nonetheless, the diversity of strategies does make evident that they are strategies, and underlines the consistency of Sherman's desire: to find or uncover a limit to the images of self overwhelming her, which give her only herself as a possible subject (object) of reflection. And while these photographs do figure materiality as that limit, they nowhere consistently insinuate that materiality as animate and dislocated by the insistence of clichéd images perspicuously lacking interiority. Or perhaps more accurately, all the problem of interiority in these pictures is condensed into the eyes: Do they look back? And if so, *who* is looking, cliché or subject?

This suggests something of the kind of achievement the *United Film Stills* is. In the *Film Stills* temporal lag not only permits a certain distancing, but together with the repetitions of the series, it functions as a force of negativity and abstraction. As Sherman evidently came to recognize, in order to generate the negativity

necessary to reanimate the dead image, to locate the limit of the cliché through the image, she would have to get behind the cliché, to image and express what it excluded. She required, literally, the reverse image of the cliché image; but she needed the literal reverse image to be, simultaneously, abstract, not the fact of the reverse image, but its normative and cognitive claim. In order to accomplish this end she had to discover (invent or disclose the possibility of) uniquely photographic means of abstraction, mechanisms more radical than technique and quotation: parody (to reveal the cruelty of the beautiful, its production of ugliness, in the 'fashion' pictures), fantasy (to image our nightmarish dreaming of the monsters we have become), horror, pornography, et al.[25]

For deep historical reasons, and I suspect intuitively for Sherman herself, the abstractive potentialities of horror come to control and dominate this series. What makes sense of what is in effect Sherman's high art appropriations of realist horror,[26] its claim, is the discontinuous philosophy of history that has transformed tragedy into the sublime, and the sublime into modernist horror. What these transformations map are the forms of availability of auratic animism, that is, the decreasing availability of the animistic person for direct representation and the art historical forms in which the claims of animism continue to be made. Reductively, the series operates in accordance with rules of inverse proportion: the more reified individual life becomes, the less narrative can be its organizing frame of reference; the less narrative is the organizing frame of reference, the more abstract, disorganized, and formless the object of 'tragic' representation becomes; the more formless the object of 'tragic' representation becomes, the less boundary there is between culture and nature; the less boundary there is between culture and nature, the more life becomes a mimesis unto death; the more life becomes a mimesis unto death – a direct proportionality now – the more

difficult, painful and horrible, the recognition and experience of animism becomes.

Tragedy, sublimity, and horror are immensely complex art historical genres, whose complexity is well beyond the scope of this essay. In placing them in a series, however, their complexity can be narrowed down to their collective stake as forms of experience. They represent the cultural forms through which the experience of animism, the materially *a priori* relation between culture and nature, has been sustained. This tradition opposes the complacent portrayal of nature as always already harmoniously amenable to being integrated into culture, as represented by the *pleasure* we take in beauty, natural and artistic. The counter-tradition inaugurated by tragic drama highlights the nature that opposes human purposes and yet remains, as a limit, a condition of them. Hence this counter-tradition essayed a movement from pain (the experience of the limit) to pleasure (the acknowledgement of the limit). But within it there was always the case, and the worry of the case, of an absolute or outer limit which could not be acknowledged, could not be integrated. *Disgust.*

In Aristotle what aroused disgust – a good man falling from good fortune to bad without reason – was morally repugnant;[27] in Kant the object of disgust is what resists transformation, idealization, beautifying as such.[28] In the shift from Aristotle to Kant disgust has already lost its status as a fully ethical category and become merely contemplative, a limit of the reach of reason as such, but still of a reason that could be affirmed. Once that affirmation disintegrates, because reason, having become just instrumental, is the source of the downfall of the subject, then disgust slips into the space vacated by ethical and rational fear as the *ugly*; the material remnant that is product and excess of the rationalized gaze, becomes the objective *pathos* that brings us to ethical and rational self-consciousness. This is the ugly that Kant resists, the ugly that insists on us liking it, desiring, wanting it. What is an

ugliness that insists on our enjoying it? Perhaps just this: this is now what is left of me, myself; this is my better self, my alter ego whom I must love and cannot love.[29]

Horror is non-phenomenal ugliness, the illusory appearing of the monstrous sensuous particularity that is the violated and brutalized remnant of the corporeal subject. Horror is an ugliness that connects or modulates the difference between the fearful and the disgusting. It connects with the fearful because it is the site of a disastrous event, a violation of the self that has already been perpetrated. Horror recognizes the violation of the animate body in violence and underlines it. In horror psychic violence and physical violence are violations of embodied subjectivity. Violence and vile transgression, as the successors of sublime natural might, shatter rational form as the inaugural condition permitting the reunification of belief and emotion. Horror connects with disgust because the consequence of that violence is the ruin of the embodied subject. Death in horror is always active, a verb. Corpsed.

Untitled, #153 is dominated by the pale, composed, dead-eyed face of a striking bleached (almost too white) blonde. Her left cheek, neck, and clothed left shoulder are covered in dirt, muddied. Encircling her head, framing it, is green – indeterminately moss, grass, shrub. Her face strikes me as just another film still – a typical murdered beauty – with just the contrast of the face of death and the perfect green of grass, moss, dirt suggesting that something is terribly missing here – all the life is in the framing green, and the death in the human. What thus makes this photograph uncanny is the absence of horror, the absence of the devastating event that has brought about this quiet, still, composed completion. The composed quiet of the scene echoes the camera's cool, beautifying regard (itself a quiet echo of the cold beauty of classical sculpture). To the question that would be the film's title, 'Who Killed the Beautiful Blonde?' we know the

Cindy Sherman, *Untitled Film Still*, #177, 1987. Reproduced courtesy of the artist and Metro Pictures, New York.

answer: the camera did it. Contrast this with *Untitled*, #177 in which an exposed, bare bluish-white buttock with several large boils or pimples directly confront the viewer. Enveloping it too is a narrative; perhaps a realist horror movie, a slasher film. The murder, the rape, the violation, the terror of it about to happen and happening, none of these are there; perhaps because in seeing them we would not see what needs to be seen, or we have seen them too often and wrongly. Instead we have the face in the right hand corner, staring out at us – or is she looking upon the scene of devastation itself; the face is shadowed in bluish purple, somewhat out of focus; it is unclear whether this is the face of someone living or dead, whether it is Sherman's signature, the ghostly apparition of the violated body or, given its and the buttocks' equally frontal position, a severed head.[30] What is unambiguous is that the most vital, living things in this picture are the livid

pimples de-aestheticising and thereby de-eroticising the buttocks, and the ants wandering freely over its surface, about to enter and make their home there. Those livid pimples are (the) unforgettable; suffering life. *Untitled # 150* is a fantasy of cannibalism that makes the monster enormous in comparison with her victims. But it is, of course, her tongue, enormous, fleshy, with the taste of flesh still on it, that rivets our attention. Almost affectless – as confirmed by the smallness of her victims – without disgust, she tastes flesh, tastes herself (her finger); her tongue, impossibly real, is the figure of a desire that remains ambiguous between the sexual and the cannibalistically culinary, the sort of culinary tasting that aesthetic tasting has too often collapsed into. So, we have a complex weaving of an allegory of beauty as cannibalism and elaboration of the cold cannibals we have become, eating and being eaten. And yet – the entire fantasy exists for the sake of releasing the image of the tongue, a tongue that has lost the power of disgust, lost the sense of limits, and through that very fact arouses it.

All of these photographs are compelling objects of visual attention, (anti-)culinary spectacles of colour, fantasy, anxiety which, in their gross, hallucinatory moment of sensuous excess conjure and institute an auratic animism quite remote from the human face or the human figure: it is misplaced life, livid pimples, and fleshy tongue that now bear the full burden of the claim that life lives. At the extreme of this series are those of decay, and those that press the question of life to the limit of the indeterminacy between the organic and inorganic. The first feature of *Untitled #190* one notices is its lustrous, gleaming, dark mucous surface, with glints of intense blue like gems shining in the darkness. These are the visual trinkets and baubles, which, like the surface sheen of the colour photograph in general, catch our naïve eye; how easily we can be tricked into looking, how casually we buy the visual spectacle. But this is all surface, and the surface is shit. If we look

Cindy Sherman, *Untitled Film Still* # 190, 1987. Reproduced courtesy of the artist and Metro Pictures, New York.

any longer it is the stained, white teeth and reddish tongue covered in excrement, what we think must be excrement. Is that face, with its blue eyes like the indeterminate glints of blueness, buried in colonic slime or is it emerging out of it? Maybe one wants to say about this picture that its ugliness is too much, too close to the cliché of the horrible to be truly revolting (although if your are really revolted by it, I would not argue the point), and that it is, finally, almost comic, kitsch horror. Even if that is true, it is unlike the comic horribleness of classic horror movies, for whether we view it as truly or only comically disgusting, we are left with an imprint: the excremental scene is the natural habitat of the human face.

4. Re-animation: Sex pictures and history

In suggesting that the excremental scene is the natural habitat of the human face, I want to make the claim that this is a stratum of meaning, not a real beyond meaning, but a locus of meaning, where meaning begins: the glint of light becoming the glint of the eye, life emerging from and merging back into slime, in the cry of terror or agony or disgust through which revolting nature becomes an object, becomes something that stands over or opposed or is different from us, but is still us: phantasmagoric affinity. Adorno would perhaps speak here of nonidentity, Kristeva of the symbolic *in* the semiotic. Contrast this way of thinking about and responding to Sherman with Norman Bryson.

> The body is everything that cannot be turned into representation, and for this reason is never directly recognizable: if, in our minds, we were to picture this body-outside-discourse, it would not *resemble* a body at all, since the body-as-resemblance is precisely that into which it may not be converted . . . Like language, visual representation can only find analogues and comparants for this body: it is *like* this or that . . . At the edges of representation or behind it hovers a body that you will know about only because

> these inadequate stand-ins, which are there simply to mark a limit or boundary to representation, are able to conjure up a penumbra or something lying beyond representability. The penumbra indicates that discourse-as-sight cannot quite detect this region or bring it into focus.[31]

This is confused, and worse, its mistake repeats the very assumptions about meaning that are the root cause of the violence of discourse that Sherman's pictures are criticizing. The contrast between representation and the real assumes that we – subjectivity, language, discursive practices, call it what you may – are the locus or origin or self-sufficient source of all meaning and sense, that our capacities to speak and mean are perhaps conditioned by a material substratum but are not dependent or parasitic on it. At a certain level, there is something theoretically silly in the way the real is posited as excessive; so when Bryson comments that 'the medical-student mannequins and body parts and Halloween masks and prostheses cannot live up to, cannot *match*, the affect they induce,'[32] we may well ask what kind of failure this is? What is it to provide a representation, a mimesis of pain or terror or violation? Does language ever 'match' the affects it induces? Does (the word) 'pain' match (the object) *pain*? What sort of matching is being assembled here? Is not Bryson's thesis simply repeating the classical dualism: disembodied and so imageless soul that gives meaning versus material nonmeaning? What law – other than that of rationalized reason – ordains that the expressive components of the image are not also representational? Does not Bryson's way of carving up the terrain, cultural meaning versus material non-meaning, presuppose that cognition is to be exhaustively discursive, and what is non-discursive is thereby non-cognitive? Is not that construal of meaning and cognition what is here being so emphatically brought into question? Can there be *living* meaning without what is cognized non-discursively?

What Sherman presents is beyond the culture industry's

rationalized regime of representation, beyond what is established as formations of meaning and significance. As Bryson rightly says: 'What reemerges from that very disappearance [of Sherman's own body] is everything about the body that the image stream throws out in order to maintain the ideas of the body as socialized, clean, representable: the body's material density, its internal drives and pulsions, the convulsiveness of its pain and pleasure, the thickness of its enjoyment.'[33] However, while livid pimples, gross tongue, colonic slime are surrogates for this real, and images of it, in the context of Sherman's work they are not the beyond of representation but its very origin. They both break through rationalised cognition, and with horrific or comic insistence force upon us another scene of knowing: what we cannot swallow, ingest, taste, is equally what we cannot doubt. The illusion of rational mastery is undermined in an instance of binding cognitive revulsion. Horror is one of the art *forms* that Sherman employs in order to permit these others to speak; or, one might say, Sherman deploys or discovers horror as a mode of abstraction which can de-realize the given, remove from it determinate meaning, in order to provide it with an illusory insistence that returns to it a power to originate. If one were Kantian, one might say that here works are sites of transcendental affinity. But the affinities are not transcendental in Kant's sense: they are empirically indexed and bound – they are a consequence of mechanism, discursivity, the implacable cliché. Sherman offers a new material *a priori*, and thereby a reminder of experience beyond what experience has become.

To be sure, we are operating in the domain of art and illusion – the colonic slime is, thankfully, odourless and tasteless – and in ordinary life these natural yet anthropomorphic sources of meaning have been excised in all the ways we earlier saw Bryson helpfully track. But that is what raises the stakes for this other scene of meaning. Although a space of illusion, Sherman's picture

refers us emphatically to a sensuousness and corporeal excess of which disgust and/or laughter is a marker. Is there any other public way in which our beliefs and emotions could be unified? Is there any other shared and social space in which our beliefs about our bodies and embodiment could be so radically transfigured in order to lodge an anti-sceptical claim? What do we know, know in the full sense of believing and feeling, about our embodiment that is a better knowledge, cognition than what Sherman's horror pictures supply?

Sherman's art is the most insistently and unashamedly cognitive I know; each work tests, criticizes, and re-configures its materials into another scene of knowing, or even more radically, the scene of knowledge itself. It is the consistency of her epistemic performance that distinguishes her work from the apparently similar. The history and sex pictures work in an analogous two-step manner in which there is a moment of radical de-aestheticizing of the original scene accomplished by the substitution of a medical prosthesis or mannequin for a body part or whole person; in the disconcerting second moment we experience a re-animation of the original scene. The plastic substitute strikes us as *more* material, *more* living and vital than that which it replaces. The history pictures are genealogical: they trace the subtle, almost invisible de-materialization of the human body in the very art that was, we can now see, not just celebrating but idealizing it in a way that has *become* suspect: idealization has become reification.[34] Without the moment of re-animation, these pictures could not accomplish all their other exchanges with the history of art; without the moment of re-animation these works would become theoretical toys for critical reflection. Only the moment of re-animation makes these emphatically *works*.

Re-animation not only de-sublimates the original, but simultaneously gives it back its auratic power by revealing the

dependency of the ideally beautiful on what it sublimates. But if that is correct then these works are ambiguous and ambivalent in a way that, for example, Rosalind Krauss misses: 'It is as though Sherman's own earlier work with the "horizontal" had now led her back to the vertical, sublimated image, but only to disbelieve it. Greeting the vertical axis with total scepticism, the *History Portraits* work to dis-corroborate it, to deflate it, to stand in the way of its interpellant effect.' [35] Is the vertical axis met with total scepticism or is it made more complex? Can we forget that, again, this is Cindy Sherman interrogating, experiencing for herself, for us, a dead past, but still one whose decisive moments were turning points in the construction of the modern subject? Hence each such moment was not only a destructive sublimation of materiality, but an opportunity missed, a slim chance of identity, including gender identity, that might have been otherwise. What else are we to make of her impersonation of male characters? They enable us to detect aspects of both contingency and non-contingency in the historical formation of gender identities. But in giving to the past works an ambivalence, making them into scenes in which the work of idealization occurs before our very eyes in virtue of its material correction, Sherman equally returns to these works their *historical* effectivity, a historical depth that is anything but purely formal. Her re-animations tear these works out of the museum as if out of a sepulchre, and turn them into elements of historically effective consciousness.

I claimed earlier that Sherman's modernist appropriation of the genre of horror releases its cognitive and critical potentials; the sex pictures do something analogous for pornography. In making this claim I am suggesting that pornography itself contains cognitive and critical potentials that its social circulation aestheticizes and mystifies. This should not be news. In its culture-industry use pornography operates as a simple objectification of, dominantly, the female body as a space in which fantasies of sexual

gratification through subjugation are played out as stimulants for the male gaze. In order for the predominantly female body to function in this way it must be aestheticized, sex and violence idealized. However, that work of aestheticizing, cleansing and purifying objectified sex and sexuality is continuous with culture's more routine de-naturalization of sexuality. Culture does to sex what it does to beauty, and it did it to sex first. Pornography in modernity has always been, *also*, a reminder of a set of uncomfortable grammatical facts: that all human sexual practices are transgressive, breaking the boundaries of culture and revealing the interchange between nature and culture; that all human sexual practices contain moments of objectification, aggression, and solitariness; that human sexual practices are never simple acts of mutuality and reciprocity, that mutuality and reciprocity are, when present at all, complex and indeterminate achievements. What is particularly disconcerting about these uncomfortable facts is that public acknowledgement of them, if there is any, occurs in pornography. Pornography is ambiguous.

Sherman's sex pictures underline rather than remove that ambiguity. In this respect, *Untitled* #179 (1987), which belongs awkwardly to the disaster and fairy tale series, anticipates what comes later. There the insistent images of discarded implements for vaginal penetration leave no space for the aestheticizing imagination to take a grip. The one thing we are not reminded of is sexual gratification; but that does not mean we become forgetful of sex. Presented is a sense of sexuality that makes female sexuality invisible, derivative, a faceless, imageless corollary of indifferent tools and instruments. Those tools and instruments are *real*, not painted, not fantasized. Brute, phallic things brutally observed. From the fact that all these phallic things appear as so much debris, we can infer their utter uselessness, but equally both the female subject's dissatisfaction and her obsessive search for satisfaction. Does that put sex out of mind, Hal Foster asks, in a

context I will return to – 'can there be an evocation of the obscene that is *not* pornographic?'[36] If the pornographic is ambiguous, and part of that ambiguity is its implication of transgression, of searching for the limit against culture's aesthetics of sex, then while there can be obscene things that do not come within the ambit of pornography or the pornographic, the thought that art should avoid slipping into the pornographic demands an ethical purity of artistic action that is not available. Only conceptually would it be true to say that the grammar of pornography, its syntactical power, is not itself pornographic.

Even the most irreal of Sherman's sex pictures, like #250, by dint of their materialist de-sublimation of sexuality, and hence in order to give back to the fantasized body its materiality, generate a re-animation and animistic surplus that cannot be critically controlled or contained. Yet, there is always something else; is there not something touching, unutterably *sad* about *Untitled*, #250? That it is in the violated and degraded body, the body carved into parts, anatomized and sexually dissected, that this surplus occurs says more about the context that produces pornography than it does about pornography. It should be no odder that the usually hidden, material, and obscene side of the pornographic image can be the site of insight, than that tragic insight, in its broadest sense, should occur through scenes of murder or patricide. Materialist pornography, which is and is not pornographic, is another inflection of the ugly.

5. Art versus psychoanalysis

Regarding Sherman's photographs as exemplars of 'abject art' is, like the idea of abject art itself, unintelligible. Her art does emerge out of the same set of historical and social conditions that make the discourse of abjection an appropriate conceptual characterization of the pathologies of the present. More precisely,

because our social symbolic has become cliché, has become a matter of images that simulate the aura of human identity while leaving it empty, discharging from itself all that a working symbolic is responsible for processing and elaborating, then we possess no symbolic order, no language of everydayness, that can support or articulate usable systems of meaning. Psychoanalytic discourse emerges out of the collapse of the modern symbolic as a generalized analysis of the functions and constraints that need to be satisfied by symbolic regimes in general, regimes of truth, if anything like a human identity is to be formed. Only regimes of truth will do because, as Sherman's art and psychoanalysis both make evident, there are radical, material constraints on subject formation which, if not adequately symbolically acknowledged, return in disabling and even terrifying ways. Psychoanalysis *points to* and anticipates socio-symbolic truth, to normativity, while always itself remaining at a distance from it.[37] Psychoanalysis is not the truth of subjectivity, but the functional framework or form of symbolic truth.

The normativity of art has been, from the outset, from the time of tragedy or before, a symbolic that re-cycled into culture its *internal* relation to its limit conditions, conditions which are already there in our everyday beliefs, even if the emotions proper to those beliefs are split off from them. Tragedy and sublimity were the traditional languages of the exchange of nature and culture within culture that obviated the need or necessity for a wholly theoretical discourse on that relationship. What has changed from the time of tragedy to the time of the present is that we cannot any longer, or at least not obviously, integrate into culture at large art's successful sublimations of those boundary conditions. But this was anticipated in the shift from tragedy to early sublimity where the sublime had already become a still life of tragedy, frozen tragedy. Tragedy operated internally to Greek culture; the modernist sublime and horror can only point to

another space of meaning by demonstrating, again and again, that, at least in the illusory space of art, culture and nature are not opposites or opponents, that material meaning is *possible*.

Psychoanalytic aesthetics, by failing to fully embrace the cognitive and normative claims of art practices, asks the wrong questions in the wrong way. Thus Hal Foster: 'Can the abject be represented at all? If it is opposed *to* culture, can it be represented *in* culture? In other words, can there be *conscientious abjection*, or is this all there can be? Can abject art ever escape an instrumental, indeed moralistic, use of the abject?'[38] This is helpful and confused. Helpful because Foster is recognizing the normative claiming of this art, its 'conscientiousness'. Confused because, first, what is opposed to culture *now* is not the abject, but the material stratum of significance which the concept of abjection points to as at issue in the earliest moment of subjectivity. But, secondly, this is to say that we are not concerned with the abject or the unconscious; they are meta-symbolic forms. In Sherman's photographs we are concerned with the matters themselves as still available, if only in art, to symbolic shaping. By departing from the language of tragedy, sublimity, and horror, from beauty and its cruelty, from life, death, violence and violation, from flesh and blood and guts, from colour and excrement, from rape, murder, pornography, from interest and disinterest, from pain and fear and disgust and pity, psychoanalytic aesthetics unknowingly deprives us of the only resources we have to think and feel who and what we are and what might become of us. Psychoanalytic aesthetics objectifies and rationalizes; it excises from works their being objects of experience. Sherman's photographs, again and again, by a second mimesis, resist culture's mimesis unto death, offering back to discourse the experiential conditions that might make of it something through which one might live.

Notes

1. Norman Bryson, 'House of Wax,' in *Cindy Sherman 1975–1993*, text by Rosalind Krauss (New York: Rizzoli, 1993), p. 217.

2. Having come to see that this was the *stakes* of the early works, her later 'history' photographs, among other tasks, provide an explicit chronicle of that suppression.

3. In denominating what is revealed through abstraction as the syntactical character of the object I am, provocatively, employing the terms of reference which Michael Fried originally used, in the 1960s to describe Anthony Caro's sculpture. The relevant essays are now collected in Fried's *Art and Objecthood: Essays and Reviews* (Chicago: The University of Chicago Press, 1998). For an account of the evolution of this vocabulary, see Fried's 'Introduction', pp. 27–33. 'Syntax', of course, is not an ideal term, but 'transcendental syntax' is not far off. For reasons that will become apparent, I will opt for 'material *a priori*'.

4. The alternative framework employed here, derived from Adorno and Horkheimer, is not, of course, the condition of our seeing, but enables what is seen is to be held in place, its *claim* elaborated and vindicated as a claim.

5. Max Horkheimer and Theodor W. Adorno, *Dialectic of Enlightenment*, translated by John Cumming (London: Allen Lane, 1973), p. 5. For an example of my attempt to vindicate the claim of sensuousness without animism see 'The Death of Sensuous Particulars: Adorno and Abstract Expressionism', *Radical Philosophy*, no. 75, March/April 1996, pp. 7–16.

6. Ibid., p. 57.

7. Ibid., pp. 10–11; emphasis added.

8. Bryson, op. cit., p. 219.

9. Ibid., pp. 218–219.

10. Horkheimer and Adorno, op. cit., p. 15.

11. Ibid., p. 19.

12. For substantiation of this claim see my 'The Death of Sensuous Particulars'.

13. Theodor W. Adorno, *Aesthetic Theory*, translated by Robert Hullot-Kentor (Minneapolis: University of Minnesota Press, 1997), p. 110.

14. Ibid., p. 111.

15. 'The Schema of Mass Culture', translated by Nicholas Walker, in Theodor

W. Adorno, *The Culture Industry: Selected Essays on Mass Culture*, edited with an Introduction by J. M. Bernstein (London: Routledge, 1991), p. 81. On writing, script, etc., in this essay see Miriam Hansen, 'Mass Culture as Hieroglyphic Writing: Adorno, Derrida, Kracauer', in Max Pensky (ed.), *The Actuality of Adorno: Critical Essays on Adorno and the Postmodern* (Albany: State University of New York Press, 1997), pp. 83–111.

16. If it is a truism that photography has been good at representing suffering with dignity and film capturing, especially, female vulnerability, then Sherman's consistent ability to reveal vulnerability within ordinary clichéd identities is an accomplishment that deserves separate treatment.

17. 'The Schema of Mass Culture', op. cit., pp. 81–2. And my introduction, pp. 10–14; and Hansen, 'Mass Culture as Hieroglyphic Writing'.

18. Laura Mulvey, 'A Phantasmagoria of the Female Body: The Work of Cindy Sherman', *New Left Review*, no. 188 (July/August 1991), p. 140. For all my disagreements with this essay, it remains the best single account of Sherman's work as a whole.

19. Verena Lueken, 'Cindy Sherman and her *Film Stills* – Frozen Performances', in the catalogue *Cindy Sherman*, Staatliche Kunsthalle, Baden-Baden (1997), p. 25.

20. Susan Sontag, *On Photography* (Harmondsworth: Penguin Books, 1979), p. 154. Here is the whole sentence in which this phrase occurs: 'Such images are indeed able to usurp reality because first of all a photography is not only an image (as a painting is an image), an interpretation of the real; it is also a trace, something directly stenciled off the real, like a footprint or a death mask.'

21. More precisely, the subject, and hence her aura, is a consequence of her being nothing but vulnerability and anxiety: non-fungible pain.

22. This pervasiveness is the claim and the limit of the claim of the postmodern sign universe.

23. One way of collecting all these thoughts would be to say that in these pictures the interiority is no longer an animate excess, but is rather the interiority of the represented and clichéd subject herself. Sherman's singularity disappears behind the cliché represented.

24. This sentence embeds a host of cruces for the argument that I have been unable to include here, namely, the stakes of the exchange between photography and painting in the emergence of modernism. Photography's capture of representing the real is certainly an element in the account of what forced painting into abstraction. That painting made a virtue of that necessity through uncovering a stratum of material meaning inaccessible to discursive, representational perception is its achievement. But that achievement was only ever temporary because in locating a terrain or domain for itself, painting left the authority of photography unchallenged. The *exact*

locale of that absence of challenge can be stated: although only a medium, the mechanism of photographic looking automated, as it were, *disinterested* and hence *aesthetic* looking – the very thing which abstraction accomplished in painting. If that mechanization of disinterestedness remains uncontested, then the aesthetic and the mechanical become one. Adopting painterly techniques in photography is thus bound to fail since painting's regress to its material substratum is conditioned by the medium, not the art, of photography. The transformation of photography into art, turning the language of photography to art purposes, is the unfinished business of painterly modernism.

25. Of course, none of these genres are unique to photography. A more accurate statement would be that Sherman's uncovers the privileged position of photography with respect to each of these genres once they are recognized as forms of abstraction. Each genre concerns the *unseen within seen*, where what is unseen is also real, also material in character. The unseen within the seen is its syntactic or a priori character, hence the *claim* of that materiality. Once photography becomes the privileged mechanism for recording the possibility of seeing, *the* site of intuitive seeing without a concept (the camera's hegemony over disinterestedness), then these genres must be relocated as properly within the provenance of photography. Sherman's abstractions, in effect, succeed to the extent they accomplish the work of genre relocation, which is their premise.

26. For a more direct version of this claim, see Peter Schjeldahl, 'Delirious Watching: Cindy Sherman and Horror Movies', in the Staatliche Kunsthalle catalogue, *Cindy Sherman*, pp. 142–146.

27. *Poetics* 13, 1452b30-1453a8. In taking the Greek *miaron* to be 'disgusting' I am following Jonathan Lear, '*Katharsis*', in Amélie Oksenberg Rorty (ed.), *Essays on Aristotle's Poetics* (Princeton: Princeton University Press, 1992), p. 339. In general, my comprehension of the claims and nature of tragedy in this essay is heavily indebted to Lear's fine essay.

28. *Critique of Judgment*, trans. Werner S. Pluhar (Indianapolis: Hackett, 1987), § 48, p. 312: 'There is only one kind of ugliness that cannot be presented in conformity with nature without obliterating all aesthetic liking and hence artistic beauty: the ugliness which arouses *disgust*.'

29. The ugly, I am contending, is the generic form, the appearance character, of what exceeds rationalization and beautification.

30. This same sort of ambiguity is present in #167, where we have both the face buried in dirt, its finger distributed in a manner suggesting they are no longer connected to the body as a whole, another face (whose?) in the small, make-up mirror.

31. Norman Bryson, 'House of Wax', op. cit., p. 220.

32. Ibid.

33. Ibid., p. 222.

34. I am assuming here that beauty or what we think of as beauty is to be located initially in the spontaneous act by which sexual desire idealizes its object. Beauty, we might say, is one of the forms through which culture acknowledges its bondage to libidinal nature. So long as the social-symbolic circulation of beauty acknowledges that bondage, however indirectly, idealization stops short (just) of outright reification. Again, it is the cultural usurpation of beauty, the complex exchange between culture and nature, that is the decisive blow. Because idealization cannot happen without abstraction, however, there is always a sublimated violence in beauty, and hence a potentiality for the worst.

35. Rosalind Krauss, op. cit., p. 174.

36. Hal Foster, *The Return of the Real: The Avant-Garde at the End of the Century* (London: The MIT Press, 1996), p. 156.

37. Psychoanalytic discourse, I am urging, relates to spaces in which all possibilities of sublimation have failed. Where sublimation succeeds, where there is art, for example, then psychoanalytic insights are inapplicable (except in pointing out the terrain that has, in any particular instance, in fact been navigated). By inserting itself into achieved sublimations, psychoanalytic discourse blinds itself and us to what has been achieved since it will, necessarily, provide a factual or functional account about a normative achievement and thereby pass over the normative claim being raised.

38. Foster, *The Return of the Real*, p. 156.

And woman?

A response to Bernstein

Mandy Merck

Since her first exhibitions in the late 1970s, the work of Cindy
Sherman has been a focus for feminist criticism. Both the thematic
association of its female figures with an anxious or endangered
eroticism, adolescent reverie, violence, filth or decay, and its
formal attention, via images of the artist posed in pastiches of
film, fashion, pornography and oil painting, to 'Womanliness as
Masquerade'[1] have elicited commentaries on these photographs as
representations of femininity. Commenting on the 'Film Stills' and
'Untitled' series in 1983, Judith Williamson argued that 'Sherman's
pictures force upon the viewer that elision of image and identity
which women experience all the time, as if the sexy black dress
makes you *be* a femme fatale, whereas "femme fatale" is, precisely,
an image.'[2] Subsequently Laura Mulvey has described Sherman's
project as the de-fetishization of the female body, unveiling its use
'as a metaphor for division between surface allure and concealed
decay'. In her reading this divestiture progesses from the 1977
'Film Stills' through the 'Centerfolds' to the prostheticized 'Old
Masters' and the abjection of the corpse-figures in a movement
from 'reverence' to 'revulsion'.[3]

Following Mulvey's observations, Parveen Adams has related this
'lifting of the mask' to the literal face-lifts by which the French
artist Orlan disfigures the 'standard phallic representation of the
woman's portrait':

> We are acutely aware of the mask-like character of the face and we
> apprehend it as an object which will be replaced, refigured. The
> successive character of the face underlines that there is nothing
> beneath the mask. Like Cindy Sherman's early work, the series of
> images is in principle without end.[4]

Most recently, Elisabeth Bronfen has declared that Sherman's
'performances of femininity, of the monstrous, and ultimately of
the mechanical body, compel us to see this staging as a
performance. In one and the same gesture she urges us to focus
both on the process of figuration and on the traumatic material
that is screened out by any aesthetic figuration, or, if it cannot be
contained, that emerges from it in its excessive, monstrous
shape.'[5]

Jay Bernstein takes a different tack. While acknowledging the
vulnerability portrayed in the 'Film Stills' and the contingency of
gender identity suggested by Sherman's male impersonations, his
emphasis is on the indexical rather than the sexual. Unlike the
mere semblance or symbol offered by painting, the photographs'
physical connection to their model – 'the "fact" of Sherman
herself' – and their (potentially indefinite) seriality signal an
'unbearable tension between anxious singularity and clichéd
identity'. And since the clichés of the 'Film Stills' are those of the
culture industry *par excellence* – Hollywood – they become
illustrations of Adorno's lament for the deadly imitation enjoined
upon us by cinematic identification and captured in its 'stills'.
'The cumulative effect of the series', Bernstein concludes, 'is to
throw into radical doubt the conceit of the autonomous –
individual, ironic – subject and to pinpoint the blame for this
disappearance on the culture industry's employment of the
technology of image production.'

One could pose a number of objections to this argument. The
monolithic interpellative power which Adorno and Horkheimer
attributed to the culture industry has long been contested, for

reasons too familiar to rehearse here. Moreover, it isn't at all clear that Sherman's work, one of the most widely reproduced ouevres of contemporary art photography, stands outside it. (In the *Dialectic of Enlightenment*, 'avant-garde art' is described as a 'counterpart' to the entertainment industry in its use of anathema and novelty.) Finally, Sherman's own uniqueness in modelling for photographs exploring clichés of femininity is questionable. Anticipated as early as the 1920s by the French surrealist Claude Cahun, her work is currently flanked by a host of related projects, of which Orlan's perhaps claims the cutting edge. Less noted are photographs by lesbian artists interrogating cultural production, gender identity and tabooed desires. Here I would cite Millie Wilson posing as the faux Fauve 'Peter', a cross-dressing woman artist whose imaginary biography she documents in her 1989 'Fauve Semblant'. And in her 1989–90 'Dream Girls' Deborah Bright montages images of herself, as a quiffed and leathered dyke, into actual film stills to woo the great female stars. Neither of these examples, I grant, correspond to the extensive seriality of Sherman's successive images, nor to whatever narcissistic disturbances such a proliferation of non-individuated self-images might give rise to (although Orlan's work certainly provokes a profound unease). But the sexual thematics which they share with Sherman's photographs cannot be discounted.

To pursue these, I would suggest a return to the excursus in the *Dialectic of Enlightenment* where the idea of 'mimesis unto death' is first advanced.[6] There, in a reading of Homer's epic, the wily Odysseus is hailed as the prototype of the enlightenment subject, 'the hero who escapes from sacrifice by sacrificing himself'. Cunning and persevering, Odysseus survives the Trojan wars and ultimately returns to his island kingdom, but only after 20 years' absence. His subordination of means to ends anticipates the 'irrationalism of totalitarian capitalism, whose way of satisfying needs has an objectified form determined by domination which

makes the satisfaction of needs impossible'.

In one characteristic episode, Odysseus outwits the cannibal cyclops Polyphemus by identifying himself as 'Nobody' before blinding him. Thus he can escape when Polyphemus cries out that 'Nobody' has wounded him: 'he saves his life by losing himself'. Similarly, in mastering the natural forces represented by such mythic figures, bourgeois man must not only demystify nature but adapt to that demystification himself – 'mimesis unto death':

> Imitation enters into the service of domination, inasmuch as even man is anthropomorphized for man.

And woman? Unlike Bernstein, Adorno and Horkeimer see the relation of sexual domination to the self-denying ordinances of civilization. They end their reflections on the *Odyssey* by contrasting the courtesan figure of Homer's epic, Circe the enchantress, with Odysseus's faithful wife, Penelope, who waits for him at home. Observing the complementarity of wife and prostitute within property relations – one represents possession, the other pleasure, but pleasure which is also bought and sold – they pose both as figures of 'female self-alienation in the patriarchal world'. But it is for Circe, who tempts Odysseus' crew to surrender to instinct and turns them into swine, that they reserve their tenderness. In their snuffling subordination, the wretched sailors prefigure Circe's own fate, for her powers will also be vanquished by the hero's, as enlightenment extinguishes myth. As a representation of nature mastered by rationality, 'woman in bourgeois society' – Adorno and Horkheimer conclude – 'has become the enigmatic image of irresistibility and powerlessness.' Enchanting she may be, but in 'the civilized judgment', a lowly beast. In enlightenment's founding epic, as in the work of Cindy Sherman, woman declines from perfection to abjection, a progress which cannot be purged of its feminine specificity or its feminist relevance.

Notes

1. The renewed interest in Joan Riviere's 1929 article, republished in Victor Burgin, James Donald and Cora Kaplan, *Formations of Fantasy*, London and New York, Methuen, 1986, undoubtedly influenced these discussions of Sherman's work.

2. Judith Williamson, 'Images of "Woman"', *Screen* Nov–Dec 1983, vol. 24 no. 6, pp. 102–106.

3. Laura Mulvey, 'Cosmetics and Abjection: Cindy Sherman 1977–87', *Fetishism and Curiosity*, London and Bloomington, British Film Institute and Indiana University Press, 1996, pp. 65–76.

4. Parveen Adams, 'Operation Orlan', *The Emptiness of the Image*, London and New York, Routledge, 1996, pp. 141–59.

5. Elisabeth Bronfen, *The Knotted Subject: Hysteria and its Discontents*, Princeton, NJ, Princeton University Press, 1998, p. 430.

6. Theodor Adorno and Max Horkheimer, *Dialectic of Enlightenment* (1994) trans. by John Cumming, London, Verso, 1995, pp. 43–80.

David Batchelor, *The Found Monochromes, London: Bethnal Green, 12.12.99*, C-Type print, 24 × 20 ins, courtesy Anthony Wilkinson Gallery.

In bed with the monochrome

David Batchelor

Anyone can make a monochrome. Most of us probably have made one at some time or another, although we wouldn't necessarily have recognised it. And we wouldn't necessarily need to have made one, as most of the time we are already surrounded by ready-made monochromes of various shapes and sizes. The world is full of unintended, sometimes accidental, often temporary, and mostly unnoticed monochromes. (See *Found Monochrome* opposite)

Every city is a museum of the inadvertent monochrome. Someone should do guided tours pointing them out and, while they are about it, point out that these monochromes have always preceded the monochrome-as-art; that the monochrome-as-art was new only to art; that one of the values of the monochrome-as-art is that it draws attention to monochromes *before* art; and finally that one of the minor consequences of this is that the monochrome now also precedes art in the sense that a blank canvas can be experienced already as a work of art. Clement Greenberg in 1962: 'a stretched or tacked-up canvas already exists as a picture'; Jeff Wall in 1993: 'A new piece of canvas is already a monochrome'.[1] This condition powerfully affects our experience of art. It haunts our experience of art. For artists this leaves a number of intriguing possibilities. For example: the possibility that the raw materials in the studio might be plausible as art before anything is done to them. Or, more troublingly: the possibility that they may be less interesting

as art once they have been worked upon. Or: the possibility that
that which is discarded and piled in a corner of the studio in the
process of making a work, may also be as interesting as the work
itself. Or, again: more interesting.

Since the early part of this century the threshold between art and
non-art has been anything but clear and anything but constant
and anything but consistent. The monochrome has its share of the
responsibility for this, along with the ready-made and the
photograph. For some this has heralded the negation of value and
the death of art; for others this has been a dynamic and creative
uncertainty, a self-doubt which is a condition for the continuation
of art. This uncertainty is at least as practical as it is theoretical. It
may provoke philosophical inquiry into matters of artistic
intention and attention, or reflection on the ontological status of
the work of art, but before that, it is a condition vividly
experienced on a day to day basis by just about every serious artist
around. It is a part of the pleasure and a part of the pain of being
an artist. And it is a part of the pleasure and the pain of being a
beholder of art.

Greenberg again: 'The paradoxical outcome of this reduction has
been not to contract, but actually to expand the possibilities of the
pictorial: much more than before lends itself now to being
experienced pictorially or in meaningful relation to the pictorial:
all sorts of large and small items that used to belong entirely to
the realm of the arbitrary and the visually meaningless.'[2] But he
kept this sentence within parentheses; behind bars.

Anyone can make a monochrome. Many have. El Lissitsky didn't
but in 1924 he still relished the consequences: 'Now the
production of art has been simplified to such an extent that one
can do no better than order one's paintings by telephone from a
house painter while one is lying in bed.'[3] Clearly a strong part of
its attraction is that the monochrome, like the ready-made, carries

within it a constant reminder of that unstable boundary between the rarefied practice of art and the more vulgar realities which surround it. For Alexander Rodchenko, who, arguably, executed the first 'true' – but hardly pure – monochromes in 1921, the boundary was not so much to be acknowledged and negotiated, as abolished: 'I reduced painting to its logical conclusion and exhibited three canvases: red, blue, and yellow. I affirmed: this is the end of painting. These are the primary colours. Every plane is a discrete plane and there will be no more representation.'[4] For the artists of the Russian Revolution this was a revolutionary possibility. The end of representation. The end of easel painting. The end of art. The end of old inherited bourgeois norms and practices. The beginning of a new life, a new mode of production, a new culture. The promise of the 'sublation of art into the praxis of life'; but a promise which was destined to remain only a promise. And thus after Rodchenko: '. . . the monochrome remains the boundary-marker of the point we have not been able to reach, the reminder of the culture we have not been able to create.'[5]

Anyone can make a monochrome. Or have one made. It needn't be difficult and it needn't take long and it needn't be expensive. But would it be any good? Would it be *interesting*? 'A stretched or tacked-up canvas already exists as a picture', said Greenberg, only to add immediately: 'though not necessarily as a successful one'.[6] How would you make a monochrome which didn't simply repeat what had been done before? Or if it was to repeat what had been done before, how could this be interesting in itself? To answer these questions we would have to be clear about what the monochrome has done and where it has been and what it might have meant. What are the conceptual dimensions of the monochrome? What are its practical limits? What are its cultural implications? What is the best operating temperature and driving position? For several commentators the monochrome is always essentially the same, and to make *a* monochrome is to make *the*

monochrome. Singular. The monochrome as category more than genre: a conceptually indivisible and largely fixed category, without substantial internal variations, divisions, tensions, conflicts, contradictions or developments. Which leaves: repetition, interesting or otherwise.

Repetition: not quite as straightforward as it sounds, either in theory or in practice. In theory: for some, repetition in art is only redundancy and wretchedness; a worthless recycling of received forms which only and always diminishes the criticality of the original. For others though, repetition can also be recovery, renewal and revaluation; the means by which the original act may be better understood and its critical purpose continued. In the red corner: Peter Bürger's *Theory of the Avant-Garde*, which makes the argument for repetition as decadence. For Bürger, the repetition in the post-war period of earlier avant-gardist devices (of which the monochrome would be one example), merely 'institutionalises the avant-garde as art and thus negates genuinely avant-gardist intentions'.[7] If Rodchenko's monochromes marked 'the end of painting', then subsequent monochromes mark only the institutionalization of the end-of-painting as painting. And in the blue corner: *October* magazine's Buchloh-Krauss-Foster, who, between them, over a period of more than ten years, have set out to counter this 'evolutionary' version of avant-garde events, to recover the critical value the 'neo-avant-gardes' of the 1950s, '60s and since, and to do this in large part by a systematic deconstruction of conventional accounts of 'originality' and 'repetition'. For Benjamin Buchloh and Hal Foster in particular, the revaluation of repetition is achieved by replacing Bürger's 'historicist' account with a version derived from psychoanalysis. Here repetition can be understood in terms of a recoding of an earlier, repressed, trauma; and, critically, it is *only* through the process of its repetition that the trauma may be fully analysed and understood. Hence, rather than diminish or degrade, repetition

becomes the key to comprehension. And hence, 'rather than cancel the project of the historical avant-garde, might the neo-avant-garde comprehend it for the first time?'[8]

Repetition: as well as talking of recycling the monochrome at different times by different artists under different circumstances, there is also the question of the same artist remaking the monochrome within his or her practice. Examples: for Buchloh, Rodchenko had reduced painting to 'seriality and infinite repeatability'; we are left with the 'infinite repetition of the structurally analogous or identical'. Among monochromes (and other neo-avant-garde practices) 'the inherent qualities of the work no longer offer sufficient possibilities of differentiation among one another'.[9] Here we are told the monochrome is a kind of token-painting; an emblem of the end of painting repeated endlessly; end-game painting. The content of the monochrome is the contentlessness of painting and it is always essentially the same. Thus, for example, Yves Klein's Milan exhibition of 1957 consisted of ten 'identical' blue canvases, and Gerhard Richter's *Grey Paintings* of the late 1960s are just 'a negation of content'.[10] Jeff Wall sees something similar in the several hundred partial monochromes of On Kawara's date paintings, made continuously since 1966: 'Painting for him continues in a state of repetition.' And: 'Instead of painting, he letters the date of his refusal to paint'.[11]

In these instances repetition is rescued and accorded a critical and potentially revelatory value. This is important. There is however a price to be paid: the price of meaningful variation and differentiation. But is this true? Is it right to assume an automatic and necessary relationship between repetition and identity? Anyone can make a monochrome, but does that mean that every time anyone makes a monochrome, he or she always makes the *same* work? And does everyone who makes a monochrome make the same monochrome as everyone else? And does this correspond

with the actual experience of looking at or making a monochrome?

What if we think of the monochrome not so much as a category but as a genre; not so much as an emblem or token but as a practice? What if we think not so much of 'the monochrome' as of *instances* of monochromes? Is there any room for plurality? The motivation for doing this might not be as driven by the needs of conservative academicism as some have suggested: it might be just that the experience of various monochromes doesn't easily fit the theory which demands the convenience of identity and repetition. What if, when I look at different monochromes, I see different things? Might it be possible that the single, uniform, all-over, continuous, unbroken surface of the monochrome contains within it all or many of the discontinuities, tensions, divisions, polarities, splits and conflicts of other genres of art?

This is what I want to argue: that the monochrome has been many things to many people; and that it has resulted and can still result in work which is either adventurous or academic, absurdist or serious, amateur or professional, hilarious or humourless, critical or conventional, beautiful or banal, innocent or implicated, light or heavy, literalist or illusionistic, mystical or materialist, quick or dead. And this: that these and other possibilities continue to make up a practice which has in different instances signified either the end of painting, or the renewal of painting, or the breakdown of the distinction between painting and sculpture, or the transformation of painting into something else entirely.

Erasure, palimpsest, repetition, contingency

More examples: Robert Rauschenberg made a number of monochromes during 1950 and 1951. Some are white and some are black. Some are single panelled and some are multi-panelled. Some are matt and some are glossy. The white paintings are mostly

unbroken surfaces of flat oil paint. Many of the black paintings have paper pasted over the support, on top of which are laid one or more coats of gloss paint, leaving a hard, shiny, crinkled, ruptured surface. The white paintings are symmetrical and clean and absorbent; the surface treated as an arena for the temporary accommodation of passing shadows and light. In this they are the analogue of John Cage's later composition *4'33"*, in which a fixed temporal space is provided for the contingent and random sounds of the audience to become the focus of the work. The black paintings are heavier and reflective, less regular in the arrangement of panels or distribution of surface incident. Light in the studio or gallery catches the creases in the crinkled paper, creating highlights which appear and disappear unpredictably as the viewer shifts position. Both groups of work imply and exploit the presence of the viewer, but not necessarily in the same ways.

One or two years later, during 1953, Rauschenberg made his infamous *Erased de Kooning Drawing*. The story goes that he visited the elder artist's studio and asked if he could have a drawing; de Kooning asked why and Rauschenberg answered that he wanted to rub it out. De Kooning is then said to have replied that he would make it difficult for Rauschenberg by giving him a good one. The resulting work by Rauschenberg is a monochrome in the form of a blank, or very nearly blank, piece of paper. In the course of the same year, Rauschenberg made a number of other small works, several of which were finished in gold leaf. The irregular surface of the work and areas in which the leaf has flaked show that underneath the monochromatic film there lies a congealed accumulation of paper, fabric, wood and glue. What is noticeable about both the *Erased De Kooning Drawing* and the *Untitled (Gold Painting)* (as well as the black paintings) is how in each case the monochrome is such a *laboured* achievement of erasure or covering-over. In both instances there is a sense of there being something either physically beneath or temporally prior to the

finished work. Removal or cover-up. Neither is anything like Rodchenko's *reduction* of painting, neither is it simply a cancellation of painting; rather, here the monochrome is a *corruption* of some other work. A palimpsest. Not a tabula rasa. Neither singular nor clean nor clear, palimpsests are always already marked by the world, by contingency. They are not beginnings or ends but continuations. They are never pure. They are always both less than and more than what immediately precedes them. They are always provisional. And they are always unique. A palimpsest always seems to imply that, because it has happened once, this cover-up could happen again. It says: watch out: this surface is no more secure than the previous one.

The *Erased de Kooning Drawing* is really a story of the not quite circular passage between two monochromes: the blank piece of paper which came before it and the blank piece of paper which it became. The *Gold Painting* marks, and shows the marks of, the passage from one monochrome to another, but the passage is more linear than circular. Here the relationship between painting and the monochrome is not one of reduction but of *becoming*. And un-becoming. *Ten Thousand Lines, 5' Long, Within a 7" Square* (1971), by Sol LeWitt, is also a laboured monochrome, or a gradual overcoming of one monochrome and a gradual emergence of another in ten thousand equal and evenly repeated stages. The result though is neither even nor equal, but something scratched, dented, scuffed and rubbed. Some of Richter's monochromes are also palimpsests: blurred paintings of out-of-focus photographs, blurred to the point at which the image (of, for example, a lion snacking on the leg of a tourist) is lost in an opaque fog of undifferentiated grey. The vacancy of these works is also a very laboured vacancy, a complex blankness, a blankness achieved against the odds in an image-riddled culture. In all these instances the monochrome appears as a temporary and unstable state, a state which is in a constant process of being lost and recovered and lost

again. Or painting here is a temporary state between monochromes. These monochromes are markers not of the end of painting but perhaps of the endlessness of painting. They parallel, in their way, the endless but transient monochromes of the city – lost, recovered, covered-over, lost again. 'Fugitive, ephemeral, contingent', as Baudelaire characterised the experience of the modern city.

And what of repetition? Clearly repetition is implied in these works, and for art more generally, but here – because of the ever present and unavoidable and inherent contingencies, because of the absence of any 'pure' state, because of the palimpsest – repetition is the generator not of identity but, perhaps, of endless *differences*. Repetition is always the same and it is always different. Monochromes have sometimes shown this – to artists if not so often to critics. Richter in 1975: 'At first (about eight years ago) when I painted a few canvases grey I did so because I did not know what I should paint or what there might be to paint, and it was clear to me when I did this that such a wretched starting point could only lead to nonsensical results. But in time I noticed differences in quality between the grey surfaces and also that these did not reveal anything of the destructive motivation. The pictures started to instruct me. By generalising the personal dilemma they removed it; misery became a constructive statement, became relative perfection and beauty, in other words became painting'.[12]

Richter acknowledges the critical but unpredictable difference between conception and perception, without which, he implies, there would be no reason to visit the studio and no art of interest. That which he could not conceive of in advance, 'in time' reveals differences which in turn become the motivation for continuing. Klein said something similar in rather different terms about his 1957 exhibition of ten apparently 'identical' monochromes: 'All of these blue propositions, all alike in appearance, were recognised by the public as quite different from one another. The *amateur*

passed from one to another as he liked and penetrated, in a state of instantaneous contemplation, into the worlds of the blue. However, each blue world of each picture, although of the same blue and treated in the same manner, revealed itself to be of an entirely different essence and atmosphere; none resembled another, no more than pictorial moments or poetic moments resemble each other . . .'.[13]

For some, this is just 'desperate' or 'facetious' self-justification on Klein's part; and the same people tend to be equally at a loss with the idea that Richter's monochromes could be anything other than 'negation'. But is there any reason not to take the artists at their word? Klein's 1957 monochromes have something of the quality of Rauschenberg's earlier black and gold works, at least in that the 'pure' pigment always covers an irregular, ruptured or otherwise compromised surface. However much he may have tried to make 'identical' works – and the evidence is that he did not try very hard at all – the results are always different. The question of course is whether these differences carry any significance. John Cage, on the work of Fluxus composer La Monte Young: '[Young] is able, either through the repetition of a single sound or through the continued performance of a single sound for a period like twenty minutes, to bring about that after, say, five minutes, I discover that what I have all along been thinking was the same thing is not the same thing at all, but full of variety. I find this work remarkable almost in the same sense that the change in the experience of seeing is when you look through a microscope. *You see that there is something other than what you thought was there.*'[14]

This passage could easily be used as a commentary on the monochromes of Rauschenberg or Richter or Klein; in fact it probably owes something to Cage's experience of Rauschenberg's work. Again the focus is on the *asymmetry* between repetition and identicality. Repetition reveals differences, and demonstrates what Donald Judd referred to as 'the complete omnipresence of chance'.

However hard we might try, Cage seems to be saying, we will never escape this condition; a condition which should be embraced as a source of pleasure and learning. Repetition works like a 'microscope'; it becomes a technique for looking more closely at the world, and at those aspects of the world which we might otherwise pass over or not notice.

Buchloh has argued that it is at best meaningless and at worst 'bordering on the grotesque'[15] to make conventional discriminations of value and meaning between the monochrome works of Klein or Rauschenberg or others. Clearly the differences between two same shaped, same size, same colour Klein paintings from 1957 are not of the same order as the differences between, say, two portraits. Klein's works don't make reference to the world in the same way. Rather, differences are revealed, as Cage noted, through comparisons between elements in a series. Any meaningful difference attributed to an individual part in that series only shows itself within that series, for difference is produced through the process of repetition. Which is not to say we can't meaningfully look at a Klein monochrome on its own, but we are unlikely to get too much from it if we do not carry to it knowledge of other related works.

The omnipresence of chance: the unpredictable, unavoidable and uncontrollable contingencies always around us and within us, variables of which we may be hardly if at all conscious, but which nevertheless affect the outcome of everything we do. Consider the lengths scientists go to to replicate exactly a particular experiment. Consider the lengths industry goes to to produce identical components and products. And consider how often they fail. Consider the forces acting on a single index finger pressing on the same note of the same piano. Consider the variables at work in preparing and assembling and painting or otherwise making a monochrome . . .

During the late 1960s Lawrence Weiner embarked on a group of works based around the idea of a 'removal'. *A Removal to the Lathing or Support Wall of Plaster or Wall Board From a Wall*, when I saw it executed for an exhibition in Paris in 1989, produced a kind of monochrome. All that was visible was a shallow chiselled and scratched area of raw plaster a few millimetres behind the smooth white gallery wall. It was about three feet square, set at eye level. Given the context, it resonated with references to painting. It is not a painting of course, and there is no requirement that monochromes be paintings, but reference to painting is almost unavoidable. In the context of this essay, the obvious reference is to Rauschenberg's *Erased de Kooning Drawing*. But whereas Rauschenberg eradicated a picture of sorts, Weiner erases another (at least potential) monochrome: the wall. Like Rauschenberg's and Klein's before him, Weiner's monochrome is a ruptured, irregular and wonderfully impure work. It also reveals the wall-as-monochrome as itself a covering-over of some other surface, another palimpsest in a potentially endless chain of other coverings and erasures. The work is contingency made visible; and while eminently repeatable, the work could never produce the same results twice. And perhaps more than any other mono-chrome, here the threshold between the work and the world is made extremely uncertain. And, of course, like Rauschenberg's erasure, it is also funny.

Klein talked habitually about his blue monochromes in terms of entering an infinite space: 'Come with me into the void'.[16] Weiner makes a kind of literal void, one that, unlike Klein's, can't be optically entered, but can be measured; he literalizes the traditional idea of a painting creating a virtual space behind the picture plane. Rauschenberg literally voided de Kooning's drawing. And in different ways his black and gold monochromes are also manifestly literalist works: in their reflectiveness and physicality they admit no interior space. For Leo Steinberg they marked the

beginnings of the 'flatbed picture plane', a kind of hybrid art which abolished the illusion of three dimensions and took to those dimensions literally. Perhaps then this is the place to differentiate one group of monochromes from another: the literal from the optical. But it isn't so simple, for, in spite of all Klein's talk of infinite space, the more his paintings accrued and accumulated the physical debris of the studio, and in particular the sponges which he had originally used for applying his IKB pigment, the more the work seemed to become emphatically finite in its dimensions, to the point where it was asserted on an invitation card for a Paris exhibition: 'The monochrome propositions of Yves KLEIN secure the sculptural destiny of pure pigment today'.[17] This is a curious and interesting aspect of Klein's work, and we will come back to it later.

Paintings and paint-jobs

In Jeff Wall's commentary on On Kawara's *Today* series, Rodchenko's monochromes become marks of a categorical rupture, a threshold – 'the moment at which we break with the whole tradition of figuration, of art as essentially figuration' – and painting after Rodchenko is represented as the act, conscious or otherwise, of covering-up a monochrome: '. . . all the genres are able to be continued through the act of putting something on top of a monochrome, by effacing, supplementing, or disfiguring a monochrome.'[18] Thus Kawara's works also become palimpsests. (fig. 2) Wall is mainly concerned with the relationship in Kawara's work between the monochrome and the inscription in the work of the date on which the work was made. For Wall, the date becomes a cipher of another genre, parallel to but at odds with the monochrome, the genre of the painting of modern life, or more loosely, of representation. Each painting, then, enacts the unresolvable collision between these two antagonistic forces: 'These two big conceptual "knots" are

David Batchelor

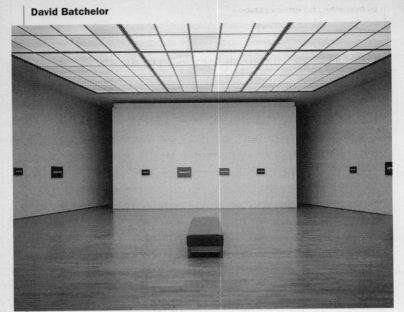

Fig 2. On Kawara Date Paintings. Museum für Moderne Kunst, Frankfurt am Main.
Photograph by Alex Schneider

brought together repeatedly in On Kawara's paintings. Kawara's
gesture of repetition is the road on which Baudelaire's two
antagonists [poetry and progress] confront one another. However,
neither gives way. The confrontation is repeated ad infinitum,
becomes permanent, and the dilemma becomes the foundation
for a production.'[19]

It's a striking image, these two figures endlessly puffing out their
chests and bouncing off each other. (For some reason I always see
them as large men with moustaches wearing long grey overcoats.
They might belong in a Marcel Broodthaers film-loop. In fact there
is a Broodthaers film-loop of two fat wrestlers locked in an endless
tumble routine, but sadly neither of them are wearing overcoats.)
But as well as being striking, it is also a blinding image. The motif
of repetition (mentioned three times) and confrontation (twice)

makes a picture which tends to exclude just about all other possibilities.

'Painting for [Kawara] exists in a state of repetition'. But what kind of repetition? What exactly is repeated? One answer would be: 'the monochrome' and 'the date'. But this only tells us which broad categories are repeated. It says nothing of what, if anything, goes on within these categories, or, more to the point, of what goes on within the painting. To address this question we have to move closer to the work. The date: to repeat the date is, obviously enough, a paradoxical form of repetition, as the date is never the same twice. But this paradox doesn't disrupt the system because it doesn't get us inside the work. To repeat the *action of painting the date* is a rather different matter though. This is where contingencies and irregularities begin to creep into the system and break its will to symmetry. The first of these is that, since 1966, Kawara's signwriting technique has inevitably and visibly changed. This may not seem very important, but at the same time we cannot help but notice it, particularly when the competencies of the painting as a whole have been narrowed down to such an extent. The second contingency is that the language and conventions of inscription change, depending on the country in which Kawara is working. Again, this might seem a fairly trivial point, but it also breaks into the system of the work by announcing that the practice is somehow located in a world, and that changes of location, for whatever reason they occur, and however abstractly they are represented, nevertheless enter the work. In a schematic and inexpressive way, the work begins to accrue and become marked by the contingencies of a life.

The monochrome: it is always there in Kawara's work, but it is not always the same monochrome. The surface is by and large unchanging: flat, matt, brushed acrylic; but size, format, colour: these are continually varied. Size and format are, as it were, fixed variables: Kawara uses six different canvases ranging from 8" × 10"

to 26" × 36", but again, in a practice of such a restricted vocabulary, such changes become highly visible and begin to appear significant. Colour is used much less systematically. Many of Kawara's works look the same dark and rather cold grey; others, though, are bluer; some are quite bright blue; others are bright red. This suggests, in keeping with the formats used by Kawara, that colour is also allowed into the work as a finite set of variables. In fact this is not how it is used in these works. In the artist's scrupulous and obsessive documentation of his date paintings – which is consistent with all the other forms of documentation which make up his practice – a series of A4 loose-leaf sheets of paper record, in tiny swatches, the colours used for that year's work. What they show is that, while a dark tonal range tends to predominate in the work, and while for some periods the same colour is used for thirty or more works, at other times the colours are varied from day to day by the addition of small quantities of blue or red or sometimes green paint, and then occasionally the series is punctuated by a more vivid red or blue. Again, this may seem a small point. But put all these minor variables together . . .

A room full of thirty date paintings, one from each year since 1966: I find I cannot ignore the differences that occur from work to work, so what should I put them down to? What motivates the choice of size and colour? And what motivates the other variable, the profound variable, which is fundamental to Kawara's work: the decision whether or not to make a painting that day? One possible answer: temperament; that is, that other cluster of unpredictable variables and contingencies which makes up something or much of what we are. Shown together, the paintings look oddly and intensely personal, very idiosyncratic, very *moody*. Kawara's practice is a production-line, to be sure, but this seems to do nothing to shut out the life which is put to the service of this production. On the contrary, it appears that the production-line repetitions provide the conditions for *revealing* a life. What, after

all, is the subject of Kawara's lists and catalogues and postcards and telegrams if not the 'I' of 'I am still alive' or 'I got up'? An 'I' measured and mapped in a very strange way, to be sure, but all the more interesting an 'I' as a result.

Forty years before Kawara got up, Lissitsky had advised staying in bed. But perhaps there was something similar at stake. For adults, getting up is usually the prelude to going to work. Lissitsky's staying put marked a refusal to go to work, or, more to the point, a recognition that painting might have become largely a question of going to work. A job, like many other jobs. A kind of labour rather than a form of creativity. Now that anyone could make a monochrome, why not stay in bed and order it up? This is perhaps the greatest threat that the monochrome could whisper in the ear of painting: 'Pssst, you're not so special; there's no difference anymore between painting and a paint-job.' Except there is a difference, of course, and it is exactly what makes, or made, the monochrome so special. Painting as paint-job, or paint-job as painting, is neither simply painting nor a simple paint-job. The monochrome may aspire to, or be represented as, merely a kind of labour, but at the same time it also remains something distinctly abstract, abstruse and exclusive. And its condition as a product of apparently dumb labour rather than dashing creativity is exactly the means by which it makes itself all the more exclusive as art. This inner paradox of the monochrome is perhaps one of the few areas of relative consistency in the genre. It is a paradox which defines and sustains Kawara's work, and equally one which confuses many critics. (Might it be that the inability to see in the monochrome anything but negation and repetition, is really an inability to see any worth or any complexity in the products of mere labour?) Rather than the artist handing over the job of art to someone with a job, as Lissitsky had recommended, Kawara turns the representation of his life into a kind of job, in order perhaps to remain an artist. But the apparent contradiction between the

production line of his practice and the curiously personal nature of its results, between its ubiquity and its uniqueness, is not one principally of Kawara's making. Rather this relationship is in the monochrome, or within certain practices out of which certain monochromes are made.

But not within all practices which produce monochromes: there are many instances of gestural, autographic, monochromes; instances of monochromes which carry within them all the conventional markers of conventional creativity: sweeping brushwork, fragile balances, improvised adjustments and happy accidents. Virtuoso monochromes. And almost without exception these works preserve the monochrome within painting, rather than test the limits of painting through the monochrome; they tend to cluster around the finer end of the remains of Fine Art; they can often look vulnerable and nervous next to the traffic of ordinary life.

So: stay in bed, get someone else to do it. This advice – to separate out conception and execution, design and fabrication, to introduce a division of labour into the quaint cottage industry of art, to produce, that is to say, something adjusted to the dictates of the modern – was not fully exploited until the early 1960s. The partial result was the partial reconnection of art, and the monochrome, with the world outside art, insofar as art often came to look like it had been made in the same way, by the same processes, as other things. Rauschenberg's black paintings look hard and shiny; LeWitt talked about making work which was 'hard and industrial'; Warhol's output came direct from the 'Factory'; the whole of Minimalism was literally made in factories; Kawara's studio becomes a production line; Weiner gets an assistant to chisel away at a gallery wall; and so on. The work of art became a partial mirror of a world of work, and it wouldn't be long before artists would look to actual mirrors to reflect this world which, since Romanticism, has been the imagined other of art. It wouldn't be long before the mirror itself became a kind of monochrome. Yes;

in the mid-1960s, at the age of about forty-five, the monochrome entered its mirror phase.

Examples: In 1965 Art & Language covered four small equal-sized stretched canvases with four small mirrors bought from a local hardware shop or glazier. At various times since the mid-1970s Richter has exhibited works made of mirrored glass, or glass panels painted on the rear face. And these mirror-monochromes were accompanied by a number of other mirrors in art – most notably by Michaelangelo Pistoletto, Robert Morris and Robert Smithson – as well as by a more diverse range of reflective or very shiny surfaces – from Judd's Plexiglas to McCracken's polished planks. In this context the mirror has a double value. First it is a manufactured surface: clean-sharp-polished-bright; and it is a ready-made: it can be ordered up by phone from bed. Second, the mirror is pure contingency: it does nothing but reflect its setting and the passing traffic; its content is all context; what's in it is all outside it. The mirror-monochrome pushes this particular relationship in painting to its limits: the relationship between painting and interiority; and the brief history of the monochrome is also the story of an untidy and unresolved relationship with this question of pictorial space. Rauschenberg's and Weiner's and Richter's and LeWitt's and Klein's and Kawara's monochromes admit little interiority. Nor do Robert Ryman's or Alan Charlton's or Imi Knoebel's or many others I have not mentioned. Their literalism may carry some ambiguities, but they are all paintings-in-the-world rather than worlds-within-paintings. Of these artists, only Klein has made use of a matt, absorbent, dark-toned surface – the condition, by and large, for producing optical depth in a monochrome – only immediately to react against this by breaking up and thereby re-literalizing the picture surface. Matt can have depth, but shiny always sits on the surface. Shiny is skin-like. Rauschenberg's black is a skin, as is his gold. By definition, reflectiveness always locates itself in relation to a world. By a

constant registration of its continuous change upon a shiny surface, this world is identified as unstable and inconsistent and unpredictable. The actual mirror does this almost absolutely, almost didactically. Richter's partially mirrored monochromes have a constancy of colour which is constantly interrupted or overlaid by the play of reflection on their glass surface: palimpsests of another kind. They also narrate the relationship in his work between the photo-paintings and the monochromes in new terms: the temporal overcoming or erasure of one by the other is replaced by the simultaneous coexistence of both, apparently contrary, elements. These works contain all the detail and all the indexicality of a snapshot, while at the same time they remain rectangular sheets of flat colour. They show directly and in an instant that the blank surface of the monochrome is not necessarily a means to exclude a world, but perhaps something like the opposite. The monochrome – or, rather, certain monochromes – may have a peculiar capacity to register exactly what other paintings have sought to fix but ultimately failed to capture: the fugitive and the ephemeral and the contingent of our continuously shifting present.

Deep spaces, big screens

We might end the discussion here or here about. It could finish with a recapitulation of the main themes of laboured blankness and repetition, and restate that, contrary to the claims of Buchloh, Wall and others – for whom repetition and monochromes represent the suppression of variation and difference, the exclusion of the here-and-now, the exclusion of a life, and so on – a fuller examination of existing monochromes shows something like the opposite: they reveal the here-and-now in their recognition and exploration of the constancy of contingency; and in this exploration they multiply and differentiate themselves from one another. Jeff Wall: 'In a monochrome, by definition, no event can

make an appearance.'[20] In practice though, events constantly appear and disappear and reappear. In the proliferation of actual monochromes the category of 'the monochrome' is left standing proud and theoretically upright, but also hollow and empty and shadowless. These monochromes are neither reductions nor mere negations, but always complex blanks: blanks in a world, blanks with a history, blanks with a life. This would be a convenient end to the story, but it would also be a premature end. It would leave at least two areas untouched: it would ignore all those monochromes which are neither principally literalist in orientation nor marked by varieties of repetition; and it would forget entirely to address the question of colour and the monochrome.

For some artists, the monochrome has represented an opportunity to pursue what was announced by Klein, but then also partially annulled in his own work: a virtual world of infinite, or indefinite, or impalpable, or immeasurable space. Not a bit of local history refracted through certain materials or processes of effects, but something more lasting and general. Deep space. Interiority. The void. The sublime. Or something approaching it. James Turrell and Anish Kapoor have in different ways sought to frame a void. Turrell has literalised interiority, sometimes, by framing the sky and making a natural monochrome which can be viewed through an aperture made in the gallery ceiling. A framed square of space, isolated from earthly referents and scale; changing ever so gradually and subject to occasional interruptions by passing 747s or cloud formations. Turrell has also made less natural monochromes with less depth and interiority, by fabricating actual interiors. These often consist of a hidden artificial light source illuminating one wall of an otherwise darkened room. They are often successful in producing a glowing, ethereal and unlocatable luminescence. To achieve this, however, requires the suppression of as much of the local conditions as possible, the blocking out of all other light sources, the elimination of such contingencies. That

is to say, these works appear to head off in exactly the opposite direction to those monochromes we have looked at so far: away from the local, the immediate and the specific. Except that there is always a kind of remainder: the carpentry and the blackouts, the electric lights and the paint-jobs on the floor and the walls: the practical and contingent framing machinery necessary to isolate the void-monochrome from the greater horde of contingencies which would otherwise overwhelm it. And this remainder, always a little thin and tinny perhaps, always more stage-set than architecture, never quite disappears. It lurks around the edges of the monochrome, psychologically as well as literally. This is obviously true of a lot of art which uses projected light of one kind or another, and the result is that sometimes the viewer is not so much offered a particular type of experience as required to submit to a regime of directions and imperatives. Follow this path. One-at-a-time. Stand here. Wait . . . But perhaps this is the point; perhaps these conditions are what give the work its specific, melancholic (rather than ecstatic) character. Perhaps this is what allows the work to approach, somewhat like Klein's, something simultaneously transcendental and realist.

Perhaps Klein, like Turrell, recognized the price that would have to be paid for entering the void. His sponges mark his recognition of contingency in the shape of studio debris, and his refusal or inability to deny it. (Remember: we live in a time when it is all too possible that that which is discarded and piled up in the corner of the studio in the process of making a work, may be as interesting as the work itself.) Other artists have continued this precarious and paradoxical balancing act in making monochromes which are at once highly optical *and* emphatically literal. *Adam* (1989), by Anish Kapoor, is not much like anything we have considered so far. It is a free-standing, rough-cut lump of rock. Its literalness is inescapable. At about eye-level on a relatively smooth and vertical face there is a small black or blue-black rectangle: intense,

absorbent, matt. At first sight this rectangle appears to rest on the surface of the stone; but sooner or later it becomes clear that this blue-blackness is in fact a kind of space hollowed out of the centre of this stone, and the rectangle a kind of window onto this void. A hollow monochrome of impenetrable blue-blackness. A void in a block of rock. It is as if literalism is taken by Kapoor not as a negation of opticality, not a something to be suppressed-as-much-as-possible in the creation of deep space but, on the contrary, as its necessary precondition. Blink and the stone returns. And in each of Kapoor's monochrome-voids, it is clear that the particular shape, size and colour of the stone container has a major influence over the dimensions and shape of the aperture it carries. Thus each of these works appears specific and individual and unique rather than serial and repetitive. But if, as Kapoor's work implies, in art the void can come into being only at the moment of its being framed, limited, and contained, what then are the limits of the frame? A rock? A room? A building? A volcano?

I don't want to go any further down that path, a path which often leads away from the city and its fugitive moments and towards something altogether more grand and occasionally grandiose. I prefer to stay and look for the voids in modernity, at the gaps where gaps shouldn't exist, at the blanks which are occasionally carved out of the impacted and replete surfaces of buildings, hoardings, roofs and pavements. And I want to refer to one further monochrome, a quintessentially urban one (although not always seen in urban environments), but also one which is also vividly optical and luminous: Derek Jarman's 1993 film, *Blue*. *Blue* is both static and mobile, repetitive and varied, continuous and broken. For an hour and a half the monochrome is a constant beam of cyan, projected onto a rectangular screen. At the same time the soundtrack is a sliding, merging, more or less loosely connected series of narrated episodes. It is a narrative which points in more than one direction: backwards into reminiscences; forwards into

the immediate and less immediate future. It is difficult to untangle one from the other, the forward-looking from the backward-looking bits. Perhaps it doesn't matter. *Blue* is a meditation on death: a memorial to dead friends, and observations about the artist's own AIDS-related decline. When making *Blue* Jarman was going blind in one eye. The blue of *Blue* becomes a very uncertain space; at times very distant, vague, out-of-focus and almost beyond recall; at other times close at hand, almost too local and painfully close. It is more indefinite than a Klein or a Kapoor, more infinite (because less literally so) than a Turrell.

As well as pointing forwards and backwards, *Blue* is also a beam of light pointing at a screen. As blue light projected onto a white rectangle, *Blue* alerts us to another monochrome, one of the truly great monochromes of the twentieth century: the cinema screen. So great and magnificent that it has to be kept in darkness and behind a ludicrously fenestered and often polychrome curtain. But so great that, like other monochromes of the city, it is almost always overlooked. The cinema screen: another palimpsest. Another covering over or erasure of a world, a world behind the screen, which in turn becomes the ground for another world to be poured onto the newly whitened expanse. Very occasionally, this monochrome has been registered: think of the photographs of empty cinemas and deserted drive-ins by Hiroshi Sugimoto; and think also of those few films where a scene takes place *behind* the screen. In these fragments the screen is made visible as screen, as monochrome, as palimpsest.

Notes

1. Clement Greenberg, 'After Abstract Expressionism' (1962), *Encounter*, December 1962; republished in *Clement Greenberg: The Collected Essays and Criticism*, vol. 4, ed. John O'Brian, University of Chicago Press, Chicago and London, 1993, pp. 121–34, p. 131; Jeff Wall, 'Monochrome and

David Batchelor, *The Found Monochromes of London: Holloway, 07.04.00*, C-Type print, 24 × 20 ins, courtesy Anthony Wilkinson Gallery

Photojournalism in On Kawara's *Today Paintings* (1993), in *Robert Lehman: Lectures on Contemporary Art*, no. 1, eds. Lynne Cooke and Karen Kelly, Dia Centre for the Arts, New York, 1996, pp. 135–56, p. 135.

2. Clement Greenberg, *op cit.*, p. 132.

3. El Lissitsky quoted in Benjamin Buchloh, 'The Primary Colours for the Second Time: A Paradigm Repetition of the Neo-Avant-Garde', *October 37*, Summer 1986, pp. 41–52, p. 45.

4. Alexander Rodchenko quoted in Benjamin Buchloh, *ibid.*, p. 44.

5. Jeff Wall, *op cit.*, p. 136.

6. Clement Greenberg, *op cit.*, pp. 131–2.

7. Peter Bürger, *Theory of the Avant-Grade*, Minnesota University Press, Minnesota, 1984, p. 61.

8. Hal Foster, *The Return of the Real: The Avant-Garde at the End of the Century*, MIT Press, Cambridge Mass. and London England, 1996, p. 15.

9. Benjamin Buchloh, *op cit.*, pp. 48–9.

10. Gerhard Richter, 'Interview with Benjamin H.D. Buchloh, 1986', in *Gerhard Richter, The Daily Practice of Painting: Writings 1962–1993*, ed. Hans Ulrich Obrist, trans. David Britt, Thames and Hudson, Anthony d'Offay Gallery London, 1995, pp. 132–66, p. 154.

11. Jeff Wall, *op cit.*, p. 154.

12. Gerhard Richter, in *Gerhard Richter*, Tate Gallery London (exh. cat.), 1991, p. 112.

13. Benjamin Buchloh, *op cit.*, p. 50.

14. John Cage, quoted in Simon Shaw-Miller, ' "Concerts for everyday living": Cage, Fluxus and Barthes, interdisciplinarity and inter-media events', in *Art History*, vol. 19, no. 1, March 1996, pp. 1–25, p. 13.

15. Benjamin Buchloh, *op cit.*, p. 45.

16. Yves Klein, quoted in Sidra Stich, *Yves Klein*, Hayward Gallery London (exh. cat.), 1995, p. 66.

17. Restany, quoted in Stich, *ibid.*, p. 91.

18. Jeff Wall, *op cit.*, pp. 135–6.

19. Jeff Wall, *ibid.*, p. 152.

20. Jeff Wall, *ibid.*, p. 148.

The absolute monochrome

Howard Caygill

A response to Batchelor

David Batchelor's description of the repeated monochrome as a 'complex blank' strangely echoes Hegel's view of what it is to philosophize in modernity. In the Preface to *The Philosophy of Right* the task given to philosophy at the end of 'a shape of life grown old' is to 'paint grey on grey' – to work up a monochrome. It is curious that the same philosopher who in his *Lectures on Aesthetics* proclaimed the death of art and its resurrection in the philosophy of art should describe the practice of philosophy in terms of *painting*. This suggests that the Hegelian 'death of art' is more complicated than it initially seemed, and that even the proposition 'where theory [philosophy of art] ends, there art begins' may prove to be Hegelian. Hegel's 'philosophy of art' not only succeeds art, but also philosophy, with philosophy and art transforming themselves into 'absolute painting'. The latter works towards a complex monochrome, one that Hegel pits against the 'boring' or 'formalist' monochromes of abstract thinking.

The discovery that Hegel's philosophy of art corresponds to the 'complex blank' of the monochrome is inconvenient for critical theory, which has long traded on a Hegel that is simple and replete. The monochrome vocation of philosophy proposed in *The Philosophy of Right* is indeed directed against the claims that philosophy should supply detailed simplicity, exemplified for Hegel by Fichte's fantasy of passport regulations in which 'the passports

of suspected persons should carry not only their personal description but also their painted likeness'. The implications of such 'picture thinking' and the future complicity of realist painting (later photography) and the state were not relished by Hegel, who posed against it the 'complex blank' of speculative philosophy. In this, as shown at the end of the *Phenomenology of Spirit*, the form of life grown old – the diorama of the 'slow moving succession of spirits' manifest in 'the gallery of images' that was the *Phenomenology* – is succeeded by the monochromatic night. But unlike the undifferentiated night with which the *Phenomenology of Spirit* begins – the night in which all cows are black – this night is complex, lit by the twilight which announces 'the new existence, a new world and a new shape of spirit'. Whether this be the grey of twilight or dusk, emphasizing the end of a shape of life, with the owl of Minerva taking flight, or that of the morning, with the anticipation of a new shape (*Gestalt*) of spirit being born, remains undecidable. Common to both is the understanding that philosophy must paint the shape, whether of life or of spirit, and that this means painting its shine.

Hegel as a monochrome painter is less familiar than Hegel as the perpetrator of the 'idealist aesthetic' refused by everyone. The familiar Hegel places conception and form before realization and content and proclaims the death of art as its sensuous character or materiality is translated into the white light of thought and philosophy. Yet Hegel's favourite term of abuse is 'formalist' and his least favoured colour is white. Hegel's critique of formalism has three targets – an idealist formalism, a materialist formalism and a formalism of difference. In each case, the complex shine of the *Gestalt* is reduced to unity or the condition of a formalist monochrome.

Idealist formalism 'subjects everything to the absolute idea' and offers 'a monochromatic formalism which only arrives at the

differentiation of its material since this has already been provided and is by now familiar'. The shine of *Gestalt* is reduced to the 'monotonous and abstract universality' of white or black, the 'void of the absolute' or 'pure identity, formal whiteness'. The inversion of this position produces materialist formalism, in this case a formal blurring of shape in which abstract materiality is the dominant characteristic 'the others being present only in blurred outline' or *Gestalt* 'shrouded to become a mere shadowy outline'.[1] Out of opposed formalisms emerges the third possibility of a formalism of difference. The procession of shapes that make up the *Phenomenology of Spirit* are looked upon as outcomes of the difference between black and white. The abstract black or white of the idealist and the blur of materialist formalism resolving themselves into the formal difference of 'the silhouette'.

The abstract difference of light and shade that constitutes the silhouette announces the formalism of difference. The latter is compared to 'a painter's palette having only two colours, say red and green, the one for colouring the surface when a historical scene is wanted, the other for landscapes',[2] the choice of red for the historical scene following from Hegel's comparison of history with a slaughterboard. Each formalism paints a bad monochrome, reducing the 'complex blank' of the shine of *Gestalt* to a single abstract and uniform value. Philosophy as painting must produce complex monochromes that shine, as in the shine of the surface of a mirror whose monochrome may serve as the vehicle of other colours without reducing them to its abstract unity.

In the *Aesthetics* Hegel discusses the shine of *Gestalt* as a monochrome which is the product and the vehicle of other colours. Here Hegel radically and explicitly distinguishes the painting of shine from the conceptual and formal privileges of drawing and from the tonal modelling associated with it: 'nowhere is there any harsh or sharp line, transition is everywhere; light and shadow are not effective as purely direct light and shadow, but

they both shine into one another'. With this 'hither and thither of reflections and sheens of colour, this mutability and fluidity of transitions, there is spread over the whole, with the clarity, the brilliance, the depth, the smooth and luscious lighting of colours, a pure appearance of animation'. The shine is animate – a play of shape and colour which has neither surface or depth, nor an inner or an outer – and in which we have 'the shining of one colour through another'. The medium is the monochrome, without it there can be no animate colour. 'If we look closely at the play of colour . . . we see perhaps only white or yellow strokes, points of colour, coloured surfaces; the single colour as such does not have this gleam which it produces; it is the juxtaposition alone which makes this glistening and gleaming'.[3]

The shine which serves as the monochromatic vehicle for colour has a number of analogues in Hegel's writings. Among the media which carry and are carried by their contents are the appearance which is the arising and passing away that does not arise and pass away, the Bacchanalian revel which is 'just as much transparent and simple repose' and 'the spiritual daylight of the present' in which the I is a we and the we an I. The task for philosophy is to present the shine that carries and is carried by colour, to paint the grey on grey of the light of the mirror. In the *Phenomenology of Spirit* Hegel called for the absolute to be thought; in the *Aesthetics* he described the monochrome as absolute painting: if the absolute is to be painted, then perhaps it can only be in the grey on grey of a 'complex blank'.

Notes

1. *Hegel's Phenomenology of Spirit*, trans. A.V. Miller, Clarendon Press, Oxford, 1977, pp. 9, 31, 16.

2. Ibid., p. 31

3. *Hegel's Aesthetics: Lectures on Fine Art*, trans. T.M. Knox, Clarendon Press, Oxford, 1975, vol. 2, pp. 848, 600.

Notes on contributors

Sylviane Agacinski is Professor of Philosophy (EHESS, Paris). Her books include *Aparté: Conceptions and Deaths of Soren Kierkegaard* (1988), *Volume: Philosophies et politiques de l' architecture* (1992), *Politique des sexes* (1998) and *Le Passeur de temps, modernité et nostalgie* (2000).

David Batchelor is an artist and writer on contemporary art and Senior Tutor in Critical Studies at the Royal College of Art, London. His publications include *Minimalism* (1997) and *Chromophobia* (2000). Recent exhibitions of his work include 'Postmark: An Abstract Effect' at SITE, Santa Fe (1999) and 'The British Art Show 5', Edinburgh and touring (2000).

Jay Bernstein is Distinguished University Professor of Philosophy in the Graduate Faculty, New School for Social Research, New York. His books include *The Fate of Art: Aesthetic Alienation from Kant to Derrida and Adorno* (1993) and *Recovering Ethical Life: Jürgen Habermas and the Future of Critical Theory* (1995).

Howard Caygill is Professor of Cultural History at Goldsmiths College, University of London. He is the author of *Art of Judgment* (1989), *The Kant Dictionary* (1994), *Walter Benjamin: The Colour of Experience* (1998) and *Levinas and the Political* (2001).

Alexander García Düttmann is Professor of Modern European Philosophy at Middlesex University. His books include *At Odds*

with Aids (1996), *Between Cultures* (2000) and *Lifeline and Self-Portrait: Philosophical Essays*, forthcoming from Serpent's Tail.

Christoph Menke is Professor of Philosophy at the University of Potsdam. His books include *Tragödie im Sittlichen* (1996), *The Sovereignty of Art: Aesthetic Negativity in Adorno and Derrida* (1998) and *Spiegelungen der Gleichheit* (2000).

Mandy Merck is Professor of Media Arts at Royal Holloway College, University of London. She is the author of two collections of essays, *Perversions: Deviant Readings* (1993) and *In Your Face* (2000) and the editor of *After Diana* (1998).

Peter Osborne is Professor of Modern European Philosophy at Middlesex University and an editor of the journal *Radical Philosophy*. His books include *The Politics of Time* (1995), *A Critical Sense* (ed., 1996) *Philosophy in Cultural Theory* (2000), and *Conceptual Art* (forthcoming, 2001).

Jacques Rancière is Professor of Aesthetics at the University of Paris-VIII, Saint-Denis. Recent books of his available in English translation include: *The Names of History* (1994), *On the Shores of Politics* (1995), and *Disagreement: Philosophy and Politics* (1999).

Jonathan Rée is Reader in Philosophy at Middlesex University. His most recent books are *Kierkegaard: A Critical Reader* (co-ed., 1998), *Heidegger* (1998) and *I See a Voice* (1999).